Bombay, October 2012

Happy reading,
Susan.

Much love,

Birjet

The *Painter*

A Life of Ravi Varma

The *Painter*

A Life of Ravi Varma

Deepanjana Pal

RANDOM HOUSE INDIA

Published by Random House India in 2009

13579108642

Copyright © Deepanjana Pal 2009

Random House Publishers India Private Limited
MindMill Corporate Tower
2nd Floor, Plot No 24A
Sector 16A, Noida 201301, UP

Random House Group Limited
20 Vauxhall Bridge Road
London SW1V 2SA
United Kingdom

ISBN 978 81 8400 064 1

Typeset in Adobe Caslon by InoSoft Systems, Noida

Printed and bound in India by Replika Press Private Limited

To
Sajan Venniyoor, because he asked for it first, and
Anjalee Kohli, for pounding the pavements with me.

Contents

Contents

Author's Note

'Culture is for the living, and art should be about taking part,' wrote the playwright Lee Hall in the introduction to his play *The Pitmen Painters*. When researching for this book, I found myself going through books, diaries, notes, articles, catalogues, and a lot of dust. Most of it yielded valuable facts and information, but every page and the often archaic turn of phrase reminded me that this was history. It was not about the living; it was about analysing one who had lived long ago and swaddling the person in hindsight. In contrast, when I listened to people telling me the stories they knew about Ravi Varma, the man came to life.

While writing this book, I wanted my reader to feel that same sense of immediacy that I had felt when hearing about Ravi Varma and the people he knew. I wanted to tell Ravi Varma's story in a way that felt alive, was accurate, and drew the reader into his world whether or not they were interested in the beginnings of modern Indian art. So I decided to not be boxed in by documented evidence. I included, in the narrative, vignettes and gossip that cannot be verified. I let in the emotions that facts suggested but did not always announce. In this entirely non-fiction tale, I have used fiction and imagination in parts, to recreate a bygone world; and I have been careful to keep that which has been recorded distinct from that which was imagined. In the text you will find the latter in italics. At no point have I deviated from the history of Ravi Varma. As my aunt, author Nabaneeta Dev Sen once told me, 'Fiction doesn't necessarily mean fictitious.'

June 2009,
Mumbai

Principal Characters

The book uses the full names of all characters in the first instance of occurrence, and then refers to them using the shortened, informal forms.

Ravi Varma Coil Thampuran	Ravi Varma and Raja Ravi Varma
Uma Ambabai Thampuratty	Amba (Ravi Varma's mother)
Ezhumavil Neelankantan Bhattiripad	(Ravi Varma's father)
Raja Raja Varma	Raja Varma (Ravi Varma's uncle)
C. Raja Raja Varma	Raja (Ravi Varma's brother)
Maharaja Ayilyam Thirunal	Ayilyam (Maharaja of Travancore)
Pooruruttati Nal Thampuratty	Bhagirathi (Ravi Varma's wife)
Sir Thanjavur Madhava Rao	Madhava Rao (Dewan of Travancore and later Baroda)
Vishakham Thirunal	Vishakham (Ayilyam's successor)
Kerala Varma Valiya Coil Thampuran	Kerala (Ravi Varma's friend and brother-in-law)
Maharaja Sayaji Rao III	Sayaji (Gaekwad of Baroda)

Raja Deen Dayal	Deen Dayal (friend of Ravi Varma and acclaimed photographer)
Fritz Schleicher	Schleicher (Manager, and later owner, of the Ravi Varma Fine Arts Lithographic Press)
Anjanabai Malpekar	Anjanabai (Ravi Varma's model)

Key Dates

1848 Ravi Varma born on 29 April in Kilimanoor
1860 Raja Raja Varma born on 3 March in Kilimanoor
 Ayilyam Thirunal becomes Maharaja of Travancore
1862 Ravi Varma moves to Thiruvananthapuram
 Ayilyam Thirunal marries his second wife, Nagercoil
 Ammachi.
1866 Mangalabai born at Kilimanoor
 Ravi Varma and Bhagirathi are married.
1868 Theodore Jensen visits Thiruvananthapuram. He and
 Ravi Varma both paint a portrait of Ayilyam Thirunal
 and Nagercoil Ammachi.
1870 Ravi Varma decides to become a professional artist.
1872 Kerala Varma arrested.
 Ravi Varma expelled from Ayilyam Thirunal's court.
1873 Ravi Varma is invited back to Thiruvananthapuram by
 Ayilyam Thirunal. He wins gold medal at Madras Fine
 Arts Exhibition.
1874 Ravi Varma again wins gold medal at Madras.
1875 Kerala Varma, son of Bhagirathi and Ravi Varma, is born
 in Mavelikkara.
1876 Ravi Varma wins gold medal at Madras for the third
 time.
1880 Rama Varma, son of Bhagirathi and Ravi Varma, is born
 in Mavelikkara.
 Death of Ayilyam Thirunal. Vishakham Thirunal ascends
 the throne of Travancore.

1881	Ravi Varma invited to Baroda. Maharaja Sayajirao III offers Ravi Varma the first Baroda commission.
1884	Death of Ravi Varma's uncle, Raja Raja Varma.
1885	Ravi and Raja Varma are invited to Mysore for a commission.
	Death of Vishakham Thirunal. Srimoolam Thirunal ascends the throne of Travancore.
1886	Death of Ravi Varma's mother, Uma Ambabai Thampuratty.
1887	Ravi and Raja Varma invited to Mysore for a commission.
1888	Sayajirao III offers Ravi Varma the second Baroda commission for Rs. 50, 000.
	Ravi and Raja Varma complete a tour of India.
1890	Paintings from the Baroda commission exhibited in Thiruvananthapuram.
1891	Death of Bhagirathi.
	Paintings from the Baroda commission exhibited in Bombay.
1892	Paintings from the Baroda commission shown in Baroda.
1893	Ravi Varma participated in the World's Columbian Commission International Exhibition in Chicago. He received two certificates of merit.
1894	The Ravi Varma Fine Arts Lithographic Press starts production.
	Ravi and Raja Varma take Prince Aswati Thirunal on a tour of central and northern India.
1900	Ravi Varma meets Lord Curzon, Viceroy of India.
	Ravi Varma's granddaughters are adopted into the royal family of Travancore.
1901	Ravi and Raja Varma go to Udaipur for a commission. Ravi and Raja Varma go to Hyderabad for a commission.

Ravi Varma diagnosed with diabetes.

1903 The Ravi Varma Press is sold to Fritz Schleicher.

1904 Raja Varma wins gold medal at Madras Fine Arts Exhibition.

Ravi Varma is awarded the Kaiser-i-Hind.

Ravi and Raja Varma go to Mysore for a commission.

1905 Death of Raja Varma on 4 January in Madras.

Raja Varma wins gold medal at Madras Fine Arts Exhibition posthumously.

Ravi Varma completes paintings for the Maharaja of Mysore in Kilimanoor, assisted by Rama Varma.

1906 Ravi Varma invited to be part of the entourage accompanying King George V on his visit to Mysore.

Death of Ravi Varma on 20 September in Kilimanoor.

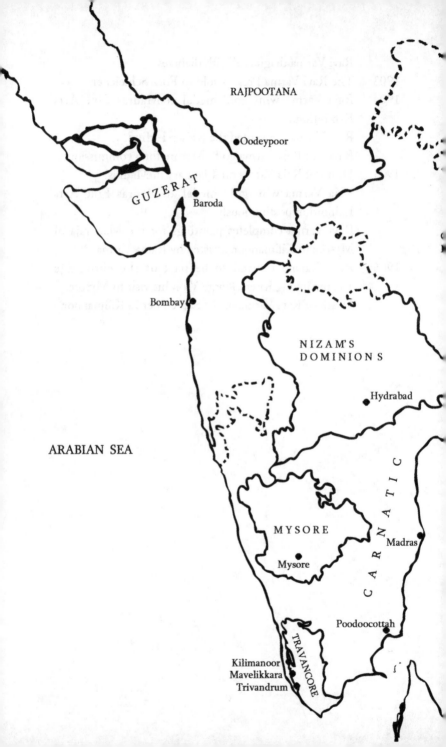

B E N G A L

Calcutta

RAL
NCES

BAY OF BENGAL

INDIA
1872

Part One

A Boy in Travancore

Cowdiar Palace is in the heart of modern-day Thiruvananthapuram (or Trivandrum, as it is known in its Anglicized version), with a noisy market behind it and a Café Coffee Day five minutes' walking distance away. While the Maharaja of Travancore lives in the more secluded Pattom Palace, Cowdiar Palace is home to the Maharanis of Travancore. It stands atop a slight bump of a hill, surrounded by perfectly manicured lawns. The six Ravi Varma paintings that the royal house of Travancore has managed to hold on to as personal property are kept in this palace.

The painting titled 'At the Bath' is one of the six, and it is in the salon on the ground floor that visitors are brought to. The life-size oil painting, now a little yellowed with age, hangs above a love seat and faces the large windows. The girl in the painting stands shy yet seductive, holding her white sari close and drawing the eye to the gleaming skin of her shoulders and the tumbling softness of her long black hair. Near the bottom of the painting, you can see her delicate foot slipping out from under her sari. It's as though she is thinking of stepping out of the heavy golden frame and into this old room. If you follow her eyes, she seems to be looking upstairs with sweet nervousness, as though she doesn't want this moment between you and her to be discovered or interrupted by those who could come down the staircase and enter the room at any moment.

Maharaja Studios is a few minutes away from Pattom Palace by car. It's like a hundred other shops in Thiruvananthapuram

and Kerala, where you can get a photograph taken, or buy a picture or print of anything, from a heavy-lidded Jesus with a glowing heart to a suspiciously obese, pink baby Krishna painted in the Tanjore style. If you ask for a print of the painting 'At the Bath', a glossy photograph of an oil painting will be placed upon a counter. It is a painting of a woman standing at a bath, clutching her unravelled sari to her chest. She looks straight at you, mischief and temptation in her eyes, and she holds the wet folds of white fabric so as to artfully show off her breasts. If you ask the salesman whom this painting is by, he'll tell you that it is by Raja Ravi Varma.

* * *

Ravi Varma was born on April 29, 1848, in a small estate called Kilimanoor, a few hours away from Thiruvananthapuram, the capital city of the kingdom of Travancore. He was the first of the three sons and one daughter born to the ruling family of Kilimanoor. We should call him Ravi Varma Coil Thampuran because that was his official name, the one that acknowledged the aristocratic lineage of his mother, Uma Ambabai Thampuratty. In Malayali, Thampuratty means princess, and it was her blood that made him a prince, or Thampuran, because the southern kingdom followed the matrilineal system of inheritance, according to which property was inherited through the mother's line. So daughters inherited from mothers, and this raised the position of women in society. However, the controlling power remained with men, but instead of the husband or the father, the matrilineal system placed a girl's brother in the position of power. Consequently, a maharaja's successor was his nephew, his sister's son. This is why royal families often 'adopted' daughters from other aristocratic families—to ensure that the line remained unbroken. This system of adoption would lead to one of Ravi Varma's granddaughters becoming the Maharani of Travancore. Her son, Ravi Varma's

great-grandson, would see the kingdom of Travancore, which had been the most powerful in the region, become a part of the republic of India. Along with other smaller kingdoms like Malabar and Cochin, Travancore's lands turned into the state we know today as Kerala.

The title of Raja was one Ravi Varma earned on his own, many years later, with a little help from the British who referred to him as 'Raja Ravi Varma' in the citation for the Kaiser-i-Hind medal in 1904. For now, however, at the time of his birth, he was only a prince, known simply as Ravi Varma, and little more than minor royalty. His home estate of Kilimanoor was tiny and had few connections with the seat of political power.

This isn't to say it was entirely insignificant. Although small and nestled inland, away from the avarice of spice-trading Europeans, Kilimanoor had played an important part in the history of Kerala. It was a Varma from this family and this land who had founded the royal house of Travancore, back in the eighteenth century. This history had granted the little estate autonomy, which meant the rulers of Kilimanoor could collect taxes (although not impose them), and when Ravi was banished from the royal court of Travancore many years later, there was only one place in Kerala where he could live beyond the reach of the Maharaja's ire: Kilimanoor. But those days were yet to come, and when Ravi was born, no one would have imagined that this child would grow into a man who would become more well known than the ruler of the kingdom.

Decades later, after Ravi had become a name that drew gasps, some said that Uma Ambabai had dreamt of a white elephant when she was pregnant, just like the mother of the Buddha. The Varmas of Kilimanoor laugh that story off, although there are some obvious similarities between Ravi Varma and the Buddha—both were princes; both left their homes, effectively abandoning a wife and a young son, to pursue their calling—so perhaps it isn't

unlikely that Uma Ambabai had the same dream as the Buddha's mother in faraway Nepal. The legend that isn't scoffed at is the one about Uma Ambabai and the spirit of the yakshi.

In the galaxy of gods and divine figures from Hindu, Buddhist, and Jain mythologies, the yakshi is a starlet. In northern India, the yakshis are fairy-like spirits who are the guardians of hidden treasure and, due to their ample proportions, are believed to be fertility symbols. They can be seen sinuously wrapping themselves around trees in many temple carvings, and the gifts they offer are hedonistic. Travel south and the connotations change completely. In Kerala, the voluptuous yakshis were feared as dangerous spirits who waylaid men with their beauty and then sucked their blood. It isn't too much of a leap to see this diametrically different depiction of the yakshi as a sign of anxiety that the matrilineal system caused in men. On some rare occasions, the yakshis were benevolent, but that was only when they were tamed by Brahmins, whose knowledge of the mantras (traditionally, this was not passed on to women unless there were extraordinary circumstances) protected them from the yakshis' hunger. The similarity between the yakshis of northern and southern India was that both had a fondness for trees and secluded spots.

Within the palace walls of Kilimanoor but a distance away from the main buildings is a temple, now musty with neglect. This temple is believed to be guarded by a yakshi, which is why even today, men don't go near it. Tall trees shrouded the little clearing in which the temple stood, curtained in shadows and aloof from the rest of the palace. Every morning and evening, there used to be prayers. Lamps were lit, bells rang, chants droned. Now, it has few visitors other than a priest who comes on certain days to perform special prayers. One of the stories about this temple has Ravi Varma's mother, Uma Ambabai, playing a key role and it goes like this…

The women of the household came and stood in front of the goddess

4

as they did every morning. No one uttered their wishes out loud, as though the goddess would turn away if she knew there was someone else in whom her devotee had confided. But everyone knew that women came to the temple to ask for a child or to beg the goddess to tame an errant brother or uncle. The morning it happened, the priest thought the idol's eyes seemed strangely alive. He put all of himself into the prayer even as his mind wondered whom the eyes were looking for. Then it happened. Without any warning, Amba started quivering. She was suddenly on the floor, her body shaking. Her eyes seemed to be rolling upwards. Her lips shook as though the muscles holding her mouth together had been slashed. Indecipherable words slipped out of her in a voice that no one recognized. The women stood around her in a circle, unsure whether they should try to hold her down. The younger ones nervously looked to their elders and the idol that impassively looked on at the pregnant woman who had fallen to the ground. Then just as suddenly, it was over and Amba lay limp and unconscious. Sweat ran off her, as though frightened of her goose-pimpled skin. 'Get some water,' her mother said, and one of the younger girls ran to the house.

That was when the whispers began that the child Amba was carrying was a special one, especially after the ayurved came and said the fall had not hurt it. Some said they had heard the yakshi speak through Amba, promising glory and greatness and a son. Others whispered that it wasn't the yakshi but the goddess who had spoken in magical tongues and that Amba's child would be somehow unnatural. A few were certain she wouldn't survive childbirth, for such children sucked the strength out of their mothers. Amba herself never spoke of that morning. If anyone asked, she only placed her hand over her swollen belly and said it was not for men and women to understand the ways of the divine.

Some husbands might have felt a little nervous about being married to a woman who had been possessed, but Ezhumavil Neelakantan Bhattatiripad, an erudite Brahmin, wasn't one of

them. Even when he had married Uma Ambabai, he wasn't perturbed by the fact that he had been selected not so much for being the best candidate for the Thampuratty, but because his love for the ancient Sanskrit texts had been taken as a sign that he would encourage the precocious young Uma Ambabai, who soaked in stories like parched earth did rain. And he did. In matrilineal Kerala, it wasn't unusual for a princess to be taught how to read and write, but it was unusual for her husband to be as enthusiastic about her scholarship as Neelakantan was. Amba proved to be gifted in Ayurveda and she wrote operas that would be performed by the Kathakali troupe patronized by the Varmas of Kilimanoor. It was unusual for Neelakantan to stay in Kilimanoor as much as he did. Most husbands chose to be visitors in their wives' homes, but for Neelakantan, Kilimanoor was where he put his roots, content to be Uma Ambabai's husband and father to their children. And never mind what they must have said when Uma Ambabai became pregnant with their daughter Mangala twenty years after giving birth to her first child and a few years before becoming a grandmother.

The Varmas of Kilimanoor were a respected family, and while they were not known for their wealth, the property they owned was fertile and enough to keep the family comfortable. They had a small palace in Thiruvananthapuram, as did all important families of the time, and their palace in Kilimanoor was a sprawling one, surrounded by lush paddy fields. Unlike the palaces of northern India, the one in Kilimanoor was a labyrinth of low buildings that were built as the family grew. Today, the palace is in ruins and the greenery is a wild tangle of leaves, dust, and undergrowth. The descendants of Ravi Varma who haven't been able to leave are a family of three, and they live in a set of rooms that could be any middle class apartment, were they not tucked in among winding paths and courtyards that had once bustled with people and activity. When you walk in through the gates, a path leads

you to an empty room with high ceilings. It used to be Ravi Varma's studio and today, all it has are cheap reproductions of his paintings, because most of what he painted was on commissions for others. The palace is silent now, too silent, as though the past is sitting with a finger over its lips and playing hide and seek with anyone who visits. Stand in the cool shadows, touch the walls, and you can almost hear the conversations that took place in these rooms.

A horoscope must have been drawn up as soon as the boy was born, and Amba and Neelakantan named their firstborn Ravi, after the sun god, who would have sat benevolently in his birth chart and blessed him with intelligence and good fortune. Venus, named Shukra in Hindu astrology, after Shukracharya, was the other planet that ruled over Ravi's chart. When the astrologer pointed out that the blessings of Shukracharya were upon Ravi and he would grow up to be artistic, it seemed to follow that Amba, who spent so much of her time reading and writing poetry and lyrics, would have such a son. But Amba's writing was the gift of Jupiter, Brihaspati, the benevolent guru of the devas. He had none of the inclinations towards luxury and indulgence that came with Shukracharya, who was the guru of the asuras. Those who had the blind Shukracharya's blessings tended to have the same sparkle as the brightest star in the sky; they were flamboyant, flaunted traditions, and were likely to be, as astrologers delicately put it, appreciative of the finer pleasures of life. But princes, even minor ones, were allowed their excesses.

It was another aspect of Shukra that boldly hinted that this thampuran would be unconventional. One of the planets that Shukra has a hostile relationship with is Ravi, the giver of much good fortune in the newborn prince's horoscope. The chart showed a tussle between the conforming goodness of the sun and Shukra's unorthodoxy. But the astrologer didn't delve into what these conflicts would mean in Ravi's life. It wasn't important. The horoscope promised a brilliant future for the boy, and more importantly, the astrologer would have known

that the real reason he had been asked to draw up the birth chart was because it needed to be matched with a prospective bride's before marriage. When the time came for matching horoscopes, it was unlikely he would be called upon to tweak the birth chart to make it suitable.

* * *

The year 1848 was one of revolutions in Europe, and closer to Travancore, in Sri Lanka, the Matale Rebellion broke out in July. India, however, saw no tumult and Kilimanoor, in particular, was idyllic. In Ravi Varma's memories of his childhood, that is how it would remain. The first thirteen years of his life were the ones he would hold most dear in his memories. Sunlight sliced up the long corridors of the Kilimanoor home and if you put your ear to the wall or wrapped your hand around one of the columns, you could hear the throb of the drums that played as the Kathakali troupe practised in one of the courtyards. Strains of song could be heard all day, whether it was one of the many women humming or a visiting singer unfurling a raga. The children, particularly the boys, who were unhampered by any kind of clothing until they were about nine or ten, scampered around and enjoyed the freedom of not being old enough to sit down and learn things. As a boy, Ravi spent hours sitting on his father's lap and listening, awestruck, to the stories Neelakantan told him from the Hindu epics and legends. He was known to be something of a mischief maker, and one with a ready smile and bright eyes. Everyone, from the maid who ran after him as a boy to the models who fell in love with him when he was older, remembered the twinkle that often glinted in his eyes, and the servants despaired over how the boy just could not be stopped from scribbling on the walls. There was enough work to do in a crowded palace without having to scrub off his doodles.

There is one story of Ravi as a boy that is much repeated. One day, Uma Ambabai's brother, Raja Raja Varma, noticed his nephew crouched against a wall. The uncle, who was a talented

8

dabbler in painting and sculpture, and was a student of the Thanjavur style, drew closer to the boy and saw that he was drawing on the wall. The lines were thin and quivered their way over the uneven surface but even so, the drawing amazed Raja Raja. It was a simple enough scene—a few cows, a field, a river, the beginnings of a home with walls not unlike the walls that were being drawn upon—but for it to be executed so neatly and accurately by a child was no common thing. He would not have been more than ten years old at the time. From that day, along with his lessons in Malayalam, Sanskrit, Kathakali, and music, Ravi began learning how to draw from his uncle.

The Thanjavur style of painting is also known by its Anglicized name, Tanjore. It developed in the 1600s in the city of the same name, which is now in Tamil Nadu but was ruled by artistically inclined Maratha rulers, the Nayaks, until 1855, when the British took control of the area. Traditionally, Tanjore paintings were done on wood panels covered with cloth. Upon these panels, drawing would be made, usually of bejewelled gods or goddesses whose bodies seemed to be made of curves rather than lines. They were shrouded under endlessly pleated saris and dhotis that rested on the figures as though they were cut out of paper. Jewellery, often created out of real semi-precious gems and gold, decorated almost every visible part of the skin that was painted pale pink. Then, stones and gold foil would be pasted on the drawing, and they would remain just a little raised so that even a blind man could put his hand on the painting, follow its lines, and see much of it in his mind's eye. This was the dominant artistic style of southern India, where miniature painting and Mughal art were virtually unheard of. In the north and in Bengal, the East India Company had employed artists since the 1700s, and their style of painting was copied by many local artists in those provinces. When political changes brought the colonial powers to the south, the arts soon followed. Thanjavur's rulers and their artists

developed an interest in the European tradition of portraiture.

Ravi was seven years old when the Maratha line of Thanjavur came to an end with the death of the heirless Raja Sivaji in 1855. The British annexed the court. This meant no patronage for the local artists, who knew they would find no favour with the British East India Company officials. They preferred their own artists. So the Thanjavur artists scattered across southern India, looking for aristocratic patrons. Among them was Alangiri Naidu, who found a home in the Travancore court. Aside from the paintings he made for the Maharaja, he also became an art teacher to members in the royal family and frequent visitors to the royal court, like Raja Raja Varma.

It was not unusual for princes and aristocrats to dabble in the creative arts. All courts gave patronage to a few artists, and these men often taught interested patrons. Although art and music were supposed to be hobbies, many took these activities seriously and studied them with rigorous dedication. Raja Raja, for example, had studied art since he was a boy. When he became a student of Alangiri Naidu, he was, in all probability, already well versed in the basics of Tanjore painting. Naidu helped him hone his existing skills and taught him a little bit of oil painting, which was a novelty at the time. It isn't known who taught Naidu oil painting. As an artist desperate to make a living, it is likely that he learnt the rudiments from a travelling European artist.

The greatest threat to the Thanjavur artists were the European artists, with their oil paints and canvases, who came to India with the same intention as the spice traders: to make a profit. The first wave of these artists had come at the end of the eighteenth century, and they were gifted. Among them were Tilly Kettle, Johann Zoffany, and Thomas Hickey, professional portrait painters whose paintings show how astutely the artists studied their subjects. The details of the magnificent jewellery, the sumptuous embroidery of the outfits, and the different

expressions on the subjects offer an intriguing look into the world of India's royalty.

Then, in the nineteenth century came artists of mediocre talent. Those who had made a name for themselves in Europe had no need to journey to the other side of the globe. But those who were dismissed in the competitive world of British and European art found themselves being welcomed in India by the officers of the East India Company and their families, starved for a bit of the home they had left behind.

A portrait done by one of these artists, who would be mostly forgotten in a few decades, was treasured because it carried within it a sense of home and luxury. These paintings could never be mistaken as being done by an Indian because they were painted on canvas with oil paints, a medium virtually unheard of in this colony. Signed though they might have been by forgettable artists of limited skills, the paintings by visiting foreign artists became a sign of affluence and stature, and they charmed the Indians who were competing with one another for the attention of the British. For those of a narcissistic bent, the paintings opened up a world of art that no longer needed to be made up of depictions of gods and legendary figures. It was a luxury to have one's portrait painted by a foreign artist, and the royal families that could afford the fees, did so. Since these were travelling artists, they rarely became fixtures in the courts.

The portrait offered those who belonged to the present the same grandeur as those of the past, hinting as it did at glory and majesty, not to mention wealth, because oils and canvas were expensive. For the artists, oil paints transformed how a painting was made and how close an artist's palette could get to real life. But few Indian artists were privy to the secret art of making oil paints and the technique of blending colours. These were basic skills taught at every art school in the Western world but in India, they became the closely guarded secrets of European artists, who

passed them on with extreme caution, as though they were the secret of the Holy Grail. The 1850s saw the establishment of art schools in Madras, Calcutta, and Bombay. Students of these schools were among the first to be systematically taught how to draw, paint, and sculpt in the European style. They, like the other Indian artists who had managed to squeeze their way into the charmed circle of oil painting by being assistants to foreign artists, clutched the techniques to their chests and shared them with few. It became akin to a religious cult, one that smelt of turpentine and left upon its disciples clinging shadows of paints that didn't melt and disappear under water like watercolours and vegetable dyes.

The drawings that Ravi made as a child were not preserved, so no one knows for certain precisely how he drew before he discovered the realism of European art. However, keeping in mind his uncle's interest in art and his own decision to paint realistically from the time he was in his teens, it is easy to imagine Ravi as a boy who wasn't enamoured by the popular Tanjore style. As his uncle's student, he must have raised questions that resonated with Raja Raja's own thinking, because the elder was the most staunch supporter of Ravi's decision to pursue European art.

'Why do we draw the body like this?' Ravi asked his uncle, while drawing a figure in the Tanjore style.

'What do you mean?'

'Why don't we draw it so that it looks like us? Not so round or fair, but like us. Like you.'

'Because this isn't a picture of me. These are pictures of gods, Ravi. They are imagined as beautiful and handsome.'

To the boy, his uncle was perfect and so he said with childish, precocious charm, 'I think you're handsome.'

Raja Raja wanted to laugh but he said sternly, 'Once you learn how to draw, you can draw anything you want and however you want. But it is important to know something before you try to change it.'

The boy seemed to think about it for a moment and then he bent

over to complete the painting he had started. It was not as though Ravi couldn't follow the Thanjavur style. He was learning quickly and confidently, and his uncle Raja knew that it wouldn't be long before his nephew would need a more accomplished teacher.

When Raja spoke to his sister about his son, she always asked whether he wasn't expecting too much of Ravi, and then the two of them would have the same conversation that the servants of the household now knew almost by heart. 'This is a hobby for a boy,' she would remind Raja Raja. 'He'll grow out of it.'

He would shake his head. Sometimes, he would have with him a drawing done by the boy and he would bring it closer to her, demanding she look at it and notice the fluency and confidence of the work. 'I remember myself at his age,' Raja would say to his sister. 'I learnt to draw when I was as old as he was, maybe a little older. But Amba, I couldn't draw like him and I didn't care as much as he does.'

'Perhaps, but what of it?' she would ask in reply. 'Would you have him ignore his role as thampuran, abandon taking care of these lands and those that look up to him for protection and guidance—so that he can be a painter? Is that the future you see for him?'

There would be a few moments of silence. If he had one of those drawings with him, Raja would stare at it as though it had the future written upon it.

'He's still young,' Raja Raja would say finally, resigned and sounding almost defeated.

This would make Amba's voice kinder and she would tell her brother, 'Let Ravi enjoy what he is doing and you should enjoy teaching him. Leave the future to the gods.'

Sometimes Raja Raja would laugh and say, 'There is very little left for me to teach your son, Amba. My Thanjavur paintings aren't what interest Ravi. He wants something more modern, more real, like the paintings by the Europeans.'

Hearing that would always make Amba take a sterner tone. 'There's no need for him to paint like the Europeans.'

13

'Their paintings are often very beautiful, Amba—'
'So are our Thanjavur paintings. Let him learn that art.'

* * *

Sri Maha Vajra Bhairava Tantra is an ancient Sanskrit text and it offers a description of an ideal artist: 'The painter must be a good man, no sluggard, not given to anger, holy, learned, self-controlled, devout and charitable, free from avarice—such should be his character.' Considering his father's extensive knowledge of Hindu scriptures, Ravi Varma would probably have been familiar with these lines. He certainly did his best to live up to this ideal all his life, although he had varied successes with his self-control and anger management. Until his last days, he followed a disciplined pattern of waking at dawn, completing his bath, and meditating before embarking upon work. Even after he had grown out of his student days, he spent a good part of the day reading and listening to classical texts. Often when he was painting, particularly in his Kilimanoor studio, he would hire people to come in and chant scriptures. In later years, he would write poems in Malayalam and Sanskrit that showed respect for the traditional structures of Sanskrit poetry.

The arts were an important part of traditional Hindu upbringing, which isn't surprising considering one of the four Vedas, which are among the oldest texts of Hinduism, is all about music and one of the holy trinity, Shiva, is known as the cosmic dancer. The royal family of Kilimanoor was known for its love for the arts and abiding respect for its cultural inheritance. People in this household were encouraged to find and nurture their relationships with their muses. While his brother Gode spent hours practising on the svaravith and filling the house with music, Ravi steeped himself in catalogues of paintings by Renaissance painters and any prints of European art he could get his hands on. He made sketches of everything he saw, pushing himself to

14

understand how a line could be made as close to the actual thing as possible, whether it was a palm tree or a woman's mundu, the wraparound skirt that fell with soft straightness around her legs.

Outside the palace walls, change was chipping away at the ancient monument that was traditional Malayali society. Some argue Travancore, and hence Kerala, might have stayed rigidly stuck to old ways had it not been for the British Residents who played crucial advisory roles and held much power ever since the kingdom's armies were disbanded after the revolt against the East India Company in 1809. But outsiders—from the Middle East, China, Europe—had been coming to Kerala for centuries. They brought with them their ways of life, and it took centuries of slow, tentative, and sometimes unpleasant interactions for the different cultures to learn from one another. It was only from the nineteenth century that the Hindu rulers began to take stands against the rituals that today seem ridiculous. During the reign of Gowri Parvatibai, who acted as Regent between 1815 and 1829 for the underage Maharaja Swathi Thirunal, men and women from lower castes were permitted to wear gold. Tiled roofs, palanquins, and elephants, all considered signs of royalty, were allowed to anyone who could afford them. It seems a simple act until you remember that even vassal kings weren't allowed to tile roofs because tiles were meant only for the most elite. In 1855, Maharaja Uthram Thirunal Marthanda Varma, Swathi Thirunal's successor, took the enormous step of abolishing slavery. He was also the ruler who decreed that it was not illegal for a woman to wear the upper cloth that covered her breasts in temples and in the presence of higher caste men. The royal order came only after two hundred lower caste Christian women were beaten and their houses burnt down at a village near Nagercoil, all because they wore blouses introduced by Christian missionaries who had been aghast by the casual semi-nudity, and would not take off their upper cloths when Brahmins stood before them.

15

Had Ravi been born a few decades earlier, he might have grown up expecting women to take off their upper cloths as a mark of respect to his upper caste, royal self. And his painting 'At the Bath' would have had his Malabar beauty dropping the alluring, diaphanous white cloth rather than clutching it to her breast. Until the 1820s, when the problem of upper cloths first surfaced, it would have been unusual, rebellious, and insulting for a woman to stand with her breasts covered in the presence of the Maharaja or a prince. The other 'At the Bath' painting, where the woman is seen lowering her upper cloth, would have been much more acceptable, but the painting betrays its modernity with the woman's eyes that look directly back at the viewer with unabashed coquetry. She knows she's making the viewer flit frantically and excitedly between what she's revealing of her body and what she's promising with her expression. The other girl at the bath lowers her eyes and there is an untrusting nervousness in her eyes. See the two women together and one can't help wondering what happened to transform the shy Malabar beauty into a tease.

* * *

In 1862, Ravi left Kilimanoor for the first time. It was expected to be a short trip. He was thirteen years old and he was going to Thiruvananthapuram with his uncle Raja Raja to take part in a swayamvara. The Sanskrit word refers to the practice of a bride picking her groom from a gathering of suitors. Legends were full of dramatic tales of swayamvaras, like that of Rukmini who ended up seemingly kidnapping Krishna when she was told she had to select the prince her father and brother had chosen at her swayamvara, rather than the one she had fallen in love with secretly. Even in the matrilineal system, all princesses, including the one whose swayamvara Ravi Varma was going to attend, were told whom they would marry by the men in the family, and few reacted like Rukmini. They mutely accepted the man who was

selected as the groom. The swayamvara that Ravi was going for was being organized for one of the princesses of the house of Travancore, which meant the teenaged boy would be interviewed by the Maharaja of Travancore, whom he had to impress.

As a child, Ravi's father would often tell him stories of swayamvaras from the Ramayana and Mahabharat. Ravi liked these stories. They had princes and villains and damsels. As he listened to his father's voice reciting the Sanskrit texts with that unmistakable cadence, he conjured in his mind a court that was vast and filled with golden light. He felt as though he could see the gathered princes, proud and majestic in their glittering armours. Amidst them, clad in modest dhotis and the dust of journeying, would be an unassuming Ram or Arjun, depending on the story, with his gaze fixed upon the test that would win him the girl whose eyes shone with hope and love. Years later, Ravi realized it was the simplicity of the swayamvara stories that enchanted him as a child. The challenges that were set for the princes may not have been easy, but events followed like pearls being threaded to make a string. It was this neatness that made the world of myths so appealing to him. One episode led to another and all chaos settled into order by the end.

Over the decades, Ravi Varma's paintings have been attacked on many counts, including for exoticizing India and being too mannered, but he is universally applauded for introducing realism to the depiction of gods and mythological heroes. The faces and bodies he gave them were human in form, yet they were so beautiful that the viewers felt they were in the presence of the divine. Balendranath Tagore, a nephew of the poet Rabindranath Tagore and himself a writer, said Ravi Varma's paintings were special because they showed 'the naturalist treatment of inner feelings and emotions rather than literal translations of the superhuman attributes of Hindu gods'. In fact, an English art critic of Ravi Varma's time, E.B. Havell, criticized his art as

being too realistic. Havell complained that the paintings showed 'a most painful lack of the poetic faculty in illustrating the most imaginative Indian poetry and allegory'. Poor Mr. Havell was clearly more taken by ancient Hindu art with its sinuous bodies, magical creatures, and other exotic delights. Next to them, Ravi Varma's work must have seemed disappointingly prim.

What both Havell and Tagore, and many others, missed about Ravi Varma's art was that despite its apparent realism, much of it was fantasy. The paintings showed Ravi Varma's fairy tale world and in them, he smoothed away the turbulence and anxiety he saw around him. The people he painted seemed real enough to touch but they were figments of his imagination, particularly the ladies. Ravi Varma painted women who were confident enough to not lower their eyes, and the idea of a confident woman who could occupy the space of a canvas was fantastical in itself, in eighteenth century Kerala, where women needed brothers and sons to secure their position in a family. For most of northern India, where men were moulded by an intense patriarchy, Ravi Varma's heroines were bold but still commanded respect for adhering to tradition. They were committed to one man: to the husbands, sons, and lovers who were either in the paintings or strongly suggested in them; to the artist who had created their forms; to the viewer who looked into their eyes.

In matrilineal Kerala, there had, for centuries, existed a complex tradition of 'visiting husbands', sham marriages, incestuous unions, and of course, mistresses. It was a system that baffled European visitors and every one of them wrote about the curious rituals that allowed a woman to have many partners and yet so little actual liberty. Traditionally, non-Brahmin girls, like Ravi's mother who was a Nair and belonged to the Kshatriya or warrior caste that came right below Brahmins, had two marriages. The first was held before a girl turned twelve, and was a ritual marriage to a groom from the same caste. It involved the tying

18

of a tali, a special pendant, and was celebrated with much pomp. Once it was over, the bridegroom went home and had little to do with his newly acquired wife. With this marriage, the village had been given a day of merriment, the boy had given legitimacy to any children the girl may have in the future even if he hadn't fathered them and in the present, the ritual announced to all and sundry that the girl was nearing puberty. Now the hunt began for a real husband, ideally a Namboodiri Brahmin, who was believed to be on top of the social heap.

It was a system designed to allow the sexual appetites of Brahmins free reign, without imposing any responsibility on them. As the writer L. Moore observed, the tying of the tali gave 'a quasi-religious sanction to a fictitious marriage, which leaves an unpleasant resemblance to the sham marriage ceremonies performed among certain inferior castes elsewhere as a cloak for prostitution'. The tali, in essence, was a symbol of being oppressed by a system that values the woman for being a birthing vessel, one who could be taken by anyone or, at the very least, any Brahmin. The second marriage, known as sambandham, was closer to what we understand today of the institution although it began as the word to describe the relationship between an already married woman and a Namboodiri Brahmin. Over time, it became something of an unofficial contract between a woman and her sexual partner, particularly if he was from a caste higher than hers. There were no demands of monogamy from either the women or the men, which may sound terrifically progressive, but resulted from a rather ancient tradition of Brahmin men being unwilling to take responsibility for the children they fathered or the women they bedded.

Ravi Varma's mother wore a tali, as evident from the one photograph we have of her. So did his wife. Both women wore their tali for one husband. It's difficult to tell whether the girl in 'At the Bath' is wearing a tali. She holds herself and her

sari in such a way that you can't really tell. Ravi Varma did this frequently. He painted his women in such a way, often garlanding them with many necklaces, that the eye didn't notice the absence of the tali. A respectable tali-less woman was unimaginable at the time, but Ravi Varma came as close as one could to suggesting the idea. This may have been part of his efforts to create the archetypal Indian woman. The alter ego version of 'At the Bath', the one with the titillatingly dropped sari, shows a woman wearing nothing around her neck.

Marriage became a legal institution in Kerala only in 1896, but there were changes creeping into the traditions of the region from the middle of the nineteenth century. Christian missionaries offered lower castes a world in which Brahmins had no rights over them. With increasing foreign trade, the feudal order that had persevered for centuries was feeling cracks in its system. Change came to Kerala in wooden ships and travelled on rivers, deep into the land, laden with missionaries and traders. They brought with them prosperity and helped birth among the people a dissatisfaction with the old world order. It happened all around the world whenever a colonizer set foot upon a land, and Travancore was no exception. The second and third sons, who didn't inherit the family wealth and estates, moved towards getting jobs with trading companies. By 1881, the Census Report found almost half of the population of Malabar employed with regular income, rather than remaining within the old feudal system.

Old and respected families grappled with the change and some, like Ravi Varma's, chose to adopt certain unfamiliar practices, like the idea of monogamy—it made it easier to keep property within the family. Of course, to some extent, old traditions persisted, particularly among the royalty. That was why when one of the princesses of Travancore turned twelve, a swayamvara was held for her and every high-ranking family with an eligible boy appeared as a candidate—including the thirteen year old Ravi, who had

20

the ideal caste cocktail, being the eldest son of a Namboodiri Brahmin man and a Nair woman.

* * *

No one is particularly interested in the princess whose hand Ravi sought at that swayamvara because this story went nothing like the swayamvaras of the epics. The hall of the main palace in Thiruvananthapuram was not the golden dome that Ravi had imagined, but it was grand and seemed impossibly large to the teenager. It glittered with Belgian chandeliers and there were paintings with golden frames. This was, after all, the court of one of India's wealthiest kings, whose kingdom had seen traders from Europe and the Far East for centuries now. Warm yellow light bounced off the jewels worn by the proud, well-oiled dignitaries who were in attendance. Ravi was presented before His Royal Highness Sri Padmanabhadasa Vanchipala Sri Ayilyam Thirunal, who sat on a golden throne.

The Maharaja was twenty nine and Ravi was thirteen. Ravi's accomplishments were in the fields of learning and the arts: he knew the classics, he had learnt Kathakali, he could sing, and he could draw and paint. Ayilyam Thirunal had grown up surrounded by court politics, had already been married and widowed, and was about to enter his second marriage. His life had been spent in palaces and whereas Ravi Varma's younger brother was one of his closest friends, Ayilyam Thirunal's own brother was his enemy because he was waiting to inherit the throne. As Maharaja, Ayilyam Thirunal's royal decisions affected a land far beyond the walls of the fort in Thiruvananthapuram—a land made up of people and places that he would never see or even hear of unless there was some catastrophe. He had seen violent tumult and often felt that his tasks as king were more complicated than those of his forefathers because his people were not as supine as subjects had been in bygone times.

Yet everyone around the Maharaja did treat him with reverence because he was Padmanabhadasa, Vishnu's chosen mortal, and they trusted him to negotiate his way through the vested interests of his different advisors and do what was best for Travancore. Those in the courts were well aware of the machinations and manipulation that went into appointing one king, but still, the age-old belief of the king being touched with divinity lingered. It may seem ridiculous to imagine this in a time as recent as the nineteenth century; however, the king of a land was as distant as the gods to most of his subjects. His wealth and his palaces removed him from the reality that most recognized as their world, and in many kingdoms, he was also the defender of the faith. This exalted status is something that the Maharaja of Travancore retains until today, when his title is a hollow one. The only privileges he retains today are religious. Every morning, he is the first visitor to the Padmanabhaswamy Temple, and it is only after he has completed his prayers that other devotees are allowed in. He has no subjects today and the people of Kerala have been voting for a Communist government for decades now. Still, the Maharaja remains a much respected man and a large part of the reception he gets is a hangover of the effect that the badge of divine favour, flaunted by his predecessors, had on subjects.

However, even in Ayilyam's time, this didn't mean a Maharaja could necessarily control tempers or prevent violent outbreaks like the Upper Cloth Riots. Having been brought up to not doubt himself, however, Ayilyam Thirunal believed he could live up to the expectations his subjects had of him when he ascended the throne of Travancore in 1860. It also helped that he had as his right-hand man the brilliant Sir T. Madhava Rao. Together, they imagined Travancore with all the things that the British emissaries and European visitors spoke of as being standard practice in their countries—hospitals, colleges for women, roads, irrigation—and they worked towards these ends determinedly.

Ayilyam, with his round, fleshy face and small eyes, was not a good-looking man, and he was known for his determination, not his charm. As he listened to Raja Raja Varma's eloquent introduction of his nephew Ravi Varma Coil Thampuran of Kilimanoor, Ayilyam noted the boy had the dewy innocence that came from living in a cloister and, for all his expertise in the arts and literature, he lacked one thing that the house of Travancore could not afford to neglect, given its proximity to the British: the polish of an education in English. Once Raja Raja had finished, the Maharaja rejected the young prince saying he was too dark.

* * *

It was the first time Ravi had faced rejection, and the disappointment was searing, even though he didn't entirely understand what he had failed at. However, he wasn't too young to recognize the anger and worry that marked his uncle's face and body language, and he knew that he had caused it by failing at the swayamvara. It didn't make sense to him. His lineage was impeccable; he was the eldest son; he was sure there was nothing lacking in his education—his Sanskrit was as fluent as his Malayalam and he knew both the scriptures and newer writings—and how could it be common for a boy to be able to sing, dance, and paint? Raja Raja, however, had probably deciphered why the Maharaja had rejected Ravi. It would certainly explain why he chose to lavish an English education upon his youngest nephew, who shared his name and would grow up to be Ravi Varma's confidant and assistant. However, at this time that youngest nephew was only two years old and the opportunity of earning royal favour was now, and it had been squandered.

Then, unexpectedly, the royal messenger showed up at their door with an invitation for Ravi. He had been granted a private audience with the Maharaja. Raja Raja spent hours coaching his nephew for the meeting. They went over every detail: which

paintings he would carry as offerings, how he should unveil them if he was asked to do so, how he should talk, where he should sit, what he should say about Kilimanoor, how he should present his love for art as an interest in creating something new so that he didn't get clubbed with the money-minded, uncreative artists that everyone knew. It was extraordinary, Raja Raja kept reminding the boy. Those rejected were rarely granted the privilege of a royal rendezvous. It was up to Ravi to make good this opportunity. His own future and his family's honour rested upon him.

Once the ritual pleasantries were over, Ravi said that he had brought the Maharaja a small gift that he hoped would find favour. They were three paintings. Two were of young boys and one of Saraswati, the goddess of learning. Some say that, unwittingly, the face Ravi had painted for Saraswati had a startling resemblance to Ayilyam Thirunal's second wife, the beautiful Nagercoil Ammachi. Whatever the reason, the indisputable fact is that Ayilyam was won over the moment he saw Ravi's paintings. They were painted in a style that resembled that of Thanjavur, yet they were different. They looked more real and less ornamental. Ayilyam told Ravi the paintings of the boys didn't seem to depict Krishna, a favourite subject of the Thanjavur artists. Ravi politely commended His Royal Highness on his astuteness and said that one of the advantages that came of being the eldest of three brothers was that he could always find two young boys to be his drawing subjects. They spoke about music and painting and Thiruvananthapuram. Ravi praised his brother, who could play any instrument that was handed to him and whose veena could tempt clouds to rain on a sunny day. He spoke about how his mother, with her love for literature and writing operas, filled his mind with poetry. He lamented delicately about how cut off Kilimanoor was from the rest of the world and let Ayilyam Thirunal know he was revelling in being surrounded by the energy and art of the capital city.

The longer they spoke the more drawn the Maharaja felt towards this young boy. Perhaps Ayilyam Thirunal saw in young Ravi a determined dreamer like himself, or perhaps it was just refreshing to see a person light up at the thought of something other than power and profit. At the end of the meeting, Ayilyam said that provided his uncle was in agreement, Ravi should stay in Thiruvananthapuram to learn art. Aside from having the finest of traditional art available to him, perhaps Ravi would find oil paintings, a recent introduction in the Travancore court, interesting.

Ravi did his best to be composed when he thanked His Royal Highness for this generous offer, even though his heart was pounding with excitement and he could feel the blood rushing to his head. Ayilyam Thirunal rose from his seat, and without making too much effort at hiding his amusement, he told Ravi that if Raja Raja seemed unwilling to let him stay, he should tell him the Maharaja had directed him to stay and learn art in Thiruvananthapuram. The royal decree tends to persuade even the most intractable, he said, as though confiding in Ravi with a secret. Ravi's bow at the end of the meeting wasn't simply ritualistic but one of the few times in his life that he genuinely meant the gratitude and thanks that is carried in the gesture of the namaskaram.

As Ayilyam Thirunal had predicted, the royal decree was one that no one objected to, least of all Raja Raja Varma. He was delighted that his nephew would be able to learn from the best of Kerala's artists, and that Kilimanoor could again claim a closeness to the Maharaja through its young prince. Uncle and nephew returned feeling triumphant even though they had come home with three paintings less than what they had started out with, and without having tied a tali around a princess's neck. In no time, arrangements began for Ravi's forthcoming trip to Thiruvananthapuram. It was only a few hours away but everyone

thought it would probably be months before he returned. After all, he was going to study, and in the capital, no less! Respected as the Kilimanoor family was, their wealth and standing was not the kind that would make them stand out in Thiruvananthapuram. They had only the Kilimanoor estate and a few scattered palaces to their name. Next to the families who had profited from the spice trade or those who were well entrenched in the court, the Varmas of Kilimanoor were not memorable. Clothes for everyday wear, ornaments for special occasions, richer outfits for formal invitations—these selections would have been made with great care. The austere Raja Raja Varma would not have approved of opulence that the family could not afford, but having spent time in the capital, he would have known that unlike in Kilimanoor, a certain amount of fanfare was necessary in Thiruvananthapuram.

No one knew then that when Ravi walked out of the gates of Kilimanoor Palace, he would begin a new phase of his life, one in which this home would play almost no part except to provide refuge, on occasion, and a resting place. He would miss the birth of his sister Mangala, who continued the style of painting he pioneered, and who painted the only portrait we have of the artist himself. The news of his parents' death would reach him by telegraph. New buildings would come up inside the palace walls of Kilimanoor, and he would extend the part of the palace he had grown up in to build a studio—almost as though he wanted a place to retreat into, a place where he could cut himself off from the changed layout of Kilimanoor Palace. But this future was too far away to imagine. Even the near future of fame and celebrity was beyond imagination. All Ravi felt as his mother instructed that bundles and trunks be packed for him was a rushing and confused excitement. He was going to live in Thiruvananthapuram, a city of art and culture, a capital that looked out to the world.

Years later, Ravi would tell his youngest brother C. Raja Raja Varma that being rejected at that swayamvara had been one of the greatest blessings he had ever received from the gods. Had the Maharaja found him suitable as a royal escort, he would have been sucked into the usual life of a prince and the responsibilities and politics that came with it. Instead, what the Maharaja gave Ravi was a chance to live in Thiruvananthapuram and soak in its riches without having a responsibility towards anything other than art.

* * *

Some things in Ravi's life in Thiruvananthapuram were just as they had been in Kilimanoor. His uncle Raja continued to be his father figure, teacher, and anchor. The day began just as early and the rituals of bathing, prayer, and meditation remained unchanged. But once all this was over, the rest of the day didn't crawl as lazily as it used to in Kilimanoor. In Thiruvananthapuram, there was always something to see and somewhere to be. It took little for rumours to begin spreading, and the fact that the Maharaja had asked Ravi to come and live in Thiruvananthapuram, along with his uncle's name, led many to believe that the boy belonged to the house of Travancore and was related to the ruling family, rather than being a distant connection from Kilimanoor. Raja Raja played with these misconceptions delicately, because belonging to the royal family opened many doors, both to artists' studios and to the homes of important people. It was a tactic that Ravi Varma would use all his life, especially after Raja was prefixed to his name.

There was also the loneliness that came of leaving a close-knit family for the city, where there were many acquaintances but few companions. He missed having his younger brother Gode around. The sounds of Gode's veena or the rhythmic thump of a Kathakali group practising in a courtyard were gone and in their place was the silence of a city palace, broken only occasionally

by the hollow beat of a passing horse-drawn carriage. When he would step out in Kilimanoor, everyone knew him and he recognized every field and tree in sight. In Thiruvananthapuram, he was almost anonymous when he walked on the street. There were paved roads here and they wound confusingly around the fort, as though intent upon rendering him lost.

But it was also beautiful, and for Ravi, there was novelty in every building, in glass-paned windows, in the glittering sea that fringed the capital. He had never seen buildings as majestic as the ones he saw here. They sat like pearls amidst cradles of manicured gardens. There were palaces and homes that stood regal and proud alongside the newer buildings that were constantly being built.

Thiruvananthapuram was an ancient city with an illustrious history, although it had become the capital of Travancore only in 1745. Some say the ships of King Solomon used to come to this city, which was named after Ananthanag, the coiled serpent upon which Vishnu is believed to rest. Whether that is true or not, the city enjoyed much prosperity by virtue of being an ancient trading port for Kerala's bountiful spices, sandalwood, and ivory. Chinese traders came here as did sailors from Arab ports, and then there were the Europeans. The city became a capital in 1745, about twenty years after Marthanda Varma, the founder of the house of Travancore, came to power. After he had defeated all his rivals, he dedicated his kingdom to Padmanabha, the name given to the idol of Vishnu in the Padmanabhaswamy Temple, from whose navel emerged a lotus upon which sat Brahma, the creator of the world; at his right hand was Shiva. Marthanda Varma pledged that all his successors would be Padmanabhadasas, servants of Padmanabha, and that is how the Maharaja of Travancore is known until this day.

As in most old cities, in Thiruvananthapuram, there was a walled fort within which was Padmanabhapuram, which housed the royal residences and other important palaces, along with the

Padmanabhaswamy Temple. Ravi Varma's family had their own modest little palace, known as Moodathy Madham, within the fort. This would be Ravi's home for the next few years. Within a small radius of the palace were many treasures for the young artist, beginning with the temple itself. He spent hours gazing at the intricate carvings that adorned the temple walls and roof with its ten foot tall gopuram, the towering triangular roof of a temple that is traditional to south Indian architecture. Inside the temple were greater wonders, like the long corridor with three hundred and sixty five exquisitely carved pillars, and the eighteen foot idol made of the sacred stone called Saligram and adorned with gold and jewels. Twice a year, Kathakali performances were held at night in the temple courtyard, and they were magical. Lit by torches, the temple courtyard was all shadows while the flames flickered, as though moving to the music of the pieces. The greens, reds, and whites of the dancers' make-up and costumes gleamed like jewels, and the tinkling sound of the bells on their feet raced down the corridors.

Throughout the year, artists from all over southern India would come and add to the temple's beauty. In the signature-less world of traditional art, generations of artists worked upon pieces to achieve the grandeur we see today. To create something for the Padmanabhaswamy was an enormous privilege, one that only the best earned. Ravi would come to the temple, offer his prayers, and then while away his hours watching the master craftsmen and artists create fine murals and sculptures in traditional styles. He added what he saw at the temple to his existing knowledge. The Thanjavur painters whom Ravi Varma was able to see here were unmatched for the fine detailing of their work. The sculptors who worked on the pillars not only knew how to carve metal and stone, but had spent generations fashioning the curves of the Indian body as it has been depicted in temple architecture. It was awe-inspiring for young Ravi to meet these men and watch

them at work, and most of the artists too enjoyed the attention he gave them. The other reason he enjoyed spending time at the temple was because he had discovered the pleasures and uses of people watching.

The room that would become Ravi Varma's studio in Moodathy Madham began to see a pile of sheets upon which were scribbled sketches of the devotees he saw coming to offer prayers at the temple, their hopes etched upon their faces and in the curve of their supplicant palms. Often, he used the people he saw as models for scenes he imagined. The arched foot as it climbed steps to walk out of the temple could be seen in a rough drawing of a woman looking behind her with a provocative smile even as she walked with her back to the artist. Wherever he went, he turned whoever he saw into an imaginary model and tried to decipher the shapes that made the body and how clothes fell upon them. The ease with which soft white cotton fluttered in a lazy breeze; the heaviness of the thick materials the British and the foreigners wore; the tactility of skin as it stretched into a smile; the way silk fell lovingly around the contours of a shoulder, a hip. Ravi Varma's eye tried to memorize how the face changed, how an expression transformed someone because they squinted or parted their lips just a little. His sketchbooks came to be filled with drawings of people made up of charcoal strokes that became steadily more self-assured, lighter, and swifter. If his first sketchbooks were anything like the ones he had later on in life, they would have been almost like diaries, and in them, he would have recorded the sights of a city that was in its golden age.

Maharaja Ayilyam Thirunal's interest in Ravi Varma's education gave him easy entry into the different palaces in the royal complex and their libraries. This meant he was able to see palaces like the Puthen Malika, known as the Mansion of Horses for the one hundred and eight horses that were carved on the roof of the southern side of the palace, which had been built by

Maharaja Swathi Thirunal. No one lived there after his death and very few visitors were permitted inside the empty, beautifully designed palace. For someone like Ravi, its intricately carved wooden ceilings were a wonder. But, appreciative as Ravi was of the architecture, the real value of the Travancore family palaces lay in their libraries. Maharaja Ayilyam Thirunal's library in the fort had numerous albums with prints of European art, which Ravi pored over. Going through albums and journals would be a habit that would stay with him all his life, but at this stage, it was much more than a hobby. For the first four years, it was a crucial part of his art education because, in the absence of real teachers, it was the printed image that taught him how to structure a painting within the boundaries of a frame. He loved what he saw of the works by Renaissance masters and as he stared at them, he was amazed at how these foreign painters had captured nuances of shade and texture so perfectly that their subjects seemed to be real people frozen in a moment. His student's eye noticed that in European art, there were no discernible outlines while among the fundamentals of Indian painting was the bold line that ran like a boundary between different parts of a work. Colours blended into one another in the pictures he saw of foreign paintings, and the boundaries of each figure and object weren't obviously delineated.

Ravi's favourites from the albums and art journals he saw were French salon artists like Gustave Boulanger and Adolf Borguereau. He probably wouldn't have found them quite as appealing if he had seen them in reality, but in the printed medium, their bland, simplistic technique made the mannered images looked prettier than the paintings of more accomplished artists whose paintings lost delicacy and complexity when converted to prints. Even though he didn't know how to paint anything like the works he was teaching himself with, the idea of applying the techniques of European painting to show Indian scenes began to take birth in his mind.

31

He had always been able to draw. As far back as he could remember, the task of turning something that stood before him into a charcoal sketch had been relatively simple. But the European art that he saw in Padmanabhapuram didn't follow the rules of the Thanjavur style he had been taught as a child, so he re-learnt drawing by first trying to copy the prints from the albums. Placed next to the drawings he made at the Padmanabhaswamy Temple, his attempts at copying the realistic style of nineteenth century salon art showed the most important difference between the two: perspective.

In 1849, Gustave Boulanger won the prestigious Prix de Rome scholarship for his painting 'Ulysses Recognized by his Nurse Euryclea'. The story of how the hero was able to disguise himself to everyone but the old nurse who recognized him by a scar while washing his feet was known to every educated man and woman in Europe. Boulanger's painting faithfully reproduces all the details of the story, like Penelope's attention being diverted and Athena's divine light illuminating Ulysses, and it was reproduced in numerous art journals because of the acclaim it received. It isn't difficult to imagine Ravi Varma sitting with his uncle, neither of whom would have been familiar with the Odyssey, dissecting the print of the painting to understand how Boulanger had captured that moment.

'Do you see the difference?' Ravi asked excitedly. 'It isn't just about colours or how they draw their people realistically.'

'I'm not sure whether thighs as wide as that are realistic in any country,' murmured Raja Raja looking closely at the print.

'Perhaps if someone had to hold that awkward pose between sitting and leaping up for hours, they would have thighs like that,' the boy said with a grin. 'But look at this.' He pointed at what was behind the man and woman who were clearly the subjects of the painting. There was

a statuesque woman and beyond her was a window. 'Do you see how he's painted these parts? Instead of a flat wall behind this man, there's another person and behind her there's the window and even then, it doesn't stop. You can look through the window and see the clouds and a bit of the sea.'

'It feels as though the painting is stretching inward, almost like an open door, while in our paintings, we keep things on one line,' said Raja Raja slowly, as he started to pick up what his nephew was showing him.

'So the background is as important as the foreground because it is what makes the setting look realistic, and that makes the subject look realistic.'

The two of them stared at the print for a few moments.

'Isn't it amazing how he's done these shadows and the cloth?' asked Ravi, running his finger along the folds of the blue dress worn by the old woman. Each fold cast a different shadow. 'I can almost imagine just how high up the window is to let in light like this.'

'It's also interesting how they use the light to tell the viewer who is the most important person of the painting,' observed Raja Raja. 'We would make the subject bigger than the other elements of the painting and that would be enough.' In his mind's eye, Ravi saw the many Thanjavur paintings he had seen of Krishna where the infant Blue God ballooned into an enormous baby surrounded by small-sized adults. Raja Raja continued, 'But here, they use light. There are other people in the painting, but they're in shadow. Not so dense that we can't see them or what they're doing. So we are supposed to notice the woman in the background is looking longingly out to the sea.'

'Perhaps she's waiting for someone?'

'Perhaps.'

'And then there's that other person who seems to be unravelling something. Is that a boy or a girl?'

The two of them peered at the print.

'The hair is very short,' said Ravi.

33

'It could be tied up.'

At precisely the same moment, the two noticed the faint contours of young breasts under the thin gown the artist had clothed the girl in. They both straightened together.

'The point is, these characters are important, clearly, but not as important as the man and the old woman,' continued Raja Raja. 'So the light falls on them, on their faces. Particularly hers, and the artist wants you to see her age, because if someone as experienced as someone of her age is shocked, then it's considerably alarming.'

'I wonder what it is about him that has her looking like that.'

'It isn't fear on her face, just surprise. The fear is in his face, and hands. See how they're curled?'

'The other thing that the artist makes sure we see is the bowl for the foot bath and the spilt water,' Ravi said, pointing to the light blue water glinting in the light. 'So she's a maid who was washing his feet and then realized something. Discovered something about him, perhaps.'

'Something he was hiding, which is why he's afraid.'

There were so many possible stories racing through their minds.

'I almost feel like I can hear it, the splash of spilling water, the clatter of the bowl turning over on the floor,' said Ravi. 'I wonder what happened in the next moment.'

'Maybe it's there as a painting in one of the books in the library,' Raja Raja said hopefully.

The palace library was a treasure trove of books. There were novels and history books, journals on a wide range of subjects, and albums full of pictures. Some had been collected, many had been gifts. Ravi came to the library often and he sat with the books open, staring unblinkingly at the pictures before him, as though looking at them hard enough would open up the secret of how the original paintings had been made. What he was imagining at these times was the actual painting. Standing in front of it. How big would it be? How much taller than him? How did the colours

look precisely when they were close enough to touch? How did they feel? Of course, it could never happen. He had checked with many learned Brahmins, casually dropped the question into a conversation about scriptures and legends. Could a Hindu cross the seas like the Arab traders and Europeans? But the answer was always the same: to cross the oceans was to lose one's caste and there was no worse fate for the son of a Namboodiri Brahmin. It took many lifetimes of prayer and good karma to be born a Brahmin, and all it took to lose it was a journey of a few months across high seas. This meant he would never see any of the paintings that he so admired in books and the closest he could travel to them was through the pages of these books.

But even that journey was fraught with obstacles. One of his favourite books had pictures of his familiar gods—Devaki, holding the newborn Krishna to her breast before having to give him up; Ravi, the sun god, riding his chariot of Dawn, masterfully tugging at the reigns—scattered among its pages. But they were drawn as though they were sketches of European paintings, not the way Ravi was used to seeing them. He took this book out again and again.

At first, he wondered whether the script in the book talked of why the artist had seen the Hindu gods like this, or how he had drawn them. He asked for the title to be translated into Malayalam so that he knew what it meant. Then, he got the librarian to write out the unfamiliar words of the English title in Malayalam lettering so that he could pronounce the strange sounds of the original phrase. The book was titled *The Hindu Pantheon* by Major Edward Moor. It meant that the book was about the gods he prayed to, and it was written by a white man. After Ravi Varma became famous, whenever he was asked about how he developed his style, he would tell his interviewers that much of it began with the images in this obscure publication.

In the traditional matrilineal family of Kerala, the eldest

35

brother occupied a position of enormous importance. He was the real head of the family. He made the decisions, and his word was the one that was followed and never questioned, certainly not by the younger generations. Had Ravi Varma returned to live in Kilimanoor after the swayamvara, he would never have asked his uncle why he was taught Sanskrit and Malayalam and not English. It would have been unthinkable to question the decisions his uncle had taken about his education. Living in Thiruvananthapuram, however, the relationship between the two became less formal and much closer than it had been in their family home. It isn't impossible that Ravi would have asked his uncle whether he could learn English, particularly because it would turn the strange symbols in the books with European art into a legible language. Of course, his uncle would have said no. Ravi may have been an adolescent but in those times, teenagers were no longer children. He had come to the capital as a man, a nobleman, and there were enough people in the court with whom he had to compete for royal attention and favour. All around them were aristocrats and their coteries, looking for a weakness. Raja Raja knew that no one had forgotten Ravi's rejection as a suitor. But those who did speak of it recounted the story as an example of royal whimsy, because the young prince had gone on to become a favourite. Hiring an English tutor would lead to a new set of rumours and in these, the Maharaja's decision would not be the result of an inexplicable impulse but a judgement. A judgement which would find Ravi Varma wanting and inadequate. Raja Raja, as his uncle and as the head of the royal family of Kilimanoor, could not let that happen.

<p style="text-align:center">***</p>

It should have felt like being in a fairy tale and in the beginning, it did. Young Ravi was a prince on the brink of greatness—he was sure he was; his uncle said so, the Maharaja said so, everyone said

so—and the stage was set for him in Thiruvananthapuram. He had always had a certain sense of assuredness that he was destined to achieve something important, and the way the gods had engineered his coming to the city only made him that much more confident. The capital city of Travancore was seeing its golden era. The last Maharaja had done many great things, like abolish slavery in Travancore, but he had left for his nephew a weak and impoverished kingdom. The royal treasury had been forced to borrow money from the Sri Padmanabhaswamy Temple and the British demanded subsidies be paid to them. Salaries hadn't been paid to those in royal employ and there was simmering dissatisfaction among the people. It was not an enviable situation for a young king like Maharaja Ayilyam Thirunal but he was fortunate to have as his Dewan Sir T. Madhava Rao.

The two knew each other well. Madhava Rao had been the tutor for the Maharaja and his brother when they were boys. Perhaps the old relationship gave him more persuasive power with the new Maharaja than he had had with the old one, or perhaps Ayilyam Thirunal saw the wisdom of his Dewan's suggestions. Portly, moustachioed, and smiling in all his portraits, the Dewan was widely regarded as one of the most brilliant minds of his time. His family were originally Maratha Brahmins from Tanjore (the 'T' in his name stood for Thanjavur) but Madhava Rao was born in Madras in 1828. He was brought up in a strict and conservative ambience that placed great importance upon Hindu traditions and classical learning, much like Ravi Varma. He was a brilliant student and from an early age, he professed a love for art that would serve Ravi Varma well decades later. Like the painter, Madhava Rao too would fight shy of travelling to Europe for fear of losing his caste even though he modernized the workings of states like Travancore, Indore, and Baroda. His administrative policies earned Travancore the appellation of 'Model State of India' from the British government and he was made Knight

Commander of the Order of the Star of India in 1866, which bestowed upon him the title of 'Sir'.

Within three years of Ayilyam Thirunal's ascension to the throne, Travancore had repaid its debts and the kingdom was wealthy enough to give its bureaucracy a substantial raise. The Thiruvananthapuram that Ravi saw was a thriving city. Palaces and houses were being built, colleges set up, roads paved. Prosperity seemed to be everywhere and for that, the subjects thanked their new king while the court saluted the Dewan.

Raja Raja pointed out Madhava Rao to Ravi early on in their time in Thiruvananthapuram. The Dewan was, after all, the most important man in the kingdom. The king may be the one who sits on the throne but the real power lies among those who make the policies that run the kingdom. Raja Raja had seen Travancore's status weaken as the kingdom became poorer and poorer under the leadership of the old Maharaja. The difference in the way aristocrats from Travancore held themselves now that they belonged to a rich kingdom, with the British for example, was a welcome sight to behold. As the head of the Kilimanoor family, Raja Raja Varma would have come to the capital regularly, although from the little we know of him, he doesn't seem to have had great political ambitions for himself. However, the friends he urged his nephew to make and the marriage that was ultimately arranged for Ravi, show that Raja Raja worked seriously to keep Kilimanoor in royal favour. From the changes he had witnessed in the past few years, he knew that if there was one friend his nephew had to make in the court of Maharaja Ayilyam Thirunal, it was Sir T. Madhava Rao.

The young Ravi made a good impression on Madhava Rao, as he did with most important people throughout his life. He was polite and had an air of confidence about him that appealed to those who were often bored by the subservience of others. What won over Madhava Rao was the boy's curiosity. There was an

eagerness and determination in him that the Dewan appreciated, being of a scholarly bent himself. As for Ravi, the boy was fascinated by this man who seemed to know about everything. Whether the conversation was about history, the sacred texts, the politics of the British, or even hairstyles, Sir Madhava Rao had a scholarly input. Ravi, being a child among elders, mostly stayed quiet in these conversations unless he was asked to speak, but he paid attention to what was said and he watched the people around with his artist's eye. Unlike the careful, shuttered expressions of many courtiers, a kindly smile lurked beneath Madhava Rao's thick, curling moustache. The forehead was wide, as it should have been for a man of his intellect. The tips of his fingers showed that he spent many hours writing with a quill. He should have been an easy man to draw because there was nothing obviously remarkable about him. But those average features had an air of wisdom and wit that Ravi struggled to capture in the sketches he made from memory.

As regulars in the court, Madhava Rao and Ravi saw each other regularly. Madhava Rao saw the boy grow up and out of his awkward youth. He noted the envy that many felt as they saw this young man from Kilimanoor live a seemingly charmed life under the Maharaja's benevolent gaze, and he guided Ravi through the intricacies and politics of the court. Choosing political allies is never easy but it is essential if one is to survive in the capital. Had he not had Madhava Rao as a political mentor, it would have been a formidable task for young Ravi. In fact, his attempts to engage in court politics without Madhava Rao looking out for him in the later years ended up with disastrous results. But that was some years away yet. At this point, Ravi's major concern was his art education.

By 1865, Ravi was seventeen years old and had spent three years in Thiruvananthapuram. He was one among many noble courtiers and there was little to distinguish him, aside from the

fact that he had managed to remain an unflagging favourite of the Maharaja. Most of his peers were married and almost family men by now, as the letters from Kilimanoor kept pointing out to his uncle. It did not show the family in good light that its eldest son was still unmarried while preparations were being made for the next brother's marriage. Raja Raja calmed his relatives back home by assuring them that he was close to finalizing a suitable sambandham for Ravi. Ravi, however, was less concerned by these letters than he was by the feeling that his art education had stagnated.

When Ravi had been making preparations to come to the capital, his father had told the boy that he needed to be patient because it took time to settle into a new place and understand its workings. For Ravi, though, the longer he spent in Thiruvananthapuram, the more difficult everything seemed to get. Whereas at first, the artists he had come across treated him kindly and let him watch them at work, their demeanour soon changed. He began to notice that once he showed anyone a sample of his work, they seemed to become distant. Their behaviour became shifty and they seemed less inclined to give him time or even look him in the eye. It didn't make sense to him because he knew that his work was promising but not yet so accomplished as to cause jealousy. At best, his paintings looked like the work of a studious assistant, gifted with a steady hand and a capacity to paint expressions.

What unsettled the artists was the uncomfortable fact that the teenager was not an assistant, but a boy with little training and almost no exposure to modern painting; a boy who had been playing around with pigments; a proud boy who was also a prince and could tell tales to the Maharaja. He couldn't be dismissed or ousted from the artists' studios and workshops without earning royal displeasure. So the artists did the only thing they could: they treated him with distant politeness and shielded as much of their

art as they could from him. Gradually, Ravi found himself seeing only the finished works and nothing of the practice that went into the making of the paintings.

It took Ravi a little time to realize what was happening and once he did, he refused to let this be an obstacle. He ignored their hostility and tried to charm them with his good behaviour. He focused on learning from the little that was coming his way. One aspect that did improve considerably was his drawing because that was the one thing that got a lot of practice. His sketchbook went everywhere with him and he became adept at making quick studies of people and faces he saw. He spent hours in the library and focused on mastering the realism in the works of the European masters. His skill with watercolours improved and he decided that he wanted to paint with the thick oils that allowed for more complexity of texture and colour. He was able to get hold of pigments from some of the artists and with them, he experimented to figure out how oil paints were made. Getting the right consistency proved to be painstaking, time consuming, and ultimately unrewarding because he was mixing pigment and oil blindly. Ironically, the only thing that gave him confidence during these years was the hostility of the artists in Thiruvananthapuram. Unwittingly, they had done Ravi a great service—they had assured him that he was gifted.

* * *

In 1866, Ravi Varma was married to Pooruruttati Naal Thampuratty of the Mavelikkara Kottaram royal family. From being an aristocrat of princely heritage, he became a minor prince, since Mavelikkara was a much larger and more influential estate. He was eighteen years old, and at a time when boys were married in their early teens, his was a late marriage. His bride must have been six or seven years younger than him. Everyone in Kilimanoor sighed with relief. The Maharaja gave his approval to the union.

41

Finally, the blemish of having been rejected at a swayamvara was removed from the young man. Custom demanded Ravi Varma go to live with his wife in Mavelikkara, which he did for a while, but he soon returned to Thiruvananthapuram.

The little town of Mavelikkara is about a hundred kilometres from Thiruvananthapuram. It was a significant distance in the days of carriages and paths that wound through fields and forests. Travelling to Mavelikkara meant leaving the bustle of Thiruvananthapuram far behind for a place that had no reminders of the city. Instead of the sound of carriages and the dust of building sites, there was greenery and birdsong in this town on the banks of the Achankovil River. Hints of pepper and cinnamon flavoured the air. At unexpected moments, the trees seemed to shrug and let out flocks of twittering birds that would fill the sky and then disappear into another leafy tree.

Rather than the road, it was the river that had brought people from far-off places to Mavelikkara. Devotees of the Buddha had come here in the ninth century. Where they went, no one knows, but for some time at least, they must have flourished, because in 1936, British archaeologists discovered a monumental statue of a seated Buddha in Mavelikkara. Pilgrims came here to pay their respects at the Sreekrishna Swami Temple. Families brought their ailing members to the Bhagavathy Temple, hoping the goddess would heal them. Christian missionaries came and many made this land their home, spreading their faith among the less privileged. While it wasn't always peaceful, church bells and temple bells rang together and the different faiths lived side by side, first awkwardly and then respectfully. It created in the people a mindset that was a curious mix of orthodox Brahminical and liberal thought. Mavelikkara's glory days, however, came in the eighteenth century, with the spice traders who realized the town's riverside location made it the perfect place to store spices from inland areas before they could be trafficked to the tall European

ships that waited at the sea ports. First came the Dutch traders who built the storehouses but, before long, handed power over to the British. In many ways, Mavelikkara was far more exciting than Kilimanoor because, like Thiruvananthapuram, it was constantly in touch with the wider world. Perhaps Ravi Varma's uncle had thought about all this when he finalized the alliance between his nephew and the youngest princess of Mavelikkara in 1866.

In many ways, it seemed like the perfect union. The Mavelikkara Kottaram were not as old a family as the Varmas of Kilimanoor but they wielded political power in the current times, thanks to the profits from the spice trade and Sethu Lakshmibai's adoption into the Travancore royal family. It was a cultured family, one that took pride in being a patron of the arts, in being liberal and progressive. The girls of the family pose comfortably in photographs that seem to have been taken around 1870. One of them shows a little girl who may be Ravi Varma's wife. She looks about ten years old. She's much younger than the other two princesses, one of whom looks at the camera almost imperiously, while the other has the hint of an amused smile playing upon her lips. The girl looks expressionless: not afraid but not poised either. She has her hands clasped in front of her and she looks as though she's hoping to run out of the frame when no one is looking. In a photograph taken some years later, after she had given birth to her first child in 1875, the girl looks equally expressionless, though more comfortable, unexcited by the novelty of being photographed or the prospect of being immortalized with a snapshot. Although she was no great beauty, a portrait of hers painted by her second son Rama Varma shows a pretty woman with a round face, full cheeks, and pretty eyes.

A bride is judged by her family, skills, and beauty—and also by the fortune she brings to her husband. Even though the matrilineal system demanded the husband leave his childhood home to live with his wife's family, the responsibility of bringing good luck

remained with the wife. Marriage cemented Ravi Varma's social standing, and when he returned to Thiruvananthapuram after staying in Mavelikkara for a few months as a newly-wed, he discovered people had not forgotten his paintings. There were many who wanted him to paint portraits of themselves or their families. If anything, the demand for his work had increased. He accepted some of these requests, but then this raised the prickly question of payment. It seemed improper to charge for them when painting was officially only a hobby. But those he painted often wished to give him something in return because they felt it was unfair to take up so much of a prince's time in exchange for nothing. If he had been painting portraits only occasionally, it wouldn't have been too much of a quandary, but the fact was that there was quite a steady demand for his portraits.

If Ravi had been satisfied by quiet domesticity punctuated by regular trips to the political nerve centre in Thiruvananthapuram, he could have been a minor prince who was also an accomplished painter. However, life in Mavelikkara bored Ravi Varma, and he began missing Thiruvananthapuram very soon after marriage. Of course he said no such thing but there was a noticeable restlessness in his every action. After a few months, he delicately broached the subject of returning to Thiruvananthapuram to the elders of the family. In Mavelikkara, he could not continue his art education and the Maharaja himself was a great supporter of his passion for art, he said. There was also the matter of his youngest brother Raja who was in Thiruvananthapuram for his studies. If Ravi could be in Thiruvananthapuram to be his guardian, it would be of great help to their uncle who had responsibilities back in Kilimanoor. There were no objections, particularly with the Maharaja's fondness for Ravi Varma and his art being well known. The elders must have also considered the fact that Ravi's bride was a mere child at this time. At this age, she had nothing to offer to keep him in Mavelikkara. So the

permission to go back to Thiruvananthapuram was granted and Ravi headed back to the capital, leaving behind his new bride.

* * *

As a princess of Mavelikkara Kottaram, her name was Pooruruttati Naal Thampuratty but everyone called her by her other, less formal name, Bhagirathi. There was little cause to use the formal name when you were the youngest in the royal family, so Bhagirathi it was. Far away in the Himalaya, the Bhagirathi was a river that became Ganga in the plains. Legends and travellers said it was so wide that it looked like a sea and its wilful currents were so strong that few boatmen had the courage to fight it. The women of Mannoor Madham Palace must have laughed and said that Bhagirathi should have been the name of the elder sister who had been named Lakshmi, and this last princess should have been named after the quiet, docile goddess of wealth. Rani Lakshmibai, who had lived in Thiruvananthapuram ever since her adoption into the Travancore family, was a determined and wilful girl. Her sister Bhagirathi had none of that fire. She did as she was told and she never complained.

Bhagirathi's two older sisters were born a few years apart and then, after almost a decade, came Bhagirathi. She grew up slightly solitary because it was almost as though she had come into the family too late. Like all young girls, she was married before she had any idea of why a marriage was necessary or why she now had her own quarters rather than living with the other children in Mannoor Madham. Marriage meant she had a room of her own and a man would live with her. It meant his well-being and happiness was her responsibility.

In most weddings, the boys were generally only a few years older than the girls, but Bhagirathi was married to a man who was at least eight years older than her. At eighteen, he was a fully formed man: tall, with broad shoulders and long black hair coiled

neatly in the way grown men fashioned their hair. He didn't keep a moustache at the time but still, he wouldn't have looked like a boy to her.

When the ritual of marriage was taking place, Bhagirathi noticed how big his hands and feet were next to hers. He was much taller than her and she felt like a doll standing next to him. His fingers felt rougher than any others she had felt. Later on he would apologize for them and explain that he liked to paint and paints dried the skin. Years later, when she had a better understanding of what marriage meant, Bhagirathi wondered whether things between them would have been different if she had been as precocious as one of her sisters and asked him to teach her to paint. Or said things that were clever and sharp. But she was not clever or precocious, so she stayed quiet, asked him no questions, and their marriage turned out the way it did.

But that was many years later. Before that was the oddness of married life. Everything changed, right down to what jewellery she wore and how she clothed herself. The strangest part was being told that she could not live in Mannoor Madham as she had before getting married, even when he left for Thiruvananthapuram. He told her before leaving that he was going because the Maharaja had called for him. His youngest brother was also in Thiruvananthapuram, he said. This brother's name was Raja and he was about the same age as her. Just as her elder sister stayed with her and took care of her, so would he, as an elder brother, look after Raja. It was his duty, he explained. She asked him if there was anything he needed her to do to help him with his preparations. He said no. The night he left, she slept alone in the room that was now hers. Once she grew up, Bhagirathi thought of herself as something of a solitary person but that night, she hadn't yet grown up. Surrounded by emptiness, darkness, and silence, the little girl couldn't sleep. But there was nowhere she could go. She was now a married woman so she must live in her own quarters, she had been told. She could no longer live with the other children and unmarried girls of the household. That night was the first time Bhagirathi felt alone. She

thought of her husband and wondered whether the horoscopes that had been matched had shown her so alone.

He came back after a few months, to her surprise. In her girlish mind, she had thought anyone who went to Thiruvananthapuram was swallowed up by the city just as her eldest sister had been. Maybe he was able to come back because he was a man, she thought. He asked her how she had been and remarked she had grown taller. It was true, Bhagirathi realized. If she looked up at him, his face seemed to be closer than she remembered. Then after a week, he left and Bhagirathi was alone again.

There came additional responsibilities with being married, but this new status of womanhood also gave Bhagirathi the opportunity to sit around listening to the conversations of the older women. Earlier, she had always been shooed away, but one of the benefits of marriage was that you had the right to be in places where people gossiped. Apparently, when Bhagirathi's sambandham was being finalized, her husband's mother had given a little speech to the senior women and she was so eloquent that everyone was charmed. Bhagirathi could easily have imagined her husband's mother standing before a gathering and speaking boldly. There was something in the way the matriarch held herself—the straight back, the pronounced nose, and the strong bones of her face—that made everyone notice her even when she was silent. Bhagirathi would have seen her during the wedding rituals and maybe she noted that her husband's mother had the same stern expression that his uncle did. Her husband's mother was also a poet, and when she spoke, her words were carefully chosen and without fault. That was what had impressed everyone who had heard her describe her son: the grace and correctness of her language. A mother so learned must have a gifted son.

Several years later, Bhagirathi would hear the same story of how the sambandham between her and her husband had been sealed by her husband's mother. Some rumours were persistent,

especially when they carried in them a shadowy nugget of truth. Except now the whisperers said that her husband's mother had made her speech before the men of Mavelikkara Kottaram and convinced them to take Ravi Varma Coil Thampuran as a groom for Bhagirathi. The altered version had little reverence for the customs of the day. A woman would never have been allowed to interfere so boldly in matters that were decided by men, but here the truth was clearly twisted to show what a commanding woman her husband's mother was. It also suggested Bhagirathi's family had needed a lot of convincing to accept this sambandham, which was not really true. Everyone liked her husband. They didn't mind him going to Thiruvananthapuram within months of their marriage. When, two years later, he said he wanted to make a pilgrimage that could place his life in peril and leave her widowed even before she had become a mother, the elders gave him their blessings. He told them that he was going to ask the gods for direction regarding his future, and everyone believed him.

So did Bhagirathi, of course. Like all young brides, she believed her husband. But even as a girl, she must have wondered at the enthusiasm he showed at the prospect of making so perilous a journey, as though he simply wanted to bolt out of where he was. She had months on her own to listen to others talk about him and thread together her own thoughts. He told everyone that he needed to ask the gods if he should become an artist and it raised the question of why it mattered so much to him. Was it simply the love of painting and colours? If that was so, should it not be enough for him to sit and paint in their room? But he didn't paint much in Mavelikkara. It was in Thiruvananthapuram that he was the artist; in Mavelikkara, he was the prince and the husband. Bhagirathi could tell that he enjoyed Thiruvananthapuram and his life there. Everytime he came back from Thiruvananthapuram, for a few days all he could talk about was what the Maharaja had said, whom

Maharani Nagercoil Ammachi had bewitched most recently, how exquisitely his brother Raja painted. She realized he was drawn to the fame that came with a painting being appreciated. All she understood of this thing called fame, which her husband seemed to crave, was that he felt a sense of triumph when he captured reality on his canvases and he needed others to recognize his feat.

This life in Mavelikkara with Bhagirathi wasn't enough for him. He needed more activity, more people, more entertainment than she or Mavelikkara could provide. His question to the goddess at the Mookambika Temple wasn't really whether he should be an artist but whether he had divine support for abandoning his duties towards his wife by adopting a career in art. She didn't know whether this was what touched her heart with fear or the idea of her husband travelling across unknown lands.

* * *

When the legend of Ravi Varma was scripted in later years, this period of his life is generally summed up in one bland line: he spent nine years in Thiruvananthapuram teaching himself to paint. Back in Ravi Varma's time, it was important everyone thought art came effortlessly to him. This branded him as a prodigy and marked him out to be different from and better than his contemporaries. He had respectability from being a Namboodiri Brahmin's son and he religiously followed all the prescribed rituals and respected tradition. He was a prince who had a passion for art as many princes did. Most collected; he created. That art demanded labour from him would have made him seem common, like the other artists and craftsmen who toiled at their work. His Thiruvananthapuram years in particular were presented as episodes from the charmed and uncontroversial life of a privileged man, not as the story of someone who, at the beginning of his career, was so frustrated by his early struggles that he resorted to bribery in order to learn art.

49

Despite the long tradition of murals and sculpture in the Hindu tradition, art enjoyed little respect as a profession, because it was seen as something that did not require intellectual thought or training. Ravi Varma's problems were further compounded by his decision to learn oil painting, which had come to India with the Europeans. Traditionally, Indian art used water-based paints made from natural substances like plants and minerals. Slow-drying oil paints were alien to most Indian artists, although a few had picked up the art of using oils from Company painters who began coming to India from the 1700s. Although oil paints were first used in the fifteenth century, they gradually became the favoured medium for most painters, particularly after the Flemish painter Jan van Eyck came up with the idea of mixing the pigments with a slow-drying oil like linseed oil. For the first time in European painting, figures and objects cast shadows and light stopped flattening figures and showing them at harsh angles. Many painters added to van Eyck's technique of making and using oil paints. Leonardo da Vinci added beeswax to the mixture and cooked it at lower temperatures to create oil paints whose colours didn't darken as drastically as they used to upon drying. Peter Paul Rubens is believed to be the one who came up with the idea of adding turpentine. It made paints dry faster but also made the mixture thinner.

The revolution in the world of painting came in 1841 when a stable mixture for oil paints was established, and paint, packaged in metallic tubes, began to be produced in bulk. The artist no longer had to grind pigments and make his own mixture. All he needed was a couple of tubes and some turpentine to thin the paint. Open the cap and the thick paint slithered out of the tube. So long as the tube was properly capped again to make the inside of the tube as close to airtight as possible, the paint's consistency remained the same. In Europe, it meant the artist was no longer studio bound. It also meant oil paints became mobile. They

could travel across seas, to Madras and Thiruvananthapuram, for example.

Ravi Varma didn't have it quite as easy. He began with pigments and started experimenting with them, much the same way as van Eyck had done centuries ago. It would have pleased him to know that he was doing the same things that an artist hailed as the father of oil painting had done in the past. However, at that time, getting clumps and clots of paint for his efforts served only to frustrate Ravi. His uncle had learnt some basics of oil painting, and so was able to guide him when it came to applying the paint upon the canvas, but the techniques of making the paints, and most importantly, mixing colours, were largely unknown to him. Ultimately, Ravi Varma accepted that oils, unlike drawing and watercolours, were not a medium he would be able to teach himself. This was why he wrote to one of the court painters, Ramaswami Naicker, and requested a meeting. He would have been about nineteen years old at the time and significantly younger than Naicker, who was already well established,.

When Ravi came to Thiruvananthapuram, Naicker was one of the most well-known artists in the Maharaja's court, and among the few who had secured some degree of respect for the profession. Naicker was originally from Madurai, the lotus-shaped city that was one of the oldest in the subcontinent. It is not known what brought him to the capital city of Travancore, but his hostility towards Ravi Varma suggests Naicker had clawed his way to the top. He was contemptuous of the ease with which Ravi was able to approach important people like the Maharaja, and he was possessive about his own place in the court. Naicker took great pains to ensure he wasn't mistaken for one of those local Indian craftsmen; he presented himself as an oil painter, like the Europeans. What survives of his paintings suggests he wasn't particularly gifted but few in Travancore had seen well-executed portraits. The kingdom hadn't seen many Company painters, who

51

mostly visited northern India and the Madras Presidency.

Ramaswami Naicker never spoke about whom he had learnt oil painting from. In all probability, his teacher had been one from the second wave of European artists who were often mediocre and came to the colony lured by tales of wealthy, bejewelled Indian princes. Naicker's talent lay in his knowledge of making oil paints and politicking. His paintings were unremarkable depictions of landscapes and imagined scenes showing gods and goddesses. He did, however, manage to skilfully insinuate himself into the political circles of Thiruvananthapuram. As with most royal families, there was little love lost between the one who sat upon the throne and the ones who were waiting to take his place. Rather than trying to ingratiate himself into Ayilyam Thirunal's circle, Naicker decided to do some long-term planning and earned the favours of Vishakham Thirunal, the Maharaja's brother, rival, and heir. Soon, Naicker had a studio in Thiruvananthapuram, and an assistant. Everything seemed set for him to become Travancore's most famous painter until Ravi Varma came along.

At first Naicker, like all the other artists, thought that the prince from Kilimanoor was one of those bored young men who needed a hobby to keep himself busy. But the boy stayed on and he seemed to be serious about the idea of not just learning to paint, but also actually painting in competition with court painters. In the small, closeted world of the Thiruvananthapuram court, news spread quickly of this young prince who was a surprisingly gifted draughtsman and seemed to be able to instinctively pick up techniques that generally required teachers and training in order to be mastered. Then came the snide and satisfied whispers that reported Ravi Varma was getting increasingly frustrated by the polite refusals with which artists were warding him off. When Naicker received Ravi's letter, he would have known he had something of an upper hand because the grapevine, which Ravi was rarely privy to since he belonged to a different social circle,

would have told him that the prince was finding it difficult to find a teacher. He had spent three years in the capital without approaching Naicker to teach him but clearly, that endeavour had not yielded satisfactory results.

All we know of the meeting between Naicker and Ravi Varma is that it was held at Naicker's studio and that by the end of it, the two men were bitter enemies. Naicker had probably asked Ravi to come to the studio because he wanted to impress the young man with his painting skills. Perhaps he had hoped that displaying his works would give him a stronger footing with Ravi. Unfortunately for Naicker, Ravi Varma was not only well aware that he belonged to the elite, he was also convinced of his own gifts. It is very unlikely that anything in Naicker's studio would have made him feel less talented than the senior painter. The meeting ended quickly with Naicker flatly refusing to take on Ravi Varma as a student. Maybe there was arrogance in Ravi Varma's demeanour, although this is unlikely because Naicker was his last recourse and he would not have wanted to upset the elder man. The impression Ravi Varma gave to those who asked him about this episode with Naicker was that insecurity and jealousy had provoked the senior painter's decision. Whatever the motivation, it sparked off an enmity that would last for years.

Incensed by the senior painter's refusal, Ravi complained to the Maharaja and Naicker found himself served with a royal order to take on the young man as his student. This time Naicker complained, but to Vishakham Thirunal, the Maharaja's brother and heir, and suddenly the situation became extremely tense. It was no longer a small matter of an artist taking on a new student but a question of two royal egos. Neither Vishakham nor Ayilyam was ready to bend his will, especially because the relationship between the brothers was not cordial at this time. Unwittingly, Ravi Varma had created something of a crisis in the royal court and he could see no means of resolving it. Even if he had been

53

agreeable to accepting Naicker's refusal, now Ayilyam Thirunal was determined that his brother's lackey would bow to his royal command. Who mediated the situation, we don't know, but a compromise was reached where Naicker was not obliged to become Ravi's teacher but he had to let the young man sit in his studio and watch him work.

* * *

Sitting in Ramaswami Naicker's studio day after day would prove to be as frustrating as facing the wall of politeness that the lesser palace artists had built around Ravi over the past year or so. He came dutifully every morning, and he sat in silence because the painter did not speak to him, and the assistants were told to stay out of the young man's way. Now, of course, there was no way that he could not go. His uncle must have made it very clear that they could not risk a diplomatic entanglement over this. Ravi knew that part of his uncle's support for his prolonged stay in Thiruvananthapuram came from the fact that in this way, he and his uncle were able to keep the royal family of Kilimanoor within the Maharaja's charmed circle. If Ravi proved to be an annoyance that exacerbated friction within the royal family, that favour was likely to find some other candidate. So he would go to Naicker's studio diligently and when he returned home to Moodathy Madham at the end of the day, he would tell his uncle that yet again he had learnt nothing. All Naicker let him see was the process of drawing on the canvas, and painting. The actual making and mixing of the paints was done in other rooms.

They never told the world whose idea it was to tap the assistant Arumugham Pillai. Maybe Ravi noticed that it was one assistant who had been entrusted with the task of making and mixing paints because this was the knowledge that oil painters guarded from their competitors. Then perhaps his uncle had the idea of applying the strategy that has been used for centuries in

political and bureaucratic manoeuvres to Ravi's art education: if the superior isn't willing to cooperate, then bypass him by approaching his subordinate. So, cautiously but determinedly, Ravi began making friends with Naicker's chief assistant, Arumugham Pillai. He had to be careful because neither could risk Ramaswami Naicker finding out.

The friendship must have begun with little gestures—picking up a dropped brush, a little shared smile when Naicker made a mistake that both Ravi and Arumugham noticed—and it took time to win the assistant's trust. After some time, they had secret little conversations behind Ramasawami Naicker's back. Ravi didn't ask him to help immediately. He knew that he needed to be patient and convince Arumugham Pillai that it was in the best interests of both that the assistant become his teacher.

It was the first time that Ravi had to subtly charm someone into complying with his will. The fact that he was a wealthy prince and Arumugham was just an assistant with little earning and even less respect worked to Ravi's advantage. But Ravi would have liked to believe that it wasn't just the social divide that brought the two together. He didn't treat Arumugham with the contempt that Naicker did. Rather, he gave him the respect that a student should give to a man he wants as his teacher. It was something that few had given poor Arumugham Pillai, who would have probably disappeared into anonymity like the rest of Ramaswami Naicker's assistants if he hadn't agreed to teach Ravi how to use oil paints.

It was probably the money that Raja Raja Varma offered Arumugham that convinced the assistant to betray Ramaswami Naicker. But it wasn't dignified to talk about or deal with money— neither uncle nor nephew ever physically touched money unless it was Vishu, the first day of the Malayali year—so they never disclosed what they'd paid Arumugham. Anyway, the assistant's claim that it was Ravi Varma's prodigious talent that had persuaded him to break Ramaswami Naicker's trust was much more flattering to Ravi.

Whatever his motivation, Arumugham came to Ravi every night after locking up the studio, and spent hours taking the younger man through the basics of oil painting.

By this time, one of the rooms in the ground floor of Moodathy Madham had become Ravi's studio. This was where he kept all the books, photographs, and journals he studied from. His sketchbooks were here and anyone who walked in could see the paintings he was working on. The watercolours that he could now paint with deft ease were here, as were his attempts at oil painting. His first attempts at mixing colours and oils had resulted in a series of hard, dark clumps. He knew he wanted the paint to have more body than watercolours did, but the right balance of elements proved to be elusive. He also wanted more control over how a shade emerged and what lines it followed. By the time he was able to convince Arumugham, he had crossed this beginner's stage but his knowledge of how to get the right consistency was unsure.

Arumugham Pillai wasn't surprised at how quickly the prince was able to pick up everything he was taught. There wasn't much beyond technicalities that he found himself imparting. It was almost as though Ravi already knew and just needed his memory to be prodded awake. Ravi had never felt this kind of exhilaration in his life. Watching the dry powder turn into shining paint gave him a rush of joy, and he was sure he would never get past the delight he felt each time a colour swirled into another to create an entirely new shade. Soon enough, Ravi felt confident enough to try a proper portrait and asked Arumugham whether he thought he was ready for this test. That was when Arumugham knew his time as Ravi's tutor had come to an end and he humbly told Ravi as much. The prince and his uncle insisted that he still needed to be Ravi's tutor, at the very least until this first proper portrait had been completed.

The royal court in Thiruvananthapuram was a tangled web of alliances and enmities. Courtiers hungered for power. Relatives hankered for a chance to ascend the throne. Aristocrats lobbied

to make contacts. With the help of Madhava Rao and Raja Raja, Ravi did his best to tread gingerly and become friends with influential families without getting embroiled in any plot or conspiracy. The courtier Attingal Mootha Thampuram and his wife Sethu Lakshmibai were among Ravi Varma's circle of wealthy friends. He requested the young couple to let him do a portrait for them. The years he had spent honing his drawing skills showed when he was able to make the basic sketch without much difficulty. He paid attention to how the different textures looked and caught the sunlight. Recreating them with oils took him time but it was with an immense sense of triumph that he showed the completed portrait to his uncle and Arumugham. He wanted desperately to show it to Maharaja Ayilyam Thirunal as well but his uncle advised him against it. The painting to show the king was not a portrait of someone else, but of himself.

The paintings Ravi Varma had already painted were good enough to create a modest reputation for his talents. Many now approached him, asking if he would paint their portraits, like his brother-in-law, Kerala Varma Valiya Coil Thampuran, who lived in Thiruvananthapuram because his wife, Bhagirathi's sister, had been adopted into the Travancore family. Adopting princesses was standard practice in matrilineal Kerala when there were no women to continue the line of inheritance, as was the case with Ayilyam Thirunal, who had no sisters, daughters, or nieces. Kerala Varma was a young prince with big ambitions and an eye upon the throne. An accomplished poet, he was known as the Kalidasa of Kerala. As the husband of the Rani, he was able to wield a good deal of influence and in no time, he had a sizeable following. Ravi Varma, now in his late teens, was quickly charmed by him. Kerala was charismatic, flamboyant, and very importantly, he was also appreciative of Ravi's artistic talents, especially after he saw the portrait the young man made of his wife and himself. As a token of thanks, he gave Ravi a gift that the artist would

remember fondly all his life. He ordered a set of oil paints in tubes from Madras for the young artist. Whenever anyone asked Ravi Varma about his beginnings as an artist, he would mention the tubes. They made him feel closer to the artists he admired in faraway Europe.

* * *

In 1868, the Danish artist Theodore Jensen was presented to the Maharaja by the Viceroy John Lawrence. The Maharaja extended an invitation to Jensen to come to Thiruvananthapuram and paint a series of portraits. Now that his kingdom had left its memories of debt far behind and was collecting a healthy reserve fund, he could allow himself such luxuries. The offer was just the kind of commission that the middle-aged Jensen would have been hoping for when he embarked upon his Indian sojourn. Based in London, the artist had had a modest career, painting uninteresting subjects like bland still lifes and village belles. Jensen accepted the Maharaja's invitation readily.

In Thiruvananthapuram, the court began chattering excitedly long before Jensen's arrival. Among the palace artists, Jensen became Flemish, like the old masters who painted those dark paintings in the magazines, the ones with the magical touches of light. There were those who said he was British, like the Company painters. All of them wanted to know how he was going to paint and whether he would need an assistant. Some courtiers wondered just how much tradition the Maharaja was willing to abandon in his fascination for the West, because it was rumoured that he was going to ask the white artist to draw a portrait of his wife, the beautiful Nagercoil Ammachi. It wasn't as though women in Travancore couldn't appear before men, but to be presented before an outsider? She was, however, a headstrong woman, the kind who enjoyed being labelled 'modern'.

There were those who believed that no man could come into

contact with Nagercoil Ammachi, the Maharaja's second wife, and not fall in love with her. She was the daughter of one of the former prime ministers in the nearby kingdom of Cochin and was named Lakshmi. She was seven years younger than Ayilyam Thirunal, and it was likely that the Maharaja's interest in women's education and other women-related issues was inspired by her.

According to the prevailing customs of the times, she must have had a ceremonial marriage when she was younger, since when she married Ayilyam Thirunal, she was twenty three years old. Ayilyam Thirunal was said to have met her when he visited Cochin in the early 1860s, and he was immediately enchanted by her beauty and her intelligence. In no time, she and two cousins of hers were adopted into the Nagercoil Ammaveedu, which was one of the four chief families that provided consorts to the Maharaja of Travancore. So Lakshmi became Nagercoil Ammachi and was married to the Maharaja of Travancore in 1862.

Her detractors pointed to how Sir Madhava Rao and the Maharaja were moving towards estrangement ever since she began taking an active interest in affairs of the state. It was unusual for a consort to be so involved, and few appreciated her ambition. She affected an air of superiority, some complained, because she was well educated and had written books in Sanskrit that had been well received. Some of her writings were creative pieces while others explored complicated ideas about aesthetics and performance arts. Admittedly, all this was impressive, but surely that didn't give her the right to have such airs or to meddle in governance. It should have been enough for her to organize the literary and musical evenings where she invited well-known aesthetes, poets, musicians, and singers; but she also wanted to play a part in deciding administrative policies for areas like education and health. And the Maharaja seemed willing to let her be involved, even if it meant upsetting his prized Dewan.

One of the few people unconcerned by the opinions and gossip

around Nagercoil Ammachi was Ravi Varma. He was in a tizzy about Theodore Jensen's arrival. Fortunately, he could share his excitement with someone: his nine year old brother, C. Raja Raja Varma, had just joined his elder brother in the capital to receive an English education. There was a gap of eleven years between the two brothers, but in the loneliness of Thiruvananthapuram, this young brother was a source of much needed companionship for Ravi. It also probably ended up being an unexpectedly equal relationship, because it is very likely that while Ravi taught his younger brother painting, Raja Varma passed on to his elder brother the rudiments of English. There are no written records, but it is easy to imagine the two brothers building up a rapport at that moment when Raja Varma was able to decipher for his brother the hieroglyphics that spelt out the title of his favourite book: *The Hindu Pantheon* by Major Edward Moor, F.R.S.

It was the beginning of a relationship that would go on to be so intimate that the two Varma brothers would often be likened to the mythical pair of Ram and Lakshman, even though they were very different. Ravi Varma had been brought up in a strictly traditional way, learning Malayalam and Sanskrit. Raja Varma came to the capital and studied under an English tutor. He respected Hindu traditions but had little time for religiosity, unlike Ravi Varma who was a devout follower of Hinduism until his last days. The elder brother was an extrovert who enjoyed parties and meeting people, even if it meant having to communicate through an interpreter. Raja Varma preferred losing himself in books and always carried English novels with him wherever he went. The connection between the brothers was their love for the arts, whether it was poetry, theatre, painting, or sculpture. Ravi Varma found in his hero-worshipping younger brother a trusty confidant and an unwavering support system. Raja Varma had no qualms about letting his own considerable talent remain out of the spotlight. His landscapes won him prizes and the few that

are still around have a pleasing delicacy. However, Raja Varma's first priority was always his brother. It's very possible that while Ravi wove fantasies of how Theodore Jensen would get along with him famously, his younger brother would go a step further and imagine a situation where Jensen hailed Ravi Varma as the greatest painter he had ever seen.

Fantastic imaginings aside, Ravi knew that this was a crucial moment, one that he had to seize. He explained to his brother, who was the only person to whom he could speak his thoughts freely, that Jensen was a gift from the gods for the patience he had shown over the past six years. Ravi imagined Theodore Jensen to be a man without the insecurities and prejudices that filled the local artists, an artist who was accomplished, who would recognize the young man's talent.

If Jensen had kept a diary of his time in Thiruvananthapuram, we would have known just how he felt about being surrounded by all the inquisitive faces and serving staff that seemed to lurk at every corner of the palace where he was staying. Unfortunately, there is no such document that is readily available, so we can only imagine the artist's experiences in Travancore. To begin with, he would have been surprised at the low, labyrinthine palaces, which were very different from the tall European structures he was used to. The heat would have been off-putting, and when he did allow his bare feet to touch the floor, the coolness of the surface would have surprised him. Most pleasant would have been the staff that seemed to exist only to serve his every expressed need. Then there was the strange but flattering experience of knowing that he inspired awe in so many just by virtue of being a foreign painter. Yes, he had achieved some success but his careful still lifes and doll-like heroes and heroines were not en vogue back in Europe. Here in Travancore, he was being hailed almost as though he was one of the Renaissance masters. There were local artists who lined up for interviews for the position of being an assistant.

Then there was that boy, a prince supposedly, who kept asking to be taken as a student. Jensen had told him at the very first meeting that he was not planning to stay for very long so there was no question of taking on a student, but the boy kept returning. One day, he came with a few small canvases. Jensen thought they were gifts but they were actually the boy's portfolio. Clearly, he thought that showing his work would convince Jensen to change his mind. The Danish artist studied the portraits carefully. He noted the need for finesse but more significantly, he noted how well the boy had used classic portraiture techniques upon the native subjects. The still life paintings were excellent. The boy had an eye for the finer details of light and texture.

With careful nonchalance, Jensen asked the boy where he had learnt to paint like this, and the boy replied in dubious English that he was self-taught. It would have seemed unbelievable to Jensen, but it was not his job to judge the veracity of the claims of minor Indian princes. He was here to do portraits and if there was someone who was painting portraits like the ones this boy carried with him, Jensen needed to complete his before the Maharaja discovered the talent in his own backyard. Jensen told the expectant boy that there was no possibility of him changing his mind about taking on a student and that the boy was no longer welcome. Under no circumstances should he return with this same plea.

It turned out that this boy really was a prince called Ravi Varma and one that the Maharaja was most fond of. Jensen found himself being called to a royal audience where he was asked to take on this Varma as a student. He decided being imperious was the best attitude to take and told the Maharaja that he was not a tutor but an artist. When the Maharaja said that the young prince was gifted, Jensen quelled the panic rising within him. He had no doubt that His Royal Highness was correct and the boy had some degree of talent, conceded Jensen, but it was not for

him to be the boy's guide. There ended that meeting and Jensen could see that his refusal had not pleased the Maharaja. But Jensen knew he could not take the boy on as a student. There was really nothing that he had to teach him. If those paintings were any indication of his skills, then all the boy needed was practice and the experience of blending colours. He thanked his good fortune that the commission was still his despite the obvious royal displeasure. A few days later, just before the Maharaja and his consort were to do their first sitting for him, Jensen received the royal summons again. This time the Maharaja told him plainly that Prince Ravi Varma had set his heart upon receiving instruction from Jensen. It was the royal will that this favourite not be disappointed. So, asked the Maharaja, what could be done that would be unobjectionable to Mr. Jensen but also consider the wishes of the Maharaja's favourite? From the mulish expression on the royal face, Jensen could see that a complete refusal to entertain that annoyingly persevering boy wouldn't help him. In an effort to buy time, he asked what the Maharaja thought would be a suitable solution. From the smile upon the royal visage, Jensen realized he had said the right words. The Maharaja said that he appreciated and respected Mr. Jensen for the gravity with which he saw the role of the teacher. It was indeed a responsibility that could not be carried out in the short time that Mr. Jensen would be a guest in Travancore. Instead, the Maharaja suggested Mr. Jensen let Prince Ravi Varma watch him paint and so, glean from that experience, whatever he could. Unable to come up with any credible objection or alternative, Jensen agreed.

That was how Ravi Varma ended up sitting in a corner, notebook in hand, for each of the sittings that the Maharaja and his consort gave Jensen and for the entire month it took the Danish artist took to complete that portrait.

They didn't know it then but Ayilyam Thirunal and Nagercoil Ammachi were actually sitting for two portraits. The one they

knew about was to be painted by Theodore Jensen, whose behaviour did not impress them. To begin with, his obstinacy to not concede to the royal will despite being a paid painter had annoyed Ayilyam Thirunal. Then, he was positively jumpy at the sittings. He complained about the Maharaja and Nagercoil Ammachi giving separate sittings even though the painting was to show them together. Then the light in the room was not to his liking. It was too bright, he said. When it was obscured, he said it was too dark. Nothing seemed to please him. The only person who could have sympathized with Jensen was Ramaswami Naicker because he too had been forced to work under the intense gaze of a silent Ravi Varma. In addition to the unnerving experience of being watched, Jensen struggled with getting his native subjects to fit into the mould of European portraiture. Their refusal to appear together bemused him and made it difficult for him to structure the painting. Then there was the way the material of their clothing fell around their bodies, and finding the exact blend of colours for their complexions.

Ravi Varma watched Jensen at work keenly. He saw how the artist prepared his canvas, how the figures were placed in a grid, and how elements were added to populate the painting. He also saw how he could better Jensen's painting. There were mistakes Jensen was making without realizing it. For example, he was giving more importance to the Maharaja and struggling to make the plump face with the wide forehead seem less egg-like. However, the person to focus upon was Nagercoil Ammachi. Not only because she was exquisitely beautiful and features as finely drawn as hers were more difficult to capture accurately, but because the Maharaja would pay much more attention to how his consort looked in the portrait. He had few expectations of his own face but the same was unlikely in case of Nagercoil Ammachi.

So Ravi Varma made his own version of the portrait. It became an imaginary competition for him, not just with Jensen but

everyone who had opposed him. He had to make this painting perfect, so perfect that the Maharaja would feel vindicated for supporting him, so perfect that no one would ever doubt his talent again, so perfect that it would win over Nagercoil Ammachi. The twenty year old watched the Maharaja's wife at the sittings, noting the way she moved and the little gestures she made. He observed her expressions and how the light fell upon her face.

In Ravi's painting, Nagercoil Ammachi, with her sparkling eyes and lush lips, hovered like a nymph around her husband of regal bearing. He drew them in shadows that were perhaps too dense but against that dark background their skin, jewellery, and white attire gleamed in vivid contrast. This was where the challenge lay for Ravi Varma: in the art of blending colours. It was a skill that was crucial in oil painting and one of which Arumugham Pillai had known only the basics, from Naicker. Jensen knew from Ravi Varma's other paintings that blending was the one weak spot in the young man's work and that he would be watched with unblinking intensity when he began filling in the sketch. If the subjects had been white, Jensen might have managed to evade Ravi Varma's eye but the colours he had to create were unfamiliar and often he needed to correct his original blend. The corrections were enough for Ravi Varma to pick up how Jensen was creating the palette that covered the range of caramel tones that matched Indian skin.

After a month, when Jensen presented his portrait to the Maharaja and his wife, Ravi Varma said he had an offering for the Maharaja. A little something to show his gratitude for all the support His Royal Highness had shown him over the past few years. A large canvas was brought to stand next to Jensen's and when it was uncovered, it too showed Maharaja Ayilyam Thirunal and Nagercoil Ammachi. While the two figures painted by Jensen looked ably executed, there was a vibrancy in Ravi Varma's painting. The skin looked tactile. The folds of cotton were so well done that one could be forgiven for expecting to feel

fabric when touching the rough surface of the thickly painted canvas. Jensen was furious and he made it known that he saw the behaviour of Prince Ravi Varma as discourteous and offensive. But Ravi barely felt the heat of the foreign artist's displeasure because, just as he had hoped, after scanning his painting carefully, the enchanting Nagercoil Ammachi was smiling at him.

The image of a beautiful woman is a commonplace thing today. Perfect faces stare out at us from advertisements, posters, and photographs. They sell us things, they offer us intimacies. In Ravi Varma's time, beauty lay in descriptions crafted out of poetic phrases. Poetic verses described beauty in impossible terms: eyes shaped with the graceful curve of a piscine form, lips that followed the lines of a bow, fingers like petals of the champa flower. These descriptions did not translate into reality and neither did the womanly figures seen in temple murals and sculptures. They were divine, unrealistic creatures with voluptuous bodies and blank smiles. They paid scant attention to the devotees who in turn were supposed to have eyes only for the divine. Portraits like the ones Ravi Varma would paint, and photography brought real women out of their cloisters. Their beauty and awkwardness, the saris they wore, and the jewellery they adorned themselves with, all this was seen by a more impersonal, public, and yet intimate eye. And the women looked back at the artists and viewers. They met their gaze, perhaps not confidently, but always unblinkingly.

Rumour has it that Ravi Varma's paintings of Nagercoil Ammachi—and he would paint a fair number in the near future—with the Maharaja were enchantingly close to the real beauty. Few people actually saw them, just as few saw the painting he had made while watching Jensen work, but everyone in Thiruvananthapuram talked about the artist and his work. His fame began with this painting. He had competed against the Goliath-like European painter Theodore Jensen, and he had won. To some, it was a victory for Travancore against foreign

forces. The art that the Europeans so prided themselves upon had been mastered by one who had not been to one of their schools, who had never had a foreign tutor, whose education and upbringing was staunchly traditional, native to the land he had been born into. With one painting, Ravi Varma had made a name for himself as both painter and hero. Now, everyone in the Thiruvananthapuram court saw him as much more than the nephew of Raja Raja Varma of Kilimanoor. There was something else about Ravi Varma that made everyone eager to be friends with him: the fact that he had won over Nagercoil Ammachi.

Whether Nagercoil Ammachi's fondness for Ravi Varma sprang from an actual appreciation of his talents or out of a certain narcissism, no one knows. However, henceforth the Maharaja's consort took an interest in Ravi Varma's career. She gave him books and spoke to him about his art. She asked to see the paintings he was working on and she invited him to gatherings of poets and intellectuals. Ravi Varma found himself spending time with some of the finest minds and most influential men in the city. With this attention came a certain notoriety as well. Whispers began that there were portraits Ravi Varma was painting that were done secretively. Some said that Nagercoil Ammachi visited him at Moodathy Madham. Sometimes she came to see his paintings and sometimes she posed for him. The rumours implied the young artist was falling headlong into the vortex of her charm. However, the paintings he made of Nagercoil Ammachi were not seen by the public. Others were and as Ravi Varma's paintings became the talk of the town, the word on the streets was that if one wanted to see apsaras, they just had to go to Ravi Varma's studio. For Ravi, it must have been a heady time.

* * *

It was in 1870 that twenty two year old Ravi and two cousins embarked on a pilgrimage to the Mookambika Temple. Planning

such a trip was not a quick decision back in the days before the advent of highways and automobiles. It was an arduous journey that would take Ravi Varma across the length of modern Kerala to southern Karnataka. The company of three would have to make their way through jungles infested with wild animals, up slippery hills, and rely on the hospitality of strangers. They would need to find trustworthy guides for more difficult stretches and guard themselves against disease and injury. Unsurprisingly, few undertook such adventures and when they did, it was because they were deeply troubled.

Mookambika Temple remains special to pious Hindus and even today, the hilltop temple where both Shiva and Shakti are worshipped is difficult to reach. According to legend, it was the Vedic scholar Adi Shankaracharya who established the temple. He was meditating in what are now known as the Western Ghats in southern India when, pleased with his prayer, the goddess Adi Shakti appeared before him. She granted him one wish and Adi Shankaracharya said that his heart's desire was to take her to his homeland of Kerala where he would set up a temple for her. The goddess agreed to follow him to Kerala, but there was a catch. She would follow him so long as he kept faith in her word and did not look back during their journey. Much like the Greek Orpheus, Adi Shankaracharya was able to keep himself from turning for a while but at one point, he got worried and did look back. The Hindu myth writers were kinder with Adi Shankaracharya than the Greeks were with Orpheus. The legend says that the goddess stopped at the place where Adi Shankaracharya had turned and told him to make a temple there.

It took Ravi Varma and his two companions months to complete the pilgrimage. They set off from Mavelikkara in a carriage, travelling northwords. During the day, the sun beat down on them relentlessly, but with sundown came the question of where they would spend the night. In the beginning, this was

not too difficult. Local landlords were generally happy to provide hospitality to the aristocrats. The old Sanskrit adage that asserts guests should be treated as though they are gods was one that was assiduously followed. It was also believed to be one's good fortune to have the chance to play host to Brahmins. Kizhakke Palat Krishna Menon was a sub-judge who gave the group lodging when they were passing through Calicut on their way back from Mookambika Temple. The three men presented themselves at his door and politely introduced themselves. Explaining that they were making their way to Travancore after having performed austerities at the temple, they requested shelter for the night. Krishna Menon was particularly struck by Ravi. He couldn't put his finger on just what it was about the young man that tickled his fancy. He seemed to be brimming with a kind of energy, said Menon to his wife, and she agreed. Had they seen him when the group had been making their way towards Mookambika Temple, they may not have felt the same way. The Ravi Varma the Menons saw on the return journey was a very different man because by then, the goddess had soothed his furrowed brow and answered the question that was plaguing him.

Ravi Varma Coil Thampuran. Ravi Varma, painter. He must have said the two phrases to himself again and again. They became a chant in his head. He saw the words written on the walls of humble village houses, on gnarled tree barks; the stars in cloudless skies formed constellations that spelt out the two phrases, and he heard them under the gurgle of streams. As he moved with his companions through jungles and unfamiliar terrain, all Ravi did was imagine his future. Their guide warned them, in places, of wild elephants. Some trails were feared to be the haunts of dacoits. Ravi heard the words of caution and he followed the guide's instructions, but his mind remained entangled in the dilemma of whether he should follow the path that he was born into as a Brahmin or chase an uncertain destiny by following his God-given talent for painting.

All the elders he respected had told him there was no dishonour in the kind of art he made. They were all amazed by it. He often amazed himself by what he was able to fashion with his brush and paints. But there were also times when he failed, and the unsuccessful canvases could not be made to disappear. They reminded him he had learnt to paint from pictures and a lowly assistant. Every time he envisioned himself as an artist, he saw himself standing alongside petty, vicious-minded men like that Ramaswami Naicker. If that was what being an artist meant then Ravi knew it was not what he wanted to be.

Yet he wanted to paint. There was so much more to art than what Naicker and his brand of men recognized or even imagined. Ravi knew he could create wonderful things with art. He believed he could bring to life thoughts and dreams and stories. He could show a man beauty, real beauty. He watched the sunlight shift as they came closer to the temple. He noticed how it streamed through leaves and how it danced upon water. He stared at the lamps and fires that were lit at night, and his mind tried to break down the dancing flames into different colours. He could recreate all this on a canvas, and if he did, how could it not be a respectable task?

The painters of Europe were not disrespected, he reminded himself. Their works were seen as treasures. In their paintings, they showed their learning, their humanity, and their faith. Could he not paint like that, and if he did, would that be wrong? Did he have the ability to paint like them? Was it wrong to want to be like the foreigners? Was aspiring to these European ideals disrespectful to the age-old traditions he had been born into?

His companions must have found it strange that he had chosen to take the pilgrimage at the time he did. Long journeys made for confidants and they would have asked him the obvious question: why now? As one of his cousins put it, he had been on the path of art for many years, so what had spurred the need to make a decision now? He told them that at twenty two he realized he could no longer be directionless. He felt as though he had his feet planted on two boats

that were headed in different directions. It was the truth, but perhaps not all of it, because it seemed it was his marriage that had forced him to make that decision now. Mavelikkara and Thiruvananthapuram were two different worlds. When he had answered the royal summons and returned to the capital, he had thought it would be possible to be a prince in Mavelikkara and an artist in Thiruvananthapuram. But it wasn't. He felt like he was living two lives and too often it felt dishonest, because he knew he craved the delights that came from the fame of being a respected artist. He could not admit this to anyone but sometimes when he made preparations to return to Mavelikkara, the thought of the mundane responsibilities that lay ahead—meeting family, helping elders with the running of estates—made everything within him wither. He missed his life in Thiruvananthapuram when he left the city, but he never missed his life in Mavelikkara.

When he had told the Maharaja and Nagercoil Ammachi of his intention of going on this pilgrimage, the Maharaja wished him a safe journey and said he was sure the goddess would guide him well. Nagercoil Ammachi said Thiruvananthapuram would wait to see what marvel he would paint to celebrate the blessings that the goddess would no doubt shower on him. In Mavelikkara, on the other hand, the concerns were more prosaic. The elders worried about whom he would travel with and the dangers on the road. His little-girl wife gave prayers at the Sree Krishna Swami Temple for his safe journey. It was touching, but it seemed as if they were concerned only with the nitty-gritty, not his real dilemma. This swerving between pragmatic conventions and artistic dreams had become his life, and this, he told himself, was what he was looking to end.

Ravi Varma spent forty one days praying to Devi Mookambika. He sought guidance from Saraswati, the goddess of learning, and he begged Ganesha, the god of wisdom and the remover of obstacles, to show him his destiny. Just what kind of epiphany he had, he never shared but at the end of it all, he emerged certain it was the divine will that he be an artist. He was twenty two years

old, and he had decided that he would not be shackled by the feudal traditions he had been born into. He would not be like his uncle, a prince who had a serious hobby. Ravi Varma was going to be a professional and have a career, like many unaristocratic commoners. But he would embark upon a career not because he needed to earn money but because he was gifted; because the goddess had ordered him to do so. And so, on his way back, touched by Krishna Menon's kindness and hospitality, he offered to paint a family portrait. It was a celebration of Ravi's belief that the gods wanted him to be a painter and not just a man who painted as a hobby.

It isn't the most perfect of paintings. Krishna Menon's daughter looks cross-eyed, has an oddly dangling hand, and is unnaturally bloated. But the painting shows the kind of realism that had not been attempted by very many Indian artists. In the painting, the artist has used techniques of European portraiture on Indian subjects. Props have been used, like the fruits held by Krishna Menon's younger son. The shadows that fall on their faces are different from the shadows that cluster in the folds of fabric. It's easy to imagine where the light is coming from. Details of jewellery, right down to the gleaming stones in the rings, are painted with care and accuracy. Each person has a different expression: a slight question in Krishna Menon's eyes; the nervousness of his wife; the sullen impatience of his younger son; the obedient goodness of the elder child; the hint of a smile on the toddler's face. This was the first portrait by Ravi Varma, painter.

* * *

Women gossip, but that chatter doesn't make it into history books. Some would say it's fortunate because we don't need old wives' tales and unsubstantiated rumours being immortalized as facts. But this also means there are memories and true stories that are forgotten because somewhere along the way, they were discarded

along with the other things that were gossiped about. In Europe and America, women who were fortunate enough to be literate wrote diaries, filling the pages with real and imagined happenings that, regardless of their veracity, became a looking glass into the writer's life. But there was no such tradition here in India. Literacy was rare among women and even among the literate, the written word wasn't always trusted. For wives, mothers, and daughters, it was too public to entrust secrets to, even if it was as mundane as a stolen sweetmeat or a white lie about a headache. Instead they told each other stories; they gossiped. The lived history of women in India was passed on from ear to ear, as though their feelings and memories were being played in interminable rounds of Chinese Whispers. Everyone knew about everything while at the same time, there was nothing to know. No one who actually spoke to Bhagirathi ever wrote down even a line of what they spoke about, but the lingering impression is of a lonely, unhappy woman. There are no records of how she felt on any day of her life, but descendants of the families that knew hers know that her husband brought her little happiness. Her husband seems to have known this too. It is said that when he was on his deathbed in Kilimanoor, fifteen years after Bhagirathi's passing, Ravi Varma's only expressed regret was that he had neglected his wife. No one knows exactly what that means because the story of Bhagirathi, wife of Raja Ravi Varma, exists only in the realm of muffled hearsay and guesswork.

He returned from Mookambika Temple like a victorious champion, but he did not come back to her. He came to Mavelikkara, yes, and everyone could sense a radiating energy in him despite the exhaustion that clung to his muscles. She did not notice right away but she did eventually see the stains of paint on his fingers and knew deep inside that the goddess had taken her husband and given him to Art. He had painted a portrait of a kind family that had been their hosts in Calicut, he said. While creating that portrait, he had felt as though Saraswati

73

herself was guiding his brush, he said. Bhagirathi listened. The will of a man, she may have fought, but how did a mortal contest a goddess like Devi Mookambika or Saraswati? She said nothing when he said he must go to Thiruvananthapuram without any delay. They had not been able to keep him from the city when duty had decreed he stay in Mavelikkara. Now that he had divine permission to leave this palace behind, there was absolutely nothing to restrain him.

Even though the capital of Travancore was far from Mannoor Madham, news managed to reach Bhagirathi and every time she heard anything of her husband, it seemed to take him further from her, rather than bring him closer. She heard that the tales of how bravely he had made the pilgrimage and the blessings of Saraswati had greatly impressed Maharaja Ayilyam Thirunal. He had declared her husband a palace artist and awarded him a stipend of Rs. 50, which was what court painters earned, and it was a generous enough sum, even though the princess of the ruling family of Mavelikkara certainly didn't need a stipend. It seemed now he was making a portrait of the Maharaja and Nagercoil Ammachi. This was the first time the royal couple would be painted since the foreign artist had come to Travancore two years ago. The painting seemed to consume him. He was in Thiruvananthapuram when she found herself relieved of all duties because of stomach cramps and a spreading stain on her white wraparound mundu. Like every girl at the point when she loses her girlhood, Bhagirathi also thought she was dying. But the pain lessened and although the stickiness between her legs took time to abate, she realized she was very much alive. In the secluded wing where the women waited for their bloody days to pass, her companions told her she would be coming here now every month. They explained to her how her body was going to change and what it could now do.

In Thiruvananthapuram, her husband painted canvas after canvas, gaining admirers and garnering praise. Many were portraits, and with each one, his ability to draw faces and recreate textures improved. The way he blended his colours became more

sophisticated than is apparent in the Krishna Menon family portrait. He also realized his talent was for drawing people, rather than landscapes and inanimate subjects. News came that her husband had painted so beautiful a portrait of the royal couple that he had been awarded the Vira Sringhala, a bejewelled bangle from the royal treasure trove. It was unimaginable that a painter should be given the bangle! But it was her husband's now and because of something he had painted. The portrait showed such a startling likeness of Nagercoil Ammachi that a rumour had started that the Maharaja would make sure the painting was always kept private. It captured her beauty and allure so perfectly that it seemed that if one stared long enough at the painting, she could step out of it. At least that was what they said over in Thiruvananthapuram.

There was no mention of her husband's return, however. He was consumed with his painting, said those who came from Thiruvananthapuram. Nagercoil Ammachi herself was taking such an active interest in his career that it was probably impossible for him to leave the capital for any length of time, said cousins and family acquaintances. These were the small nuggets from conversations that rolled around the corridors and kitchens, gathering smothered smirks or pitying glances, until they became enormous but invisible boulders standing between Bhagirathi and the other women in Mannoor Madham. It didn't happen in those first few months. She didn't always understand the meaning that sneaked in between innocuous words. But months collected into one year and then two, and the women twittered softly about her husband.

It wasn't as though he didn't come home to Mannoor Madham at all in this time. He made trips spanning a few days that made it seem as though Mavelikkara was but a few hours from Thiruvananthapuram. From the moment he came, he began preparing everyone for his return to Thiruvananthapuram. But

he told them such stories of his time in the capital that everyone listened, transfixed. Soon after the stories ended, it was time for him to return. He had to be in the capital, he said to her even though she did not ask for an explanation. He was a palace artist, after all.

Part Two

The Painter Prince

The British government accorded the nineteen-gun salute to the Maharaja of Travancore in 1866, six years after he and Madhava Rao had embarked upon their mission to revive Travancore. At festivals, he received a twenty one-gun salute, the highest an Indian prince was entitled to. It was a sign of great honour, greater, perhaps, than when the Governor of Madras, impressed by Ayilyam's erudition, appointed the young Maharaja as a Fellow of the University of Madras. These platitudes were partly a recognition of the work being done in Travancore, but more importantly, they were among the ways in which the British administration chose to thank the native states that had opposed the 1857 rebellion that is today known as the First War of Independence.

The system of gun salutes had been devised by the British after 1858, when the mutineers and their supporters had been wiped out with brutal and ruthless efficiency. Sepoys were blown apart by cannons and entire forests were festooned with dangling bodies of peasants suspected of having supported the mutiny. Those who had sided with the British, like Hyderabad, Kashmir, Mysore, and Travancore, were thanked with morsels of territory, occasional monetary rewards, and new honours like the gun salute.

The system of gun salutes was the British rulers' attempt at creating their own hierarchy among the Indian princes. The higher the number, the more autonomy a princely family supposedly enjoyed; although the colonial government's

representatives, like the British Resident who oversaw Travancore and Cochin, continued to keep a close eye on the rulers. Sometimes Residents interfered in domestic policies as well, even though that was technically the local ruler's responsibility. In Travancore, for example, it was necessary to have the Resident's approval when adopting members into the family or appointing regents for underage kings. In effect, the gun salutes, along with awards like the Order of the Star of India and Kaiser-i-Hind medal, were signs of how extensively one had cooperated with the colonial government. With its pride in its rich cultural heritage, admiration for Western modernization, and largely peaceful populace, Travancore was a model state, not just for its rapidly improving infrastructure, but also because it possessed the perfect blend of attitudes so far as the British were concerned.

Ayilyam Thirunal ruled Travancore for twenty years, and he was revered as the man who ushered in the golden age of Travancore. Through his and Madhava Rao's initiatives, land reforms were attempted, irrigation was improved, schools were built, and health services improved. Roads were built, and there was better communication within the state. Travancore also became better connected to Madras and other important trade and power centres like Cochin and Arcot. When famines struck Madras and much of the Deccan plateau in 1877 and 1878, Travancore was one of the few places in southern India to not be ravaged. Nature had been kinder to Travancore, but the state's good fortune had as much to do with the good relations maintained by Ayilyam and his mandarins with the British administration, whose cruel policies made the effects of the famine much worse than they should have been.

When he ascended the throne, Ayilyam picked a few allies whom he could trust and whose intellect he respected, like Madhava Rao and Annaji Rayar, who had been the Maharaja's English secretary. Although his brother Vishakham and he

had been close when they were growing up, their relationship became much less cordial after Ayilyam ascended the throne. Politicking courtiers and the brothers' egos succeeded in creating an uneasiness between them that lasted until the last few years of Ayilyam's reign.

All these men shared a deep-rooted pride in their native Malayali culture and a fondness for Western academia and language. Although knowledge of English was fast becoming one of the most widely accepted signs of a person's sophistication and learning, the dividing line between the Europeans and the Indians was sharply and deeply etched. For people like Ayilyam and Madhava Rao, the scholarship and systems of the British were things to be admired and used, but not to be accepted without exercising their own discretion.

Among Ayilyam's chosen favourites from the cluster of princes and royal relatives was Kerala Varma Valiya Coil Thampuran from the Malabar royal family which had been forced to flee the land when Tipu Sultan invaded the area at the end of the eighteenth century. His relationship with Ayilyam became close when his wife Sethu Lakshmibai of Mavelikkara, Bhagirathi's eldest sister, was adopted into the royal family of Travancore. There was more to Kerala Varma than his impressive royal pedigree. Ayilyam and he shared a love for literature and a desire to translate works from other languages into Malayalam. The Maharaja had a number of translations and written works to his name, including *Sakuntalam*, a translation from the Sanskrit original, and *Minaketanacharitam*, a retelling of an Arabian story.

Kerala Varma was widely respected as Travancore's finest modern poet and the father of prose writing in Malayalam. He was one of the few people in the entire kingdom who could write with equal eloquence and grace in Malayalam, Sanskrit, and English. In 1868, he became the Chairman of the Textbook Committee, whose object was to decide about school textbooks

and which literary works, in Malayali and other languages, should be made available to students. He commissioned books on a wide range of topics, ranging from health to ethics to geography. One of his larger projects was *Mahacharitasamgraham*, a collection of biographies based on *The Treasury of Biography* by Samuel Maunder. Kerala himself translated nine of the fourteen volumes in the treasury. The remaining five were translated by the Maharaja's brother, Vishakham Thirunal. It is entirely possible that Kerala and Vishakham's close friendship began with their collaboration for these translations.

By 1870, Ayilyam's old favourites were no longer by his side. The rumours pointed to Nagercoil Ammachi's increasingly active interest in the running of the state as one of the causes. Disgruntled courtiers complained that Ayilyam himself was becoming unapproachable and egoistic. There was also a clique that started a whisper campaign suggesting Ayilyam be replaced by Sethu Lakshmibai's eldest son, so that Kerala Varma could be the de facto ruler of Travancore. According to the matrilineal system, a ruler was not succeeded by his son but by his brother since inheritance followed the maternal line. If he had no brothers, his sister's son would inherit the throne. Since Sethu Lakshmibai's adoption, the line of succession was clear except that the suggestion of Kerala Varma's supporters leapfrogged over the man who had spent most of his life being the king-in-waiting: Vishakham Thirunal. Although he didn't dismiss those who suggested kingship to him, Kerala probably did not involve himself too intricately in these conspiracies, because his relationship with Vishakham Thirunal did not suffer.

However, relations between him and Ayilyam cooled considerably. The real warning sign of imminent crisis was the increasing estrangement between Madhava Rao and Ayilyam. Discreet and tight-lipped, Madhava Rao did not encourage gossip about his standing with Ayilyam Thirunal but by 1871,

the Dewan had made it very clear that he did not appreciate how carelessly he was being treated by the Maharaja. If anyone asked him his plans, he told them that he was planning to retire very soon and settle in Madras.

This was the Thiruvananthapuram that Ravi Varma returned to, after completing his pilgrimage to the Mookambika Temple. Being an admirer of Kerala Varma and related to him by marriage, Ravi's loyalties lay with his brother-in-law, but he tried not to make his politics too obvious. Alongside these political rumblings was the hostility of Ramaswami Naicker who, it is rumoured, was consumed with jealousy when Ravi Varma was awarded the Vira Singhala in 1870. After the episode with Theodore Jensen, Ravi was very much Naicker's equal in terms of reputation, and there were many who didn't shy of openly declaring the younger man to be Travancore's finest artist. The haze of intrigue that enshrouded the court in Thiruvananthapuram offered Naicker the perfect setting to spread rumours about the young man, with the intention of bringing him down a peg or two.

To those of Thiruvananthapuram's elite that he knew, Naicker slyly posed some leading questions. Wasn't it strange that of all the palace artists, it was Ravi Varma who was awarded such a prize, and that too for a second version of a portrait he had already made? Perhaps it was because he was so close to Nagercoil Ammachi? Was it true that Nagercoil Ammachi had herself come to Moodathy Madham, Ravi's Tiruvanthapuram residence, to tell her favourite he was being given this honour? But then, there was nothing unusual about Nagercoil Ammachi going to Moodathy Madham, was there? It was but expected from a muse, after all. These were dangerous rumours to float, especially at a time when Ayilyam was viewing everyone around him with suspicion. Ravi would have relied on his closeness to Ayilyam to ensure his position in court wasn't affected.

It is extremely unlikely that there were any illicit relations

between Ravi and Nagercoil Ammachi. It would have been too much of a risk to take. However, it is possible that the young man may have been a little besotted by the royal consort. He wasn't alone. Nagercoil Ammachi charmed everyone she met, with both her wit and her beauty. In a male-dominated society, she was one of the few women who enjoyed a certain degree of power and influence. With Ayilyam's encouragement, she played an important role in Thiruvananthapuram's cultural revival. She organized regular literary soirées, where audiences discussed poets as varied as Kalidasa, with his strictly structured Sanskrit verses, and Hafiz, famed for his lyricism in Persian. Although Ayilyam reduced the royal patronage for Kathakali, he encouraged dances like Mohiniattam, and dance performances were held regularly for invited audiences.

The royal court, under the auspices of the royal couple, was in fact, buzzing with culture, just as it was with political intrigue. Ravi Varma's evenings in Thiruvananthapuram were not spent in the quiet of Moodathy Madham, but at concerts, dance performances, and parties thrown by both Travancore's aristocrats and the senior British officers stationed in the kingdom's capital. At one of these parties, a man came up to the young artist and spoke with him for a few minutes. The man expressed admiration when he learned that he was indeed speaking to Ravi Varma, the acclaimed artist. Shared acquaintances were listed. Meanwhile, the party milled around them. British dignitaries shared pleasantries with native princes. Liveried waiters carrying trays of drinks and tender coconut water mingled in the crowd.

One of them appeared in front of Ravi and his companion. Before Ravi could say anything, the other man had picked up two pretty glasses from the tray and was holding one up to the artist. Already something of a veteran of Thiruvananthapuram despite his youth, Ravi politely enquired what he was being offered. It had probably been a sherry. All we know now was that it had been

an alcoholic drink. Ravi Varma declined. He explained that he meant no disrespect, but he didn't drink alcohol. His companion expressed surprise. He said that he seemed to recall having seen Ravi at a number of parties; surely Ravi could not be a regular at these gatherings and be a teetotaller? By way of answer, Ravi said that he found tender coconut water very suitable. This made the other man laugh. So that was all the celebrated artist could handle, coconut water?

For what seemed like an interminable time, Ravi Varma found himself being trailed by this gentleman, carrying the two glasses of alcohol. He inserted himself in conversations that Ravi would join in the hope of eluding him, and found some way of bringing up the topic of the drink he was carrying. If Ravi Varma could drink fruit juices, then surely he could partake of a wine or sherry, or even whisky, for they were essentially fermented juices? Didn't the myths suggest that our gods drank alcohol? Why was Ravi so nervous of simply trying some? Surely he was not afraid of alcohol?

He followed Ravi with the dogged persistence of the intoxicated, and it was rather amusing for the others at the party to watch an increasingly embarrassed Ravi trying to first shake him off and then ignore him. Then it finally happened. When Ravi told him that he didn't drink because he was a Brahmin, the drunken man asked whether Ravi had not already violated the code of his caste by becoming a painter, that too one who painted like the seafaring Europeans. There followed a brawl, the only one Ravi is known to have ever engaged in.

It seems ridiculous to have a fight over such a minor issue, and there is no doubt that Ravi overreacted. But he wasn't reacting to only being offered a drink. It was the assumption that he was espousing European values because he painted in their style, using their paints, that Ravi Varma was attacking. Earning the praise of the colonial government was highly regarded but adoption of their

ways was unacceptable and often ridiculed. When Runganada Sastri, a judge in the Madras court, known for his expertise in Sanskrit, Latin, Arabic, French, and English literature, began wearing Western clothing, he was jeered at and derided by Madras society. It's possible that Ravi Varma thought the man who was following him around at the party was mocking him and questioning his character, which was already under attack thanks to Naicker's rumour-mongering. He had no way of shutting up Naicker without attracting more attention to the elder man's snide comments. Reputations, after all, could be repaired. When it came to a man disparaging his identity, however, perhaps Ravi Varma felt the need to be less diplomatic.

* * *

In 1872, Ayilyam Thirunal decided it was time to take action and bring his court into order. Madhava Rao was dismissed from his duties as Dewan of Travancore for colluding with critics of the Maharaja and fanning flames of dissent in the royal court. Kerala Varma was declared a traitor and was placed under house arrest at his family palace in Harippad, Alleppey. His supporter, Ravi Varma was not charged or arrested—perhaps having Nagercoil Ammachi's favour had helped, after all—but was told to leave Thiruvananthapuram immediately.

It was a grim time for Mavelikkara, with one of its adopted princes under arrest and another disgraced. The royal family of Travancore couldn't reject Sethu Lakshmibai because without her, there would be no heir to the throne after Vishakham Thirunal. At the same time, her husband's actions meant she was no longer welcome in Thiruvananthapuram and preparations were soon underway for her to return to Mavelikkara. There would have been worried whispers in the royal family about how Lakshmi must be treated in Thiruvananthapuram. She would have been suffering poisonous vibes from other members of the family, who

would hate the fact that it was the traitor's wife that the house of Travancore needed to continue the monarchy.

When her husband came back from Thiruvananthapuram, shamed, it is very possible that Bhagirathi would have felt a guilty spark of hope that perhaps the goddess had returned her husband to her through this misfortune. She was a few crucial years older. Since she was the mother of their first child, a girl called Mahaprabha, by the end of the year, Bhagirathi must have been at least fifteen. Ravi also began building a studio in Mannoor Madham. It was just a room that he was building, but it would have indicated permanence to Bhagirathi. She would have seen the studio as a sign that the charms of the outer world were now out of reach and he wasn't chasing them. He was making her home in Mavelikkara his home too. She probably didn't know how desperately Ravi wanted to shut out the whole world and paint his way out of this suddenly awry world he was in.

It was a simple, large room that Ravi built in Mannoor Madham, and choosing to build it now may have been a subtle show of support for Kerala. It proved he was not going to distance himself from his friend's family, even if they were facing royal displeasure. Over the years, it would eventually be built up into a two storey studio. Inside, he could surround himself with something that he could control and do well: his painting. When he entered the newly finished studio and shut the door behind him, he was able to put a wall between himself and the uncertainty that seemed to fill Mannoor Madham. Desperate to bring himself out of this quicksand of despair, Ravi Varma sought as his lifeline the things that had brought him comfort in his childhood: Hindu legends and art.

On the other side of the door, Bhagirathi returned to living her life just as she had when he had been in Thiruvanathapuram. As was the practice of old joint families, there would have been elder women who would have offered her advice and comfort,

especially when it became clear that Ravi wanted to spend almost every waking hour in the studio. They would have tried to explain to her that Ravi's being in the studio was like a hurt animal licking its wounds in secret. They must have told her to be patient and pointed out how much luckier she was than her elder sister, who didn't know how long her husband would be incarcerated and if she would ever see him again.

Far away in Alleppey, Kerala Varma's reaction to his arrest was much like Ravi Varma's. Barred from leaving his family home of Ananthavilasam Palace, Kerala spent all his time writing, and one of the poems that came out of that time was *Mayura Sandesam* (*The Peacock Messenger*). Modelled on Kalidasa's poem *Meghadootam* (*The Cloud Messenger*), Kerala's poem shares the same theme as Kalidasa's: romantic longing. In *The Cloud Messenger*, a yaksha banished from Indra's court begs a cloud to carry a message from him to his beloved. Kerala, however, wrote the poem with charming openness. There were no subterfuges or metaphors to hide the fact that this was not just the poet speaking but the work of a melancholy, lovelorn man, miserable at being parted from his wife. He described his feelings candidly and painted a portrait of Lakshmi as a delicate, heartbroken lover, helpless in the face of events that were beyond her control:

Tired then of singing and with thoughts of me
She throws her toilette off in broken glee.
And after painful sobs and deep drawn sighs,
Towards the sofa and my portrait hies.
She hath, in sorrow, drawn this for her ease,
She sits and views it, hoping it will please.

No doubt, with diverse kinds of work to do,
And with her innate mental courage too,
Backed up, she spends the daytime in a way;

But then the night—Ah! What am I to say?
How could she bear this parting? Will the sun
Set and the lotus lake be not undone?

Hoping to see this victim of all woe
At least in dreams, his wife doth slowly go
To lie upon a grass mat; but on her
No wink of sleep those angry fates confer.

…Pray thou meekly then
Address that pride of earthly queens again,
'Fairest of creatures! He, thy husband, there
Leans on thy love to soothe his growing care:
And prays to Skanda's holy feet to shower
On thee his blessings in this trying hour.
He doth embrace thy golden-coloured frame
And feels relieved in fancy's faithful name.
With face all stained with constant drops of tear,
Thy loving husband bides thee health and cheer.
That thou shouldst live in health and strength of heart
Is what he prays for, princess, all apart.*

Ravi Varma painted a portrait of Sethu Lakshmibai in the late 1880s. It shows a heavy-set woman with a determined expression and regal bearing. Jewels cluster around her ears and her neck, and on her fingers. In her hand is an English book. She looks like a woman whose authority no one would dare to question, and it is very difficult to imagine her throwing herself upon a sofa and heaving 'painful sobs and deep drawn sighs'. There is one portrait

* This translation of Kerala Varma's *Mayurasandesam* (*The Peacock Messenger*) is from *Modern Indian Literature, an Anthology: Surveys and Poems, Volume One* (Sahitya Akademi, 1994).

of Bhagirathi, believed to be painted by her and Ravi's son, Rama Varma. She appears to be much prettier than her sister and there is a certain softness in her expression that makes her seem more caring and fragile.

Romantics may find hints of her features—the eyes or the full cheeks—in the women Ravi Varma painted but the faces are quite distinct, and while other family members, like his brother and his daughter, showed up in his paintings, Bhagirathi didn't. He didn't fashion her face into that of a goddess or mythic beauty as he did with so many women he saw. She barely even figured in his conversations. In later years, everyone accepted that Bhagirathi existed on the periphery of Ravi's life and most attributed this to the nomadic life the artist led, thanks to his many commissions. But at the time when they were a young couple, their relationship may well have kept the ladies who liked gossiping busy, especially with Kerala's unabashed romanticism acting as an obvious contrast to Ravi's demeanour.

–*Did you see that painting Ravi just finished, the one he says he is taking to Madras for some competition?*

–*No. Why?*

–*There's something in that girl's smile that reminds me of someone.*

–*Everyone seems to see glimpses of people they know in the faces he paints.*

–*I've heard the maids tease that girl Susheela because she says he asked her to come into his studio and lie down so that he could draw her.*

–*A maid? Really?*

–*Who can tell?*

–*It could be.*

–*You know, now that you mention it, I think that might be whom the painting reminded me of.*

–*Since when did you start believing the rubbish gossip of the servants? You know the kind of nonsense they say most of the time.*

–I just think it's curious that we find glimpses of maids, cousins, and other women in his paintings but not a hint of his wife.

–She's his wife! Of course he wouldn't put her face on a painting and show it off to the whole world! Imagine a crowd of strangers seeing her. Just like that! If he did paint her, you'd then have another hundred stories to spin about him.

–Stories! I've made up no stories! All I said is that there's something strange about those two, especially considering his interests—

–Interests? What does that mean?

–He paints women. Beautiful women. So? She's had a child by him, hasn't she?

–All he seems to want to do is get away from his wife, that's all I'm saying. There's Kerala, writing such romantic letters and poems to Lakshmi even though they are many years into their marriage. And then there's Ravi, painting other women and scuttling off to Thiruvananthapuram one day, Mookambika another day, Madras yet another day.

–Perhaps there is another sambandham that we don't know about. Or perhaps a mistress?

–See, this is what I mean when I say you all spin stories. He only travels for his painting. It's work for him.

–He's a prince. Why does he need to work?

–Kerala worked too. He's a prince but he chose to work when he was made a member of that committee by the Maharaja. It's the same for Ravi.

–Why is he going to Madras now? That's got nothing to do with the Maharaja.

–I'm telling you, there's some other sambandham that we don't know about.

–You're all mad and you have too much idle time on your hands. Now, finish this quickly. Enough of all this nonsense.

* * *

When discussing the story of modern Indian art, historians often attach great importance to one event in 1871: the Governor of Madras, Lord Napier's address to the Native Christian Literary Society of Madras. In it, he spoke highly of the possibilities that Indian mythology provided to aspiring artists in India. '…how vast a field is opened for an indian pencil,' he said. 'The form of Indra, with his attendant breezes hovering over the famished plains of Hindustan, might surely more than rival the triumphant flight of the Italian Aurora with her galaxy of Hours…All that is needed to promulgate their beauty and complete their fame is that in their purer and nobler passages and with the powers of European Art, they should engage the service of the national pencil as they have fastened on the national memory and animated the national voice.'

The reason this speech excites so many is that unwittingly Lord Napier had predicted what Ravi Varma would go on to do in a few years. Just as Lord Napier suggested, India's first modern artist took inspiration from the Mahabharata, the Ramayana, and other Hindu myths; his canvases captured scenes from everyday life. They were prettified, perhaps, but they were also accurate. Ravi Varma's oeuvre makes it seem as though the artist had been sitting in Madras and taking notes while Lord Napier spoke.

The two men must have met before. The Governor visited the capital of Travancore on many occasions, and proof of his popularity with the ruling set is the Napier Museum of Art and Natural History that was built in Thiruvananthapuram in 1874, two years after Napier left India. It is possible that he met Ravi Varma and perhaps even shared with the young man his belief that Indian art would benefit from a break from its classical roots, that it had become too cloistered within its traditions and needed to reconnect with the people and the lives they lived.

Napier's words found expression in the works that Ravi Varma began to produce in the shelter of Mavelikkara. There

were no distractions of court life here. There might have been a new urgency to his work because he needed his art to redeem his reputation. He had not become part of the court because of his political acumen but because of his artistic talent. He knew that the only way to lift the shroud of disapproval that had been placed over him was by reminding the Maharaja that he was an artist, not a politician.

In the months he spent in Mavelikkara, Ravi focused all his energies into his paintings and the works showed the artist as having gained significantly in confidence as well as technique. He painted some exquisite women during this time, the most famous being 'Nair Lady Adorning her Hair with a Garland of Jasmine'. That particular beauty won him a gold medal at the Madras Fine Arts Exhibition of 1873, an event that was organized annually by the Madras Fine Arts Society.

The art societies in India were begun by British officials and they originally showcased paintings by amateur artists, often the wives of senior British bureaucrats. In the pre-1857 period, when India belonged to the East India Company, there was a degree of interest in creating a set of Anglicized Indians. Appreciating Western painting and sculpture was part of this project, and art societies played an important role here. They began informally and were made up largely of East India Company officials and their wives and relatives. Soon, Indian artists began forming similar collectives, like the Brush Club of Calcutta which was established in 1839. These were active and enthusiastic but were not much more than a meeting place for like-minded people. In the 1860s, the Madras Fine Arts Society became the first of the British groups to become an organized society, with an annual exhibition and prizes. Similar societies were set up in other parts of the country, including Simla, Bombay, and Calcutta. Their first exhibitions showcased paintings made by skilled but amateur painters and had few Indian participants,

particularly in Madras, because the local art school focused on craft traditions. Also, it was expensive to travel distances and the strictly stratified society was a barrier that few Indian artists could vault over. These exhibitions were exclusive affairs and on some occasions, artists from Britain participated. Senior officials like Lord Lytton, the Viceroy, who was a favourite of Queen Victoria herself and well known for his arrogance, often sent paintings. Stringent standards were set for Indian artists who wanted to participate, but they weren't necessarily intended to be discouraging. In fact, these art societies were part of a mission that many officers of the Raj espoused: to 'improve' the taste of the Indian populace, particularly the middle classes, many of whom were employed by the British administrative system.

The British attitude towards India was complicated. Most of the senior members of the British bureaucracy came to India to amass personal fortunes. Along with their salaries, the bureaucrats were given very generous hardship bonuses. Lord Napier, for example, accepted the offer to be Governor of Madras in 1867 because it would pay him approximately 14,000 pounds a year, which was more than three times what the English prime minister earned at the time. Once he arrived in Madras, he found it easy enough to fit in among the Indian statesmen and British officers. Although he had shown no interest in or affinity for India before coming to the subcontinent, Napier displayed a curiosity about the local culture and an eagerness to develop an imperial style of architecture that took into account the different artistic traditions of the land. While there were those who dismissed Indian culture and regarded the budding nationalism of its educated classes with suspicion, there were a few, like the journalist William Digby, who were critics of the empire and played an important role in articulating grievances. Digby was the editor of the *Madras Times* and strongly championed Indian grievances against the British administration through his articles in India and later, through

his campaigns as the secretary of the National Liberal Club in London.

In the world of art, there were teachers like Lockwood Kipling, Rudyard Kipling's father, who would, as principal of the Jeejeebhoy School of Art in Bombay and Lahore's Mayo School of Arts, play an important role in training young artists. In most British minds, there was a stereotype of the 'native artist' as one who may be an eager learner but whose work was not good enough to be considered mainstream art. Classical Indian art had its admirers, but it was mostly appreciated with a historian and archaeologist's eye. To the average British officer, the traditional art of India was mostly scandalous and lacked the subtlety and finesse of European art. The overt sexuality of temple architecture, for example, was shocking. Whatever the British discovered of ancient Indian art contributed to cementing their ideas of Indian exotica. The popular artistic forms that were still practised, like the Thanjavur style of the south or the Kalighat art from Calcutta, found few admirers. Their aesthetics were sharply different from those of Western traditions, and the prevailing opinion was that they lacked creativity since generations had been producing similar imagery. In art schools, there were distinct divisions between Western and Indian art, with the latter being studied as craft, folk, or decorative art. Only the most promising students were accepted as students of European-style painting, and their native cultural background was considered an obstacle they had to overcome in order to be competent artists. One of the most important reasons for Ravi Varma becoming such an important figure during his lifetime was that while he proved himself to be a master of Western illusionism and oil painting techniques, his training was strictly and traditionally Malayali. Ravi Varma proved that Indians could paint like the Europeans, and he did so without attending the schools that the British had set up.

Relations between Ayilyam Thirunal and Ravi Varma had

improved by 1873. The Maharaja allowed his former favourite artist back into court after a year of virtual exile and was impressed with the paintings Ravi showed him. When Ravi spoke of his desire to attend the Madras Fine Arts Exhibition, Ayilyam gave him a letter for the Dewan in Madras, K. Raghunath. It was a personal request from Ayilyam to Raghunath asking him to take care of Ravi during his stay. Raghunath was both host and interpreter for Ravi, who was still not confident about his English. The first time he participated in the Madras Fine Arts Exhibition was also the first time he travelled to the Presidency in the south.

Ravi Varma's debut was a great success. Napier's successor Governor Hobart met the artist and congratulated him on having created a beautiful painting in 'Nair Lady Adorning her Hair with a Garland of Jasmine'. The other painting, titled 'Height and Depth', showed a woman giving alms to a beggar. It was in the tradition of the salon art that Ravi Varma had seen among the albums in Thiruvananthapuram, in which virtues such as charity and mercy were allegorically realized and embodied by humans.

For all the poignancy of 'Height and Depth', however, it was the painting of the beautiful Nair that charmed everyone. Everyone stopped before the painting and marvelled at the elegant lady in the canvas. It was as though they could feel the heaviness of her thick hair coiled atop her head. She plucked gracefully at the veena and it didn't seem implausible to think that in the next moment, one would be able hear the melody she was playing. People wondered who she was, what she was playing, where the artist had found such an angelic face. And so began the love affair between Ravi Varma's sweetly smiling beauties and the adoring audience.

The curiosity about what lies beyond the image is something that Ravi Varma introduced to Indian viewers. When all one saw as art was the stuff of legends, crafted out of an artist's imagination or fashioned in accordance with longstanding

folk traditions, there was a distance between it and the viewer. Ravi Varma's canvases changed this. His paintings showed real people and feelings, even when the scenes were imaginary and the stories were mythical. People kept coming back to his paintings to marvel at how tactile his subjects were. His friends and acquaintances noticed the resemblances between people they knew and the painted heroes and heroines they saw. Of course he obscured the identities a little—lightening their skin by a few shades, adding a hint of lushness to the smiling lips—and there were reviewers who complained about this. But these touches only served to make most viewers more curious about who had been the inspiration for the painted figure. It was the beauty of Ravi Varma's heroines in particular, with their intriguing hints of familiarity and careful realism, that drew people to the paintings. Sir Seshayya Sastri, who became the Dewan of Travancore for a short period after Madhava Rao's departure and was one of Ravi Varma's great supporters, wrote in a letter, 'By constantly looking at your paintings, I have started admiring the pretty faces of your women.' In the letter, Sastri goes on to ask Ravi for copies of a number of paintings, including 'Krishna with Gopis' and 'Nair Lady Inside the Mosquito Net'. A painting titled 'The Bombay Singers', however, finds little appreciation and is dismissed for being only a 'social scene'.

It's a pity that there weren't too many takers for the works that didn't have romantic imagery and offered, instead, glimpses of the country at the time. Had there been less people like Seshayya Sastri, perhaps Ravi Varma would have painted more of those paintings, which, in turn, would have saved him from the criticisms that would be levelled against him within a few years of his death. Historian and critic Ananda Coomaraswamy wrote in an article for *The Modern Review* in 1907, a year after Ravi Varma's death, 'It [popularity] has, indeed, been his reward for choosing Indian subjects, that he has thus become a true

nationalizing influence to a certain degree; but had he been also a true artist with the gift of great imagination, his influence must have been tenfold greater and deeper. He is the landmark of a great opportunity, not wholly missed, but ill availed of. Theatrical conceptions, want of imagination, and a lack of Indian feeling in the treatment of sacred and epic Indian subjects, are Ravi Varma's faults. No offence can be greater than the treatment of serious or epic subjects without dignity...'

If instead of dreamy, romanticized retellings of myths and legends, there had been more social realism in Ravi Varma's oeuvre, work that documented a changing country at the turn of the century, perhaps later critics would have continued to find his work relevant. But there is no denying that Ravi Varma created the idea of an artist as one who is sophisticated, fashionable, and professional. From his first commission to his last, he always made sure he completed works on time and that they met with his client's approval. He painted that which he knew would be lauded by the elite because that, in turn, would bring him and his chosen career respect. As important as it was for him to paint, he also needed acceptance. It wasn't his only motivation, but the need for affirmation was a constant feature in Ravi Varma, almost as though he was insecure about his profession or unsure about how he used it.

News reached Thiruvananthapuram quickly and when Ravi returned from Madras, he was once again the darling of the court and hailed as Travancore's finest artist. The triumph was sweeter because Ramaswami Naicker had also sent a painting for the Mardras Fine Arts Exhibition but had not even received a mention, let alone a medal. The 1873 gold medal marked the end of Ravi Varma's subtle competition with Naicker because it declared him the undisputed winner. Naicker could not accuse the Governor of Madras of being partial to an artist whose work he had never seen before.

The winning painting of the Nair lady tying a strand of jasmine in her hair also marks the first of the controversies in Ravi Varma's career. Early biographers say that he and Naicker sent the same paintings to an international exhibition in Vienna where Ravi won a certificate of merit. Yet, later researchers have found no documentary evidence among the records and catalogues of the Vienna exhibition that Ravi Varma participated there. It seems particularly unlikely because the selection for Vienna would have been made a year before the event itself and in 1872, Ravi was not known beyond the Thiruvananthapuram court. His first exposure to the country beyond the boundaries of Travancore was through the Madras Fine Arts Exhibtion.

However, the Vienna catalogues do mention a painting by an artist whose name isn't mentioned by biographers like Ramanand Chatterjee, who was a respected critic, a personal friend of Ravi Varma, and the first to write a biography of the artist in 1902. The name is a variation of Ramaswami Naicker's, who was the court painter at the Travancore court since Ravi Varma's expulsion. He had sent a painting titled 'A Lady Playing an Indian Lute' and an ivory miniature to the Vienna exhibition. Somehow the gold medal from the Madras Fine Arts Society and the praise Ravi Varma received there were turned into the grander honour of earning a certificate from the Vienna exhibition.

Ravi had a love for fiction, particularly when it adorned fact prettily, presented him more majestically, and made everything in general more pleasing. It showed in his art as much as it showed in the way he lived his life. He was a prince, and a minor one at that. But it pleased him greatly that the British thought he was a king and he made scarce efforts to disabuse them of their notions, which is why the citation in his Kaiser-e-Hind award of 1904 names him Raja Ravi Varma. When someone questioned him about the 'Raja' in his name, he answered depending upon where he was and the company he was surrounded by. In Travancore

and other parts of Kerala, he pointed out his uncle's name was Raja and he had prefixed it to his own as a mark of respect and love for the man who was so important in his life and whom he lost in 1896. Elsewhere, he could claim to be a descendant of the Rajas of Malabar.

In some cases, like that of his name and title, it is possible to sift through his tales and cull out the facts. In many others, it becomes much more complicated to do so. Ravi Varma's first biographies came out between 1900 and 1903. They were written by people who spoke to him, to whom he provided details and facts. However, despite this, the accounts can't always be trusted because there were occasions when he told them what he wanted the story to be rather than what it actually was. It makes things difficult for those who tell his story later but it also drives home how much of a self-made man Ravi Varma was: he didn't only build his career but also much of the mythology that would ultimately surround his name.

* * *

In 1873, when Maharaja Ayilyam Thirunal invited Ravi back to court, Bhagirathi accompanied him. This was unusual. Visits outside their home were rare for a woman. A Malayali wife would visit her husband's home only a few times, in case of special occasions like a wedding, coronation, or funeral. Had Bhagirathi been known for her modernism, her move to Thiruvananthapuram may have been seen as an attempt to act upon her own desires. Perhaps that is actually what it was. Perhaps she was meant to give her elder sister, whose husband was still under house arrest in Harippad, companionship. Perhaps Ravi asked his young bride to come with him to sample the life he so enjoyed. To many courtiers, the fact that Kerala Varma was shown no sympathy would have been ample proof that Ravi had Nagercoil Ammachi to thank for his own pardon. To others, neither Bhagirathi nor Nageroil

Ammachi were of any importance. Kerala was paying for his closeness to Vishakham Thirunal, while Ravi's distant relationship with the king-in-waiting was holding him in good stead.

Bhagirathi's presence may have strengthened the rumours of Ravi's infatuation with Nagercoil Ammachi. Some might have whispered that her presence was a sign that Ravi's wife felt she had to keep an eye on him. Ultimately what lingered in rumours was a curiosity about Ravi and Nagercoil Ammachi, and there seem to be no stories about Bhagirathi in Thiruvananthapuram. The couple of years that Bhagirathi spent with Ravi in Thiruvananthapuram was the longest time the two would ever spend in each other's company. Ravi did very little travelling during this period, spending most of his time working on new paintings.

Bhagirathi and Ravi's must have been a strange relationship, even by the curious standards of nineteenth century Kerala. It seemed as though the two had nothing to share and yet they did manage to build a relationship that lasted until Bhagirathi passed away. She lived mute and uncomplaining, as the wife of a protean Ravi Varma, who was the outcast, the hero, the aristocrat, and the artist, aside from being brother, son, father, and husband. It seems unlikely that she took a lover because everyone who knew her appears to have had nothing but earnest sympathy for a woman remembered only as being painfully lonely. She may have been content in Mavelikkara, surrounded by the security of convention and the companionship of family members.

Ravi and Bhagirathi were married for a little less than thirty years. They had two sons and three daughters. After Bhagirathi's death in 1891, Ravi did not remarry. Even though the customs of the time did not stipulate monogamous marriages, neither of them had any spouses tucked away in the villages of Travancore. But people have speculated about their marriage, both in their time and ours. Bhagirathi seemed too quiet and conventional to

be a suitable consort for someone like Ravi Varma, who seemed to draw the limelight upon him wherever he went. He attended parties, travelling across the country and making friends with foreigners, both men and women. After that short stint in Thiruvananthapuram, Bhagirathi kept herself within the confines of Mavelikkara, raising their children and remaining resolutely cut off from the world Ravi inhabited. All those who knew her felt an overwhelming sympathy for this woman who didn't seem to want or care about the modernity that her husband was hurtling towards. Everyone who met Ravi thought how much better suited he would be to the many women friends he had, like Miss Sabina, the Italian photographer who had set up a studio in Hyderabad and took pictures of the women in the Nizam's zenana. So people talked and over the course of a century, their concerns changed.

In today's world, where monogamy is not only the norm but also the law, all speculations are about Ravi Varma's fidelity. It is perhaps the only aspect of Ravi Varma's life that still excites people: the idea of a painter who lived a bohemian life among mistresses and courtesans, unlike our contemporary artists who paint and live with the same discipline as a salaried breadwinner in a middle class household. The tales of Ravi Varma's libido got wilder with the passing decades. It began with him having a couple of 'muses', and by the twentieth century, he'd become a veritable Indian Casanova. The label would probably have mortified him because flouting social norms was not something he had ever wanted to do. Rebellion was not natural to him. He spent all his life trying to ensure his one rebellious act—the decision to become an artist—got social sanction and respectability.

In Ravi Varma's time, it was par for the course for aristocrats to have mistresses and frequent courtesans. What was much more scandalous was the fact that Ravi wanted them to be his models for canvases. His sketchbooks show quick drawings of a range of faces, both men and women. His library at Kilimanoor

had a vast collection of photographs, mostly of women. Many were photographs of nude European models in classical poses, taken expressly for artists to use as references. But there were also photographs of people whom Ravi knew:friends, their daughters, courtesans, prostitutes. Even his brother Raja had to go in front of the camera. On one occasion, he did a credible imitation of a woman reclining elegantly on a divan, that too in a sari. They all surfaced in Ravi Varma's paintings: sometimes in fragments and sometimes in entirety. There were some early critics who complained that the women in many of Ravi's paintings had awkward and unrealistic breasts. Raja Varma's photograph may be a clue as to why it took Ravi a little longer to render the female breast with the same realism that he was able to bestow upon faces from an early age. Of course, if the rumours of him having pounced upon unknown and unsuspecting women while on his travels were true, then one imagines such a criticism could not have been levelled against him.

* * *

The Madras exhibition had been Ravi Varma's greatest success, and it had also shown him what kind of work other artists in India were doing. Next to their landscapes and tentatively drawn figures, Ravi Varma's paintings stood out not just for their realism but also for the subjects he chose. The people in his paintings looked like they really existed, as though a room from a home or a street corner had been brought into the hall where the exhibition was held.

In 1874, he sent three paintings for the Madras Exhibition. One of the paintings showed two elephants playing in a pond. The other two paintings were of women. In one, a Tamil woman played a now-forgotten instrument called sarabat, which was Ravi's brother Gode's favourite. The other was titled 'A Nair Lady Playing the Veena'. For the second time in a row, Ravi

Varma won the gold medal, a rare achievement. He would create a record when he would win it again in 1876 for 'Shakuntala Patralekhan'.

'A Nair Lady Playing the Veena' charmed everyone. Ravi Varma had created, in that nameless woman, the epitome of south Indian beauty. People were unable to walk past it without lingering. Their gaze was drawn to her eyes that looked hopefully into their own. A gauzy material covered her shoulders, in deference to Western notions of modesty. Her fine-boned wrist was draped elegantly on the curve of the veena. In 1875, when the Prince of Wales visited India, Ayilyam Thirunal visited Queen Victoria's heir in Madras. Among the gifts he gave the prince was an album of pictures of which one was 'A Nair Lady Playing the Veena'.

The Prince of Wales spent a year travelling through the Indian subcontinent. He arrived at the port of Bombay on October 11, 1875. After spending a month in Bombay, he travelled by train to Pune. It was his first train ride in India, and William Howard Russell, his private secretary, noted in his diary that His Royal Highness was most impressed by the 'bandobast' even if the train did leave one and a half hours late. The royal entourage was most impressed by Indian hospitality and the grandeur of the kings, like the Gaekwad of Baroda who welcomed the prince with 'an elephant of extraordinary size, on [whose] back was a howdah of surpassing splendour, which shone like burnished gold in the morning sun and which was either made of gold or silver gilt', wrote Russell. 'It was covered with a golden canopy. The mahout was attired in a costume befitting such a gorgeous charge.'

From Baroda, the group returned to Bombay and set sail to Ceylon. From Ceylon, they came to southern India. At Madurai, Russell seems to have been quite overwhelmed by the welcome. 'The prince was received by the chief priests and crowd of inferior ecclesiastics who presented an address. As he, preceded

by guardians and a band of dancing girls of the temple, passed…
showers of what looked like gold dust were let fall by unseen
hands from the roof…The nautch girls scattered flowers before
him, fillets of gold and silver tinsel were placed on his brows and
arms; richly-scented garlands were brought in baskets and were
passed over his shoulders.' From Madurai, they went to Madras,
which was where Ayilyam Thirunal met the prince. Russell's diary
gives readers a glimpse of the kind of festivities that would have
kept the elite busy in those times.

'On 17th December a late-night function beyond 11 pm—the
native entertainment was arranged at the immense Roypooram
Railway Station. The station had been converted since the prince's
arrival into a vast theatre, nearly 800 feet long and 250 feet
wide, decorated with great splendour and richness. An elevated
platform, covered with a scarlet cloth and tiers of benches, was
reserved for the guests…and in the centre were gilt chairs for the
prince, Governor and ladies of his family, the authorities, and the
Europeans. The hour fixed for the programme was 10 pm and
it was midnight when the prince entered. Many thousands of
people, Europeans and Asians filled the place. When they were
seated, a deputation of native gentlemen advanced to the platform
and mounting to the dais, presented an address…and requested
his acceptance of the exquisite gold casket, on the top of which
was a finely-worked tiger, which was placed on a velvet cushion
on a small table in front of his chair. From the platform, there was
a gangway to a stage, whereon were seated the dancing girls and
musicians, the former dressed in the richest and heaviest robes of
the brightest colours. After the dances, music, and Nautch girls'
presentations, when the enjoyment had been sufficient, the prince
drove back to the Government House.'

None of this pageantry offers even the slightest hint of the
chaos that was festering in the southern parts of the country.
One of the reasons that the Prince of Wales stayed away from

Travancore, choosing to meet Ayilam Thirunal in Madras, was that the countryside was suffering a cholera epidemic. It was, however, just the beginning of the Deccan Plateau's woes. There was almost no rainfall in the region in 1876. The Madras Observatory recorded a mere 6.3 inches of rain in the entire year whereas the annual average was 27.6 inches. In 1877, there was a famine which, combined with British mismanagement, successfully wiped out a quarter of the population in the southern town of Bellary. Approximately one and a half million people were estimated to be dead in the Madras Presidency. The city of Madras was crowded with drought refugees from nearby rural areas.

The new Governor of Madras, Richard Grenville, Duke of Buckingham, had come to India in 1875. He had no idea that within months of assuming his new position, he would have to deal with disease, death, and grain riots. In a bizarre and macabre twist, all the infrastructural development in the country served to make the lives of the starving poor worse. Merchants used the newly constructed railroads to ship grain away from drought-stricken areas populated by impoverished peasants and closer to consumers who would be able to pay the extraordinarily high prices. The telegraph was used to ensure price hikes were coordinated. The raised prices resulted in people starving to death in places like Thanjavur, which were actually not affected by drought.

Buckingham realized what was happening and tried to salvage the situation by stockpiling grains in some areas and trying to convince merchants to lower their prices. However, these attempts were thwarted by Viceroy Lytton who, ensconced in Simla, did not believe the famine was as dire as journalists like Digby said it was. Buckingham was told to not interfere with market forces. Consequently, a record 6.4 million quintals of wheat were exported to Europe from India during 1877 and 1878, rather

than being used to relieve the starving natives. Meanwhile, the famine spread from the Madras Presidency to Mysore and the Bombay Deccan region. The British administration's answer was to send Sir Richard Temple, who had successfully dealt with the drought that had struck Bengal and Bihar a few years earlier. He was, then, able to forestall disaster by importing rice from Burma and ordering extensive relief work in rural areas. Unfortunately, all this had meant expenditure and Temple was criticized sharply for his actions. Consequently when he came to the south as Famine Delegate in 1877, Temple embarked on a starkly different plan, according to which relief camps gave people less food than the daily average in prisons. The starving peasants and refugees were made to work as labourers on railroad and canal projects. Temple's plan began to slow-starve the people, and the work camps came to be regarded as death camps.

Although the cruelty and ineptitude of the British administration's policies enraged many, particularly among the educated middle classes, it was also true that the famine affected the poorest. The elite read about the famine in the newspapers and the soaring prices would have appalled them, but they belonged to the section of society that could still afford to buy food. Ravi Varma was among those who did not suffer. While people turned into walking skeletons in the countryside, the city dweller Ravi was going through one of the best periods of his life. Bhagirathi became pregnant with their second child, and their first son was born in 1875 at Mavelikkara. The boy was named Kerala, no doubt after Kerala Varma. It was a gesture of support for the incarcerated prince that Ayilyam would not have missed but would choose to ignore. There were far more complicated issues at hand for the Maharaja, whose subjects may not have been suffering the worst of the famine, but were still affected by the scarcity of food and abundance of disease. For Ravi, however, these were good times on both personal and professional fronts.

The year after his son's birth, he won the Madras Fine Arts Society's gold medal for the third time and his prize-winning painting, titled 'Shakuntala Patralekhan' ('Shakuntala writing a Letter'), won him the admiration of one of the most important men in the British administration: the Governor of Madras, Lord Buckingham.

The painting was a significant one. It was the first time that a story from the ancient texts had been painted as though the characters were living and contemporary. They looked familiar, because Ravi Varma chose to dress Shakuntala and her friends in the way women dressed in the nineteenth century. Their expressions and body language were equally current. Buckingham was so impressed with Ravi's work that he bought the prize-winning painting and also commissioned Ravi to paint a portrait of his.

Bhagirathi would not have been happy to know of the commission. In fact, no one would have advised him to journey through the Madras Presidency at this time. He would have to travel by road, since there were no train connections from Travancore, and the rural areas surrounding Madras were in a terrible state even in 1878. There was a malaria epidemic and practically no fodder available for beasts of burden. *The Times* in London printed this description in July 1878: '…in the Bellary district, merchants send out their grain supplies to distant villages on carts drawn by men. The value of the labour of the human animal is so low that it is cheaper to employ half a dozen men to move a load of rice than a couple of bullocks. The men, at any rate, can be fed, whereas fodder for cattle employed on the roads is not to be had at any price.'

However, Ravi did go to Madras and he painted a portrait of Buckingham that pleased the Englishman greatly. On his way back from Madras to Mavelikkara, Ravi met Sir Seshayya Sastri in Tiruchirapalli. Sastri had become Dewan of Travancore after Madhava Rao was dismissed from the position, but he too

was unable to survive the court politics and he had soon left Travancore for the little province of Pudukottai, where he was appointed Dewan Regent. He invited Ravi to paint portraits of the royal household, an offer that Ravi accepted.

When Ravi came back to Mavelikkara, he announced he would soon be leaving again for Pudukottai, this time with his younger brother, Raja. Eighteen year old Raja, who had recently married into a respected but not princely family of Mavelikkara, was to accompany Ravi as his assistant. Those who knew the artist would have known this wasn't a sudden move. Ravi and his brother had shared a close relationship since their childhood together in Thiruvananthapuram. The fact that Raja was married into a Mavelikkara family, so ensuring that the brothers remained close by even after marriage, was proof that the relationship had not weakened as Ravi grew into adulthood. He was also Raja's art teacher and always praised the younger man's artistic talents. It is likely Ravi realized, after painting Buckingham's portrait, that he needed someone to help him with the paintings, particularly the larger ones, to ensure he was able to finish them within a few weeks rather than months. Raja had been his brother's de facto assistant for the past few years. He helped draft his letters, particularly after his brother's success in Madras, and was the one with whom Ravi discussed art most candidly.

It may seem a little odd that Ravi Varma was so eager to leave his newborn son in order to take on a commission at a time when the neighbouring states were all crawling their way out of famine, even though there wasn't any shortage of money. But the responsibilities of fatherhood were not among a man's priorities in the nineteenth century, particularly in matrilineal societies where the children belonged to the mother's family. The ambitious and restless Ravi had been given a taste of fame beyond the royal court and this made the idea of being tethered to his home frustrating. There was an entire subcontinent that stretched

out above the northern boundary of Travancore, and he wanted to establish himself there. They knew of him, thanks to the Madras Exhibition whose results were written about in most newspapers. To be remembered by those who had only heard of him and not yet seem his works, Ravi knew he had to step out of the confines of Travancore. The Duke of Buckingham and Seshayya Sastri's invitation to Pudukottai were the first steps.

* * *

The trip to Pudukottai in 1878 was Raja's first important journey. It wasn't just a matter of distance but the fact that this was a professional trip. He was accompanying his elder brother, his Chetta, to Pudukottai. They were going not just as brothers but as a working pair: Ravi Varma, the celebrated artist, and his assistant C. Raja Raja Varma. Of course, not everyone had been as thrilled as Raja when Chetta decided to take him as his assistant. Their other brother Gode, for example, had sounded very hesitant and their uncle too seemed to be unsure of the wisdom in this decision. 'He's just got married,' their uncle said and questioned how staying away for four months would be received by his wife's family. Their mother voiced concerns about his health, reminding everyone, though they needed no reminders, that Raja had to be careful about what he ate. But ultimately, the charm of Ravi Varma, which everyone in Thiruvananthapuram knew all about, won over everyone. Raja's wife Janaki cried a little, but her family gave him their blessings. His mother sent them a bundle with a variety of her Ayurvedic recipes, one for every health crisis she could imagine. Bags and boxes were packed, servants were arranged, carriages were ordered, and finally they were off.

Years later, when travelling from the south to the north of the subcontinent had become more common, Raja would remember how that first journey to Pudukottai had seemed to go on for a lifetime. For the first few hours, every tree and every face on

the road would have seemed worth sketching. The worst of the famine was now over but hunger was still widespread. People who looked as though they were made of sticks sat in clusters. There were few fields that were not empty. The brothers held on carefully to the food they had carried from Mavelikkara. It was simply foolhardy to eat or drink on the road. Time passed slowly, despite the efforts of the carriage driver, and Raja must have been exhausted at the end of each day.

When Pudukottai finally arrived, it proved to be a chaotic little town without the basics of town planning. Yet the palace was a haven that allowed the brothers to shut out the landscape they had seen on their journey. Seshayya Sastri welcomed the brothers warmly, and Raja saw for the first time what it meant to be Ravi Varma, the artist. A dinner was organized the day they arrived, at which important members of the court were all in attendance. It was not the first party Raja had attended, but it was his first time at a banquet thrown for Ravi Varma. It was a novel experience for the elder Varma too. Everyone knew of him, and they greeted him with the kind of respect that was shown to kings.

Raja grew up to have little fascination for banquets and social gatherings, unlike his elder brother, but as an eighteen year old, he must have been quite excited. People not only knew Ravi Varma was an artist, they also knew of his paintings individually. One admirer came up and told him he had seen 'A Nair Lady Playing the Veena' at the Madras Exhibition and so strongly had he been drawn to that charming heroine that he returned to the painting again and again. Another gentleman said he thought 'Shakuntala Patralekhan' was even more beautiful than the portrait that Kalidasa painted with his poetry. It turned out that the painting was going to be used as the cover for a translation of the Shakuntala legend by Monier Williams, a noted scholar of Sanskrit in England, so now the painting would become familiar to England too.

In the four months that they spent completing the portraits of Pudukottai's royal household, there would be many such dinners and invitations to concerts and dance performances. The reigning king Ramachandra Todaiman was known for his extravagance, which, in matters of administration, was a source of frustration for Seshayya Sastri, but it did make the brothers' stay in Pudukottai very pleasant.

The Pudukottai commission was the first time Raja saw his brother work closely. It was like being an apprentice. Raja was given certain sections of the background to paint while the figure itself was Ravi Varma's job. Raja watched how his brother used the canvas, decided where to place the subject, and what elements he added to the scene to make the portrait more attractive. He marvelled at how swiftly the face and body was sketched, each day turning closer and closer to their real counterparts. He learnt to show how light played upon surfaces—cheeks, stones, folds of cloth—at different times of the day. Ravi liked the light that fell softly upon the face—morning light softened by his brush as though there was a curtain to dull the sharpness of the rays. The idea of the portrait was not necessarily to depict reality but to paint something in a manner that seemed realistic.

It may have bothered Raja that they painted nothing of the sadness they had seen outside the palace. He might have perhaps asked his brother why he didn't paint more social scenes. Raja was one of the few people with whom Ravi did have such conversations. The answer, however, was not complicated. They had been invited to Pudukottai to paint portraits that made their subjects admire themselves. Few wanted to see real things on canvas. Paintings like the one of a woman giving alms were admired, but they were not popular. No one wanted to be forced to see scenes that pricked at their conscience. Fortunately though, Ravi would have pointed out, they had myths and legends to depict in paintings. He treated them almost like social scenes and

when he watched the world around him, he looked for images and moments that could be used for one of those paintings. A mother dragging an unwilling child away from his playmates could become the starting point of a painting showing Harishchandra's son being taken away from him, for example.

Ravi Varma focused mainly on portraits until 1880, but it was already clear to those who followed his work that there were three kinds of paintings he was interested in. There were the portraits, which showed his mastery over oil paints and the European style of academic realism. The fact that he was able to achieve this proficiency without attending any art school made him something of a hero. Indian critics like Ramanand Chatterjee emphasized his traditional upbringing, because it countered all British officials' statements dismissing Indian culture as backward and naïve, like the infamous minute by Thomas Babington Macaulay rubbishing classical Indian art and literature.

Ravi Varma's paintings of beautiful women straddled a category between portraits and 'social scenes', which were based on reality. In 'social scenes', he showed things he saw around him: stables at palaces, gypsies begging on the streets, classical musicians, a student working by the light of a lamp, and standard images of people like the painting titled 'The Jew'. By this time, Ravi had also begun work on a few mythological works that retold episodes from Sanskrit epics and Hindu legends. Using these old stories as the basis of paintings was not a novel idea. Generations of Indian artists had followed this path, but Ravi put a new spin on it. First, he picked moments from stories that were high on emotion. As art historian Partha Mitter put it, 'past history [was] imagined as present melodrama'. This was the novelty in Ravi Varma's paintings, and his audiences loved it. He combined the techniques of European salon art and used them to depict recognizably Indian scenarios and characters. It was the perfect narrative language for the times.

111

The bulk of India's intelligentsia and elite prized Western education and liberalism. The same education and liberal ideology also enabled them to view the British administrative policies critically and develop a sense of solidarity with other Indian states under British rule. The agenda for the nationalist project was to establish a new Indian identity that acknowledged its past proudly but was also in step with the modern, liberal philosophies of the West. Until the backlash against European academic realism in the twentieth century, Ravi Varma epitomized this blend of cultures, in both his person and his art.

Ever since E.B. Havell, the principal of the Calcutta School of Art, accused Ravi Varma of a 'painful lack of the poetic faculty', in the early twentieth century, modern critics have found more and more reasons to dislike Ravi Varma. His paintings are seen as too mannered, too Hindu, too literal, too melodramatic. They are seen as too eager to pander to an ideal of Indian exotica and disconnected with the turbulent reality of the times they were painted in. However, his paintings of beautiful women remain favourites among viewers and even those inclined towards the avant-garde grudgingly accept that his voluptuous and sensual heroines remain eye-catching even in today's, age of Photoshopped perfection.

Considering how Ravi Varma scoured the cities in which he lived for models, these women may have had their real counterparts, but what we see on the canvas today is a blend of varied inspirations and references. The French neo-classical style is the most obvious, and one that Ravi Varma freely admitted he admired. But there are other hints. The transparent fabric covering the breasts, for example, are reminiscent of the saris seen in Kalighat paintings, in which the curve of the breasts is pronounced under the thick bold line denoting a sari's border. Painted theatre backdrops inspired the scenery in Ravi Varma's canvases, and in later paintings, like the one of Damayanti with

112

the swan, the influence of the theatre can be seen in the pose Damayanti strikes. Ravi would pick up details from different traditions, like the way a scene was framed or how lovers held each other, and he managed to fashion a style by fusing it all together.

In the nineteenth century, people were just beginning to respond to the idea of belonging to a country called India, rather than regions and kingdoms that had their own distinct identities. The Tamil lady was not to be confused with the Nair lady or beggar woman from Hyderabad. Even if they belonged to neighbouring lands, colours changed with the language, as did the preferred fabrics and the weaves and patterns they sported. Ravi Varma was trying to present these women in a manner that paid tribute to the portraits that the masters of Western art had painted, and use their ideals of beauty to create a mould of what would become the traditional Indian belle.

So he draped them in their saris but in such a way that the bodies, copied from photographs of European models and painted nudes, were clearly suggested. The white saris of Kerala were easy to turn almost transparent. With heavier and darker fabrics, he had to paint them wound around his women in such a way that they were contoured attractively without being obvious. This caution was considered modern rather than prudish. What all the women Ravi Varma painted had in common was their expression. Their faces were filled with a demure sensuality. If they weren't heroines from tragic episodes of a Hindu legend, they invited the viewer closer with their shining eyes and lips parted in a gentle smile. And the viewers came in hordes, both Indian and British. These were the beauties that were rarely seen on the roads upon which carriages and horses rode. They were generally hidden away, from foreigners in particular, but thanks to Ravi Varma's wand-like brush, they seemed to be conjured before them. The frame became a door into their world, and all those who stood before Ravi Varma's paintings ogled greedily.

* * *

In May 1880, there were many prayers offered at the temple in Mavelikkara. Maharaja Ayilyam Thirunal had just died and his brother Vishakham Thirunal finally ascended the throne. And at last Kerala Varma was released from house arrest in Harippad. Vishakham Thirunal was forty three years old and had been waiting to become Maharaja for years. Despite Vishakham's past support of Ramaswami Naicker over Ravi Varma, it was the latter who was invited to the coronation. It was an honour bestowed upon Ravi, and an indication that the new king did not intend to pursue the cold relationship of the past. Ravi must have been cautious because this coronation was, after all, the day towards which Naicker had planned for almost a decade. However, Ravi's recent successes had weakened Naicker's position. Vishakham Thirunal even granted Ravi Varma an audience and, as a sign of royal approval, asked him to make a painting of Sita from the Ramayana. The house of Mavelikkara must have thought at that point that the gods were again looking down upon them benevolently.

Trouble came with the news that the Duke of Buckingham, Governor of the Madras Presidency, now not just an ardent admirer of Ravi Varma's paintings but also something of a friend to the painter, wished to stop by Thiruvananthapuram. He was travelling north and would be making only a brief halt at the capital of Travancore, during which he would like to pay a courtesy call to Maharaja Vishakham Thirunal and the artist Ravi Varma. Etiquette demanded the Maharaja's name be mentioned first, but everyone in the court knew that the British gentleman was coming to see Ravi Varma, not the Maharaja.

All of Thiruvananthapuram was on alert for this visit. The Governor of the Madras Presidency was an important man. Unfortunately, he paid scant attention to all the preparations that

had been made for him. His only interest was in meeting Ravi Varma. The splendour of the palace that had been opened up for him, its shining chandeliers, the richness of the chamber that he was being hosted in, nothing seemed to register. After the most perfunctory of greetings, the Governor asked after the painter and commented to the Maharaja that he was a very fortunate man to have so talented a prince in his land. It was all Vishakham Thirunal could do to keep his face expressionless and only tip his head politely.

A servant was sent to call Ravi into what Vishakham Thirunal had hoped would be a private audience. The seconds stretched in awkward silence while the two men waited for the painter. Buckingham, perhaps to break the awkwardness, said that he had actually wanted to see the artist's studio but was most disheartened to hear that he no longer had a studio here; Thiruvananthapuram must feel the loss very deeply. Vishakham Thirunal replied that the city, by the grace of Padmanabha, had many charms and he hoped the Governor would honour them with a longer visit during which he could sample some of them.

The Governor rose to his feet the moment Ravi's arrival was announced and went to the door to greet the artist. He did not wait for Vishakham Thirunal to rise first, as would have been the custom, and greeted the painter warmly. Then he asked Ravi to sit with them. He couldn't have known that with that one request, he had ensured that Ravi Varma would be struck out of the royal court of Thiruvananthapuram. Traditions were strong in the little southern kingdom and the old hierarchies they bred were deeply entrenched. The Maharaja was the representative of Vishnu, a divine figure. To sit in his presence was unheard of, that too on a chair that would put them both at the same level. It was unthinkable and most offensive. By asking the artist to join them, the Duke of Buckingham had suggested that Ravi Varma, a lowly prince of a minor estate, was an equal of the

Maharaja. He had also made it patently clear that he cared little for Vishakham Thirunal. Predictably enough, this incensed the newly throned Maharaja, but it was not the end of Vishakham Thirunal's ordeal.

Although he politely declined the Duke of Buckingham's invitation to be seated, Ravi did not excuse himself after the initial courtesies. Instead, he enquired after Buckingham's affairs. The two of them discussed the goings-on in the lives of shared acquaintances. There would have been an interpreter—possibly Raja, although the accounts of this incident don't specifically mention him—because Ravi was at this time still unsure of his spoken English even though he understood it well enough. With the interpreter's help, Ravi replied in gregarious detail when he was asked about the paintings he was working on. All the while, the regal chairs that had been arranged in the salon stayed empty and the three men remained standing. Since Ravi Varma was standing, the Duke of Buckingham too remained on his feet and the Maharaja was compelled to do the same, unless he was prepared to make a scene. And with every passing second, Vishakham Thirunal's gout-swollen joints protested ever more painfully. Then came a small procession of paintings because, as Ravi Varma said, the Governor had after all taken this exhausting trip to see his art, so this was the least that Ravi could do.

Why, despite knowing of the Maharaja's affliction, Ravi chose to keep him standing is a mystery. He didn't discuss it with anyone and some said it was the inclination for mischief that he had had as a boy that made him throw caution to the winds that day. It was a complicated etiquette call because Ravi had to choose between his own Maharaja and the colonial government's representative. Buckingham would not have been pleased if Ravi had in any way made it seem as though the Governor was in the wrong. It seems Ravi chose to please the more powerful man. He was one up on the Maharaja and he decided to savour it. As

Vishakham Thirunal stood there, listening to the two men chatter cheerfully about trivialities while his legs stiffened with pain, he must have wished fervently that Ravi Varma could be swallowed into the bowels of the earth—just as Sita had in 'Sita's Ordeal', the painting he had asked Ravi to paint for him. Finally, possibly at a time when Ravi calculated Vishakham Thirunal's legs must be ready to give way, the painter politely took the Duke and the Maharaja's leave.

It was an enormous scandal in Thiruvananthapuram. The Duke of Buckingham couldn't have known that one innocuous invitation to join a meeting could blight Ravi's life, but the life of a minor prince like Kilimanoor revolved around the court. Should the Maharaja choose to exert his authority, he could control his subordinate princes' every action: where they could go and whom they could meet. Ravi Varma was no stranger to royal whim. A similarly impulsive royal decision had made it possible for him to become an artist, and another such had led to temporary exile.

Unlike Kerala Varma, who was a royal consort thanks to his wife, Ravi Varma had no muscle power with the king. The house of Travancore needed Kerala and Sethu Lakshmibai to continue the royal line. Ravi had no such leverage, but he did love the trappings of power and the aura of royalty. He cultivated hobbies and habits that were considered kingly, like using snuff and collecting elephants, which he kept in Kilimanoor since they were associated with royalty. Perhaps he did all this to mask his insecurity at belonging to a small estate that was wealthy enough to keep its people comfortably but had nothing extraordinary in terms of riches or connections to make it stand out in the court. It could also have been a touch of overconfidence. Kilimanoor had a long history but at thirty two, Ravi Varma was already its most illustrious son. Unfortunately, he was also becoming its most infamous progeny.

The furious Vishakham Thirunal declared Ravi Varma persona

non grata in all Travancore territories for as long as he was king. He sold 'Sita's Ordeal' to Sir T. Madhava Rao, who was now the Dewan of Baroda, when he came visiting a little after this incident. The Maharaja also gave away to his old tutor the Ravi Varma painting titled 'Nair Beauty'. It was as though he wanted to erase the memory of Ravi Varma from the house of Travancore.

The adulation of the past years evaporated swiftly. Thiruvananthapuram had become hostile again. Some advised him to apologize to the Maharaja. Most were inclined to agree with Ravi Varma's belief that Vishakham Thirunal would not be mollified by an apology. There was too long a history of bickering and one-upmanship between them, thanks to Ramaswami Naicker who, no doubt, was poisoning Vishakham's ears even now. Old friends urged him to leave the capital, and Ravi realized there was nothing else for him to do. How he must have regretted that fit of arrogance that had made him stretch out the meeting with the Duke of Buckingham at the moment it struck him that he would not be able to return to the city for years, perhaps decades. He had spent most of his life in this city, and he loved its brightness and energy.

There was also the crucial question of where he would go from Thiruvananthapuram. Inviting the Maharaja's ire meant that now the entire kingdom was alienated from him. The elders of Mavelikkara Kottaram let their disapproval of his actions be known swiftly. Even though they did not say in as many words that he would not be welcome in Mavelikkara, there was a coldness and distance in them that Ravi did not miss. The family had only just recovered from the disrepute that came from having Kerala Varma imprisoned. They were not looking to return to the doghouse—certainly not for the painter consort of the third daughter, even if she was mother to his son and again heavily pregnant. Some might even have thought she would be better off without a troublesome husband like Ravi Varma.

There must have been some pressure upon Bhagirathi to enter into a new sambandham. She wasn't too old, her family was respected, and there could be no doubts about her childbearing ability. Perhaps the decision to remain Ravi Varma's wife demanded the same strength and resilience of Bhagirathi that we attribute today to those who leave husbands. Even though these details of Bhagirathi's life have not been recorded or even remembered, it's possible to get an idea of her circumstances from O. Chandumenon's novel *Indulekha*, which was published in 1889. The novel occupies a special place in Malayalam literature because Chandumenon did with words what Ravi Varma had established as his style with paints: used the European form to depict Indian stories.

Indulekha was written and structured like an English novel, but the subject was Nair society. It isn't surprising that when the novel was translated recently to English, Ravi Varma's painting of a Malabar beauty playing the veena was used on the cover. Bhagirathi doesn't seem to have had the spiritedness of Chandumenon's heroine, Indulekha, but perhaps the portrait of hers that has been passed down is inaccurate. After all, she did shift to Thiruvananthapuram in 1873, instead of letting Ravi Varma go to the capital alone. More importantly, like Indulekha and unlike the convention of the times, Bhagirathi insisted on being married to only one man. Indulekha rejects candidates who are richer and more socially acceptable than the man she loves, Madhavan, and her decision to do so is radical for the times.

Even Madhavan is unable to get his head around it. In a scene where they confess their love for each other, he admits he has trouble believing the Nair women are capable of monogamy. The system of matriliny and its stealthy encouragement of polygamy is too insistent, surely. The two have a long debate about this when Indulekha says, 'You know that I care for you. Yet you think that because kings and rich men desire me I shall go against my heart

and desire and accept one of them, right?...You think of me as such a fickle woman.'

What is unrealistic about Indulekha is the fact that she is able to say this bluntly to Madhavan. Society in Kerala leapt across a couple of thousand years between 1850 and 1900. Monogamy became the increasingly accepted practice. Men turned away from the feudal structures that had been in place for centuries and began taking up jobs, which often meant moving to cities like Madras and Thiruvananthapuram. Their wives followed and the entire family structure changed, because instead of the husband being dependent on his wife's family, he became the provider. Women were sent to schools and colleges, instead of being educated at home. People fell in love, and to make that choice of loving one person was a rebellion against the traditional set-up.

Without a more respectable man to attach herself to, Bhagirathi, who perhaps had never intended to be a rebel, found herself more and more lonely. The politics of the men generally had little to do with women, but when it was as serious as earning the dislike of the Maharaja, it extended its tentacles into the sheltered courtyards of the palace. Her decision to not marry another man would have been interpreted as taking a stand almost in opposition to the Maharaja, and it would have backed her into a corner. She was not only choosing to go against the prevailing social system of many sambandhams, but also risking her family's reputation by being faithful to Ravi Varma. The other women in the household would have pitied her, been puzzled by her, and ultimately, they would have left her alone. As wordless as she may have chosen to be, Bhagirathi must have been a young woman of much fortitude. For reasons she didn't share with enough people to be remembered or passed down generations, she stood by Ravi Varma all her life and chose to be the painter prince's wife even as he travelled across the country and little more than stories about him came home to her.

The only place Ravi could retreat to was Kilimanoor. It was the one place that would not reject him and an ancient law granted the estate immunity because in a now-forgotten battle, Kilimanoor had sided with Travancore to defeat a marauding enemy. In the past, this had meant that while the estate's ruling family could not impose taxes, it did not have to hand over taxes and earnings from Kilimanoor's lands to the house of Travancore. After the incident with Lord Buckingham, it meant Kilimanoor was one place where Vishakham Thirunal's authority was limited. Back in the house where he had spent some of his happiest years, he returned to the things that used to comfort him as a child: the drone of chanted Sanskrit verses, music, the quiet calm of his father's voice, and his mother and uncle's unwavering confidence.

But changes were setting in here as well. The elders in the family, like his uncle and his mother, were ageing. His uncle in particular seemed to retreat a little further into himself with every passing day. He said he was preparing for his vanaprastham, the Sanskrit term for retirement from worldly duties that marked the final stage of a man's life. To see his uncle so dispassionate must have been an unsettling experience for Ravi because Raja Raja Varma had been the family's driving force for years. It was his initiative, after all, that had introduced Ravi to art.

In virtual exile and surrounded by the languor of the countryside, the only thing Ravi Varma had in Kilimanoor, aside from his art, were letters. The post was one of the recent innovations introduced by the British, and like the railways, it brought the different parts of the country seemingly a little closer. Madhava Rao was now only a few days' away thanks to the post, despite being based in faraway Baroda. It was probably Madhava Rao who encouraged Ravi Varma to pursue opportunities outside Travancore.

The former Dewan of Travancore had not allowed his dismissal by Ayilyam Thirunal to act as a roadblock in his career. Even though he had said that he wished to retire to Madras after his stint with the Maharaja of Travancore, he did no such thing. Within a year of leaving Travancore's service, he had become the Dewan in Indore. For two years he held that position and then, making the best use of his good offices with the British administration and the contacts he had made during his Indore tenure, he secured the post of Dewan Regent in Baroda, where the Maharaja was a minor. The fact that a man was able to have a career, and a flourishing one, after being dismissed by the Maharaja of his native state would have been considered an amazing feat in a country that was still largely feudal. But Madhava Rao's career was proof that the old India was crumbling.

This was not the much divided subcontinent that had been bought and bartered by the East India Company. Colonialism had created a country in which boundaries like language were being increasingly dismissed in favour of shared visions and beliefs. It was still a divided country. Digby described India as a place made up of 'Anglostan, ruled by the English, in which English investments are made' and 'Hindustan, practically all India fifty miles from the sides of the railway lines'. But a few people did manage to bridge the divide and cross over from Hindustan into Anglostan.

This had happened, to a large extent, because of the East India Company's Anglicist attitude, which had encouraged Indians to acquire an English education and become part of the machinery that ran the colony on behalf of the company. This attitude changed significantly after 1857. Once India was handed over to the British government, the British administration decided to ally with the traditional landholding classes because it was thought they had displayed the power to control the masses.

Indians educated according to Western systems were considered problematic.

However, a middle class, made up of Anglicized elites that were truly bicultural, had been created and even though they were few, they were influential. These were the men who realized that the numerous little kingdoms and presidencies had shared experiences. English might have been imposed upon India as the language of governance but it, along with infrastructural projects like the post and the railway, allowed people from different cultural and linguistic backgrounds to communicate with one another. A sense of identity was being formed and the early nationalism of people like Dadabhai Naoroji and Surendranath Bannerjee was coming into its own. Ravi Varma's paintings would become a key element in this nationalist project because he was the first Indian artist who tried to bring the various milieus of India together upon one canvas.

Madhava Rao's personal success would have made him urge Ravi, who had long been dear to the statesman, to think of himself as a fêted artist, rather than as a resident of Travancore who had enraged his Maharaja. The ambitious Ravi Varma had already begun to dream of fame beyond Travancore, which is why he had submitted paintings to the Madras Fine Arts Exhibition and accepted the Pudukottai commission. Now, however, he needed to look much further because Travancore was the most powerful of the princely states in the south. To go beyond the reach of Vishakham Thirunal's ire, Ravi would have to go north. There was an entire country that was open to him.

Within months of Ravi's dismissal from Thiruvananthapuram, Madhava Rao sent a couple of the artist's paintings he owned to the Poona Fine Arts Exhibition from Baroda, on behalf of the artist. Perhaps the canny Dewan chose this exhibition because it was one in which he could probably pull a few strings and sneak in a late entry since the gold medal of the exhibition was

sponsored by the Maharaja of Baroda. It was also a convenient way of introducing Ravi Varma to the Maharaja. Rather than speak about Ravi himself, Madhava Rao knew that the seventeen year old Maharaja, who was already known for his independent thinking and would grow up to be the formidable Maharaja Sayajirao III, would be more kindly disposed to the artist if they met. So Ravi Varma made his way to Poona from Kilimanoor. On the way began his love affair with Bombay.

The quickest way to Poona would have been to take the train from Madras to Bombay and then go on to Poona. His Bombay stint couldn't have been more than a brief visit but the city charmed Ravi Varma and over the next few years, he would look for reasons to revisit Bombay. The city of seven islands was unlike any place Ravi Varma had seen before. It was a pretty city of paved roads and parks. The sea lapped against curving promenades. It had streets and buildings that stood like monuments out of a fairy story. Its roads were wide and the air was fresh with the sharpness of the fringing sea. It was a city of salons and elegance. Pretty women became beautiful when they stepped on to the stage and stood in the limelight. The city had the shine of wealth that came from its many flourishing businesses. Madras had seemed like a grand city when he had seen it for the first time but the splendour of Bombay was quite another matter.

For one, it had more people and they all lived in the city with a certain defiant determination. The port had brought in a rainbow of people: Chinese from further east, Parsis whose pinkness rivalled the British, Bene Israelis from Yemen, British, Portuguese, people from all over India. 'In a twenty minute walk through the bazaar of Bombay, my ears have been struck by the sounds of every language that I have ever heard in any other part of the world, uttered not in corners and by chance as it were, but in a tone and manner which implied that the speakers felt quite at home,' wrote a British naval officer in 1812.

By the late 1800s, when Ravi Varma first travelled to Bombay, it was a modern city of shipbuilders, bankers, and entrepreneurs. The walls of the old fort had been brought down and the seven islands had been linked. Electricity lit rooms and signs. Instead of courtesy men with large fans, breezes came from whirring blades hanging from the ceiling. Green circles had been fashioned out of empty, garbage-ridden areas. Fashionably dressed ladies and gentlemen strolled along the Esplanade. Many of the buildings were grand and new, often with Gothic spires and eerie gargoyles that were fascinating to Ravi Varma despite their ugliness, for there seemed to be such grace in their forms.

Lampposts lined the streets and in the evenings, men walked in their light and made their ways to parties, concerts, and the theatre. Carriages clattered along wide avenues that shrank into winding lanes that scuttled into neighbourhoods with neat, pretty houses and noisy bazaars. There was a man who sat on a balcony and took money to send letters to any part of India. Aside from the letter, he offered another luxury: bringing you the morning paper at your doorstep, for Rs. 50 a year. A princely sum, yes, but it was a curious luxury for the times. Trains connected the city to the cotton centres in the heart of India and these iron horses carried people who came to Bombay with hopes of seeing the world and making a fortune. Enterprise was respected here and the city's residents embraced risks, realized dreams; and it seemed as though they were not daunted when things went awry. So it wasn't surprising that when Ravi had to choose a place for his printing press—the one business venture at which he tried his hand—he picked Bombay, which would, within a few years, become his second home.

* * *

One of the paintings Madhava Rao submitted for the Poona Fine Arts Exhibition was 'Nair Beauty', which had been gifted

to him by an irate Vishakham Thirunal, and in the same year, the painting won Ravi the Gaekwad Gold Medal. Just as the Governor of Madras had been enchanted by one of Ravi Varma's beauties, so was the Governor of Bombay, James Fergusson. Fergusson requested Madhava Rao for a copy, which Ravi made. The Governor was so impressed by the painting that he wrote a letter thanking the artist and, as a token of appreciation, sent Ravi a photo album with pictures of the British royal family. The greatest prize of the Poona Exhibition, however, was winning the attention of the Sayajirao III of Baroda who, in 1881, gave Ravi the opening that would pave the way for the painter towards becoming a man of national importance. Ravi was offered a commission to paint a couple of portraits of the Gaekwads, the royal family of Baroda. It would require him and his assistant, Raja Raja Varma, to leave Travancore and live in Baroda for a few months. The timing was too perfect for all this to not have been engineered by Madhava Rao but had Ravi Varma not displayed a talent for painting eye-catching women, chances are the Dewan's plans would not have progressed so smoothly.

More important than the commission, however, was the invitation extended to Ravi Varma to attend Sayajirao Gaekwad's investiture ceremony in Baroda in 1881. It was a rare and great honour, and Ravi Varma had been invited not because he was a nobleman—his status as a minor prince in Travancore was insignificant to Baroda—but because he was an artist. It didn't matter that the Maharaja of Travancore had virtually exiled him. Perhaps for the first time in his life, Ravi Varma realized that his status came not from who he had been born as but from something he had single-handedly achieved: his profession. Feudal India was far from being dismantled, but certainly a more modern world order was emerging. In it, people sided with those whose thinking, not social status, matched with their own. For the Maharaja of Baroda, it was of little significance that Ravi

Varma had incurred the wrath of the ruler of Travancore. The promise in his paintings was far more important to the young king of Baroda.

Maharaja Sayajirao III had his similarities with the erstwhile king of Travancore Ayilyam Thirunal, the first man to recognize the significance of Ravi Varma's style of painting and its potential. Both are credited with having modernized their kingdoms. They were both tutored by Sir T. Madhava Rao whose services the two young kings would enlist because both their predecessors had left them with a ravaged treasury. Like Ayilyam Thirunal, Sayajirao was a confident king and one who believed that the throne had come to him because he was blessed. Unlike Ayilyam Thirunal, he believed in luck. Without it, he would never have ascended the gaddi, or throne, of Baroda.

Sayajirao was born Shrimant Gopalrao Gaekwad and he grew up in Kavlana, a Maratha region. Although related by blood to the Gaekwad of Baroda who ruled the kingdom, there was no reason to believe this branch of the royal family would ever succeed to the throne. The marriage tie that linked them to the gaddi was a weak one: a barely recognized union of the first Raja of Baroda with a woman of a lower caste. It was hardly spoken of and had Malharrao Gaekwad been a better ruler, the line would have slipped into forgotten obscurity.

Maharaja Khanderao Gaekwad was a popular ruler of Baroda. As in many royal families, there was sibling rivalry in this one too and Khanderao's brother, Malharrao Gaekwad, was imprisoned for trying to assassinate the king. When Khanderao Gaekwad died unexpectedly, there was no heir because his wife Maharani Jamnabai was pregnant. Jamnabai gave birth to a daughter, who couldn't inherit the throne according to the patriarchal system of Baroda, and the crown passed on to Malharrao. Among the new king's achievements during a short reign was commissioning a pair of solid gold cannons, a carpet made of pearls, and bribing

servants to poison the Resident with arsenic. His most famous extravagance was the ridiculously ostentatious pigeon marriages he delighted in organizing.

Unsurprisingly, the British had him deposed swiftly, citing misgovernance. Although there were some neighbouring rulers who didn't think him guilty, it was difficult to defend his decision to divert something to the tune of Rs. 36,00,000, which had been earmarked to provide clean water to Baroda city, to build a palace for his bride. The throne was again vacant, and Khanderao's widow, Maharani Jamnabai, called upon her extended family to find a ruler for Baroda. Among those who answered her call were Dada Sahib Gaekwad and his three sons. Each of his sons was presented before the queen and she asked them the same question: why had they come from faraway Kavlana? Shrimant Gopalrao, the second son who had been working as a farmhand for the past thirteen years of his life, said, 'I have come here to rule.'

In 1875, the boy was adopted by Maharani Jamnabai with the blessings of the British. His name was changed to Sayajirao and for six years, he ruled with a Regent, Sir T. Madhava Rao. In 1881, Sayajirao came of age and could officially claim to be the undisputed ruler of Baroda. This was the investiture ceremony that Ravi Varma had been invited for and he painted a portrait of the Maharaja in his full regalia. Even at eighteen, Sayajirao looked determined and confident, even though he was ruling a kingdom that had seen some difficult years and had a strong British presence.

He didn't have the sharp features that would make one handsome. One might even argue that if he wasn't outfitted in rich silks and glittering jewellery, the bright-eyed, moustachioed young man would have been indistinguishable from the hundreds of young men in the kingdom. However, few young men would have sat so comfortably on the gaddi of Baroda. He wore the title of Maharaja with ease and the jewels that came with the

position, with élan. The love for precious baubles would be one of Sayajirao's indulgences and his jewellery rivalled his wife's collection in both beauty and value. Among his cherished pieces were a dazzling seven-row diamond necklace and a 262 carat diamond known as the 'Star of the South'.

Sayajirao was given to opulence. It was one of the ways that he could flaunt Baroda's richness, both cultural as well as financial, in a way that could not incur British censure. Portraits and photographs show him with gems and jewels glinting on his turban, clothes, fingers—brilliant even in vintage black and white photographs. He and his wife slept on beds made of gold and there is a story that once when these gold beds needed to be repaired, he nonchalantly ordered that makeshift beds be made for them out of silver.

Sayajirao's proud attitude is unmistakable and it would make him passionate nationalist, despite all the efforts of the British administration to create a malleable leader for Baroda. Unlike many rulers of the time, he was not fixed on regional loyalties. He was always very aware that he was a Maratha ruler whose subjects were mostly from Gujarat, and a sizeable number among them were of other faiths, like Islam and Zoroastrianism. Sayajirao was also one of the strongest opponents of casteism even though he was staunchly Hindu, and in later years, he was one of the first of the Indian royalty to openly declare that the age of 'rubbishy princely states' was coming to an end. Sayajirao's focus was on progress and unity.

Modernization had been started ably by his Dewan Madhava Rao, who established British systems in Baroda, including a police force, an administrative service, schools, and public works. The Gaekwad of Baroda worked with the Dewan, and much progress was made in the state. Women's education was promoted, courts that operated like the British judiciary were set up, and the unwieldy system of royal patronage for the arts

was organized and regulated. Sayaji's passionate nationalism would irk the British, particularly in the early 1900s when the Indian freedom movement began to come together. Among those he would provide patronage to were Dr. Babasaheb Bhimrao Ambedkar, architect of the Indian Constitution, and Dadabhai Naoroji, one of Mohandas Karamchand Gandhi's mentors. Like them, Sayajirao was a hybrid of the Western education and Indian heritage that created the nationalists of the early twentieth century. Like many of his generation, Western education only served to make him prouder of his Eastern roots and more inclined towards the nationalist project. When, in 1911, King George V and Queen Mary visited India, Sayajirao broke with the convention of Indian royalty competing with one another in lavishness to impress the Emperor of India. He chose instead to wear a simple, traditional white kurta and pyjama, without a sash or any jewellery, effectively communicating his refusal to acknowledge the sovereignty of the British.

In 1881, however, there were no hints that Sayajirao would be responsible for such a scandal in the future and for the painting titled 'Gaekwad in Investiture Robes', he appears dressed in all his finery. The Maharaja was greatly impressed by Ravi Varma's command over oils and his capacity to use the opacity of the paints to create such lifelike paintings. The time Sayajirao spent with Ravi Varma, particularly while the sittings were underway for the portrait, convinced him that the artist was a truly modern Indian artist. He cared enough about both his background and his art to create work that would be distinctive to the land to which he belonged. Ravi Varma's art was a hybrid form, like Sayajirao himself and like the India that was being shaped by the politics and thinking of the day. This was what earned Ravi a commission to paint five paintings with 'Puranic and religious themes'.

There is a story about how the Gaekwads came to earn this name. Once upon a time, an ancestor was looking out from his

fort and he saw below a Muslim butcher driving a herd of cows towards the abbatoir to be slaughtered. Quickly, he ordered that a side door be opened so that the cows may escape. This was how that ancestor came to be known as Gaekwad, the one who opened the door for the cows. How the hapless butcher must have felt at losing his livestock, we don't know, but the legend is a pointer to how fervently Hindu the Gaekwads were. Their Hindu identity became all the more important to the rulers when they found an enemy in the Mughals. With this background, it's no surprise that Sayajirao asked Ravi Varma to paint the Hindu myths. These were crucial elements of ancient Indian culture that he felt needed preserving.

Thanks to Sayajirao's interest in the arts, the Baroda court operated systematically, according to rules that guided all the details of an artist's life in court: where they lived, how they dressed, how they travelled, when they could leave the court, and how much they would earn from a performance in case of musicians, singers, and theatre troupes. Courtesans like the singer Bibijaan were given a generous monthly salary as court singers and sent to study music under a leading classical music singer of the time. Bibijaan was also on the court's payroll and could not refuse the royal diktat. She was told that if she behaved improperly or did not show satisfactory progress, she would no longer receive her stipend. The strict system was not always popular—a veena player was fined for using the state bullock carts on one occasion, instead of using her travel allowance—but it helped to create a hierarchy based upon an artist's excellence, rather than religion, caste, or gender.

Ravi Varma was one of the first painters to come to Baroda, and he would enjoy a cordial relationship with Sayajirao, although he managed to retain his independence and steered clear of becoming a Baroda court artist. Vishram Baug Palace became his home and studio in Baroda. It remained his for years and in

131

this studio, Ravi Varma would paint some of his most celebrated mythological works. Some of these would cement his reputation as not only a great artist, but one who developed a uniquely Indian style—and it began with the first Baroda commission.

* * *

Sir T. Madhava Rao would have described the city of Baroda to Ravi in his letters and the city would have come across as a charming place where the modern and the traditional lived side by side. Thiruvananthapuram would have seemed almost like a village in comparison, sleepy and small, when Ravi, his younger brother Raja, and their fifty-member entourage were taken through the city to the palace that would be their home. Baroda may have surprised Ravi and no doubt, the city distracted the artist from the heaviness in his heart at having been forced to leave everything behind because of the belligerence of a gout-afflicted king.

This was the furthest north he and his brother Raja had been so far in their lives. No, it wasn't Bombay, Ravi would have thought to himself, but it certainly had its own share of splendour, and it was fascinating how each detail seemed to be different here than it was back home. The air was dry and even the dust that coated forgotten items seemed alien. No one used coconut here because there were no coconut trees. The vegetables were different as was the blend of spices that lent them flavour. Here trees were a green that didn't match the green of the grass and leaves at home. Upon the people, one saw so much colour—in turbans, women's garments which were so different—and in the buildings that were ornate and had little of the wood that was such a staple element in the palaces and houses of Travancore. This was an old, old city and it was ruled by a man who owned a pair of cannons made of solid gold, after all. There were diamonds in this treasury that people said shone so brightly, they could rival the moon on a full night. It sounded like a story spun to fill a child's dreams, and here he was, a guest invited by the king himself.

Ravi spent a lot of time walking and riding around Baroda, the city of gardens as it was known to the locals. This was an old city, established by traders in medieval times, and it had grown into the present in ways the British seemed to have little control over, despite the Maharaja's English education and Madhava Rao's policies. Eastern Baroda was the old part and was encircled by a wall. Within it were the city's main markets, with open stalls and barely clothed men squatting around the open merchandise. This is also where the royal residences and important buildings like schools and courts were. He watched the people on the street avidly, wondering whether he seemed to them as intriguing as they did to him. From the twisted style in which the men tied their dhotis to the black sheaths that the Muslim women wore if they stepped out of their sloped-roof houses, everything fascinated him. He stared at everything, needing to imprint it all to memory.

Both Raja and he longed for their uncle, particularly when they visited the Makarpura and Nazarbag Palaces to see the Gaekwad's collection of art. The Gaekwad himself decided to be their guide the first time a few of the treasures were opened up to them. All the while that Ravi and Raja stared at the paintings, they knew they should perhaps attempt to look less like wide-eyed children. Ravi was, after all, an artist of a certain stature. But he could not help himself. These were the kinds of paintings that he had studied, except their grandeur had been forced into the confining dimensions of a page. It was clear from the Gaekwad's smile that he had expected just this reaction from Ravi and that it pleased him. He told Ravi that he was free to look at the works that belonged to the family any time he chose. In a few years, the Gaekwad hoped to have a palace worthy of these works and in it, he would make a museum that would allow his subjects to enjoy all of this. It would be like having a library, said the young ruler, and Ravi could not applaud the idea enough.

The Gaekwad was almost twenty years younger than him, but Ravi was struck with respect and admiration for his vision. He was

a learned, well-travelled man who ruled over a kingdom that had traded with the rest of the world for a long time and this could be seen in the art that he called his own. His collection of paintings included the works of modest, travelling artists but also those of names that Ravi and Raja had only read before. He had a painting by Raphael and watercolours from China and Japan that seem to be made not with paint but a pearly extract of nature itself, as though the green of the leaves and the pink of the flowers had been extracted by an alchemist and used on these paintings. The locals said that underneath the magnificent Nazarbag Palace, where formal dinners and other functions were held, was the Gaekwad's royal treasury. It was supposed to be an enormous labyrinth of jewels and precious artefacts, with pearls and rubies and emeralds and diamonds spilling out of golden jars and chests.

And then there were the palaces whose grandeur and opulence far surpassed those of Travancore. They stood majestically, surrounded by perfectly manicured gardens, chattering fountains, and sun-kissed pools of water. The Makarpura Palace was one of the most beautiful. It was all arches and inside, broad corridors opened into magnificent rooms with fine carpets, dark wooden furniture, and chandeliers that were polished to the shine of diamonds. Its curtained windows sliced the sunlight broadly. The palace often hosted concerts, and on these evenings, it seemed as though the entire palace was crafted out of light. Ravi especially missed his brother Gode when they attended the concerts where bejewelled men and women teased out ragas in the northern way. It seemed less mathematically structured than the music of the south. Lyrics unfurled sensually, and they sang of love, sometimes coquettishly and at other times with a yearning that made the heart stop.

Their uncles, aunts, and cousins would be amused to know that Ravi couldn't stop himself from gaping at the sights of the city. His sketchbook was now filled with landscapes of Baroda. One couldn't blame him. Even the hospital looked like a palace, so beautifully was

it crafted. Then there was the turreted Nyay Mandir, the domed gate
that welcomed the pedestrian to the neighbourhood of Laheripura, and
the Sursagar Lake that sat like a jewel in the heart of the city. In those
first few weeks, wherever Ravi went, he imagined himself describing
the place to his family back in Travancore. Stories about the colour and
tinkle of glass bangles, the soaring cries of hawkers that sounded like
strange birdcalls, the way a prayer call from the mosque settled like a
blanket over parts of the city while the sun slipped out of sight.

Amidst all these distractions was the work at hand:five
paintings on religious themes. It must have been difficult for Ravi
to decide what to paint that would both showcase his own talents
and act as something of an ode to the city that had opened up its
beauty to him so generously. Ultimately, he chose to paint two
goddesses and three episodes from well-known Hindu legends:
the Ramayana, the Mahabharata, and the tale of King Nala and
his wife Damayanti. From the Ramayana, he painted 'Sita Siddhi',
depicting the moment at which Sita realizes she's been tricked
by the wily Ravana. 'Sairindhri' showed a melancholy Draupadi,
wife of the Pandavas, forced to live apart from her husbands
and tolerate the attentions of a lusty prince in the house of King
Virat. From the tale of King Nala, Ravi Varma chose to paint the
moment when Nala leaves behind the sleeping Damayanti. Of
all the tales Ravi Varma could have picked, he chose stories that
spoke of lovers who were parted because of cruel circumstance and
the machinations of villains. Just like himself and Bhagirathi.

Ravi Varma was not a man of letters and we can only guess at
his emotions, which were never flaunted. But his life was in his
paintings and it isn't too far-fetched to imagine him picking his
subjects in a way that allowed him a safe catharsis. There are too
many resemblances between the stories he painted in Baroda for
this first commission and where he stood in his own life. Like Nala
and Yudhisthira, he too had lost everything because he had been
reckless. He had no option but to leave behind his land, like those

mythical kings, and ultimately, he was left with nothing but a title that was meaningless, like the crown that Nala wore which was as useless as a trinket in the unforgiving forest. He lived, like Nala and the Pandavas, upon the generosity of another king, one who was just and caring. Like Draupadi and Damayanti, Bhagirathi had to bear with unwanted attentions and the pain of being parted from her husband. The women were mired in their own sadness and unaware of how their husbands suffered, how they longed to return and end this separation that seemed to go on interminably.

The Nala–Damayanti story was one that Ravi Varma was particularly fond of and he would paint different episodes from it over the years. He never mentioned to anyone if he saw himself in the tale but if he did, it offers a view of Ravi Varma as something of a romantic and his relationship with Bhagirathi comes across as very different from what the gossips suggested with their rumour-mongering. There's no doubt that the time he spent in Baroda was as an exiled prince and he would remain so for the next few years. Unlike the heroes he painted, however, Ravi Varma did not have to obscure himself. Rather, his stature as an artist grew phenomenally, and some of the works he painted during this time, like 'Lakshmi' and 'Saraswati', would remain loved by people for more than a century after his death.

As his salute to Baroda he painted Lakshmi, the goddess of wealth, and Saraswati, the goddess of learning, because the city seemed to have both these goddess' abundant blessings. Although they were for the Gaekwad and today belong to the Maharaja Fatehsingh Museum Trust in Baroda, it is almost impossible to find a person who doesn't recognize these paintings. In fact, for most Indians, these paintings are what they imagine when they hear the names of these goddesses, particularly Lakshmi who has graced millions of altars across the country in precisely this form. She and Ravi's Saraswati have smiled demurely from calendars, advertisements, and handy little plastic frames for more than four

generations now. They've watched with unchanging expressions as people prayed to them in times of uncertainty, placed sweets and incense before them, and remembered them, just as Ravi Varma painted them, at moments of triumph.

These two paintings were among the earliest examples of Ravi Varma refashioning the gods. Before this, he had applied his realism to tales from the Hindu myth cycles and introduced the notion of freezing one key moment from the narrative rather than taking on the task of retelling the whole story. Lakshmi and Saraswati were among the first of those beings described in surreal terms in Sanskrit texts that Ravi Varma turned into something far more human. They still had their four arms, but the sari and the jewellery they wore were what one would see on an affluent woman. Contemporary critics may well be amazed that the blandly smiling goddesses have captured the imagination of Indians for more than a century now, but there is an expression of attentiveness in the gods Ravi Varma painted. It was as though they looked into your eyes and listened to your prayers.

These figures are not creations of Ravi Varma any more. They've become part of the Indian imagination and are a construct of traditional beauty that continues to be harked back to in fashion magazines. But when they were first painted, they were the work of a painter who decided to re-imagine the goddesses and used a model, possibly a prostitute from Baroda's chirruping red-light area, as his starting point. She stood, alluring in her red sari, tilting her hips to emphasize the dip and rise of her body, as Lakshmi. As Saraswati, she sat a touch awkwardly with a veena. Her face remained the same: a hint of a smile and a gentle expression in her eyes. Even though Ravi Varma took away from the goddesses much of the traditional imagery—a graceful peacock replaced the swan, Saraswati's usual animal consort, for example—and placed them in a green forest landscape that didn't seem mythical but very real, they became embodiments of the

heavenly. They were Ravi Varma creations and when they were painted, they caused something of a stir because these goddesses, despite their four hands, seemed startlingly human; as though the moment the viewer turned, they would blink and their smiles would widen. The moment they emerged out of the printing press Ravi Varma set up in 1892, however, and 'Lakshmi' and 'Saraswati' could be hung in any household that could afford a lithograph, they stopped being Ravi Varma paintings and instead, became something that belonged to and was shared by the people of a subcontinent.

The late 1880s marked the beginning of a period during which Ravi Varma would create some of his most famous and popular paintings. It's important to remember that when Ravi Varma reached the height of his fame approximately five years later, he was not without competition as he had been during the time he did the Baroda commissions. By the end of the nineteenth century, there was an upcoming generation of promising artists who had talent and much more exposure than he had had as a young man. There were the graduates of the art schools that the British had established in India, like Ganpatrao Mhatre. Mhatre, who had enrolled in the Sir J.J. School of Art to study painting, caused a sensation because without any assistance from his teachers, he made a life-size sculpture of a Maharashtrian girl going to the temple. It made its public debut in 1896 at the Bombay Art Society and won the silver medal. Ravi Varma generously declared it was 'the most beautiful production of the kind I have ever seen by a native'.

Another name that would come up in the near future was Sashi Hesh, the gifted and arrogant artist, who was living a modest middle class life in Bengal while Ravi Varma was the fêted artist in Baroda. In 1894, however, Hesh would manage to find a sponsor who would send him to Italy. Admissions for the Royal Academy in Rome were not open but Hesh was able

to somehow manage an audience with Umberto I, and the king was so impressed with Hesh that he arranged for the Indian to attend the Academy. Hesh returned to India from Europe in the 1900s and attracted the attention of Sayajirao. However, Hesh's arrogance and criticism of British art—he was an admirer of the salon art in Paris, where he lived for many years—did not earn him much popularity among patrons.

None of Ravi Varma's contemporaries were able to secure a reputation quite like his. This was in part because his paintings tapped into the mood of those years perfectly. They provided his patrons and viewers with a vision of India as a land of beauty and grandeur. His paintings upheld tradition and his style of painting suggested that the values in the stories he was depicting on his canvas were not outdated. Through his art, he emphasized a living Hindu culture. He also gave his patrons what they wanted, which was another reason for his continued popularity, along with his amiable demeanour. For every enemy he acquired, Ravi Varma made twice the number of friends and these friendships would hold him in good stead until the end.

* * *

After completing the Baroda commission, Ravi and his brother went to live in Bombay for a month. Friends were easy to make since he could include Sayajirao as one of his social acquaintances and people like the Governor remembered him from his success at the recent Poona Exhibition. Bombay added an important item in the brothers' list of things they enjoyed: the theatre. It was a sign of wealth and sophistication to be a theatregoer in the late nineteenth century, and the Varma brothers took to this habit with ease. They spent many evenings at the theatre, watching the painted sceneries and the elegant actresses with fascination. They were particularly fond of Parsi theatre, which was at its peak at the time. The Anglicized Parsi community had

many who had travelled to England and they prided themselves on being as British as the real British. Heavily influenced by Victorian theatre, the halls were built in imitation of Drury Lane and the Covent Garden Theatre in London. They had wings, props like columns, and backdrops of forests, palaces, and forts that became startlingly realistic with clever lighting. Aside from English theatre, the brothers also watched Gujarati and Hindi plays although they were yet to become fluent in the languages. Many of these plays retold stories from the myths, and Ravi Varma was clearly inspired by the poses the actors struck while enacting the tales.

Bombay was a thriving city. People from all over the world seemed to flock to this place and it became a crucible for new ideas and modern notions. Soirées were a regular feature and Ravi Varma was a welcome addition to the city's elite. He was something of a celebrity, especially since the Gaekwad of Baroda had praised his paintings for their beauty, and he loved the freedom that came with being in Bombay. This was the time when the myths about him began to be shaped. One claimed that when Ravi Varma went to a party, he was fooled by a European woman artist's painting of an umbrella stand, which he thought was real. Determined to trump her, he invited the lady to dinner a few days later. When she arrived, he escorted her inside and she was surprised to find that the long dining table was already laid out. Guests sat at their places, focused on the meal. It was when she tried to take her place that she realized that the whole scene was an enormous canvas. Whether the more introverted Raja Varma had enjoyed having to spend time producing this practical joke is not known.

Another story has it that an unnamed princess was modelling for Ravi Varma when he was making a painting of Radha. Unused to striking a pose, the aristocratic beauty was stiff at all the sittings. Ravi became frustrated because although the young lady

had the perfect face, she couldn't get the expression he wanted. So, over the course of a few days, he spent time with her and wooed her subtly until she fell in love with him. As a married man, of course, he could not really pursue her, he said when he realized that she had developed a weakness for him. At the next sitting, the princess had the perfect expression of heartbreak and longing. It seems neither she nor the artist regretted the experience.

It is worth noting that Bhagirathi bore her last child in 1882, the year that Ravi Varma spent his month in Bombay. It seems improbable that she was past her childbearing years by this time. There is the unlikely possibility that the couple decided they would have no more children or perhaps this was the fallout of the myths celebrating the artist Ravi Varma having reached her in Mavelikkara. It seems more likely, however, that the intimacy that they shared in these past few years was lost when Ravi Varma began providing fodder to rumour-mongers.

While Ravi Varma had been savouring Baroda and Bombay, his well-wishers had been working frantically to engineer a rendezvous between Maharaja Vishakham Thirunal and the painter, one that would end this animosity. Their efforts came through and the Maharaja agreed to allow Ravi Varma one private audience. The venue was to be Bombay, since the Maharaja was due to visit the city en route to making a pilgrimage to the holy city of Benares in the north.

The meeting was a disaster. Politeness was abandoned early on and it degenerated into a volley of accusations and angry statements. Exactly what was said has not been recorded but Ravi incensed Vishakham enough to prompt the Maharaja to not only put a stop to his monthly stipend from the court of Travancore, but also to have the painter excommunicated from his family. Had Madhava Rao not intervened on behalf of Ravi Varma, the excommunication would have meant the painter would have been forbidden from going anywhere near Kilimanoor and all ties with

family members would have been severed. Ravi had probably been riding confidently on the wave of appreciation and respect he had received in Baroda. Living in Bombay and making friends with men who operated in the highest circles of power would have made Thiruvananthapuram and Travancore seem very far away, maybe even trivial.

Exactly what Ravi Varma said or did to be charged with 'unholiness' and 'deviation from observances to one's family' is not known but these were very serious accusations to be made in nineteenth century India, where great importance was placed on lineage and tradition. What rumours had travelled down to Travancore can only be surmised and Ravi Varma would have argued strenuously to clear his name, which would have only incensed Vishakham Thirunal; the only person to hear the painter out would have been Madhava Rao.

'It is unfair and untrue,' Ravi said repeatedly to Sir T. Madhava Rao and anyone who cared to listen. Few other than the old Dewan did. In Bombay, Vishakham Thirunal was one of many princes who commanded a certain degree of respect. In Ravi's life, however, the king had suddenly taken on monstrous proportions. Vishakham Thirunal simply hated him, Ravi decided, because there was not a grain of truth in the accusations. Not for a day had Ravi missed his morning prayers. Raja seemed to have given up those old ways and was satisfied with only the basic rituals at ceremonies, but Ravi had stuck to the discipline that had been ingrained into him by his uncle and his father as a child. Ravi defied Vishakham Thirunal to find a family member in Kilimanoor who would say he had neglected them.

'Calling him by his name isn't going to help your case,' Madhava Rao reminded Ravi. 'And the will of kings does not always require the truth.' If it came to that, Ravi's sketches of Baroda's Muslim areas and women could be used against him as a sign of unholiness. It certainly didn't help that in Bombay, many of the painter's friends were British and Parsi. Madhava Rao agreed that they were the architects of the

city's development and growing wealth, but there was no denying they had practices of which Hinduism didn't approve.

'You would like me to give up on the opportunity of meeting some of the brightest minds of our times for one man's illogical rage?' asked Ravi. He flatly refused to even entertain the idea of giving up the company he was keeping. He enjoyed the world outside Travancore and the life it offered, with its soirées, animated discussions about politics, history, and culture, the libraries with their crowded shelves, the cricket matches, the theatre, the music. Surely his curiosity about the world could not be held against him?

Unfortunately, Madhava Rao explained patiently, it could if one wanted to see him in a negative light. Having earned the disapproval of his own ruler, Ravi Varma had not apologized to the Maharaja and had instead gone off to find a new patron in a foreign kingdom. In addition, he had left behind his uncle who was also his first guru, without acknowledging the elder's role by giving him a gurudakshina. Ravi argued this was a preposterous accusation because it assumed he had a formal guru–shishya relationship with his uncle. He was Ravi's father figure and he would never expect a ritual gurudakshina.

However, as Madhava Rao pointed out, the fact was that he could be accused of negligence. His behaviour showed no contrition, not in Travancore and certainly not in Baroda or Bombay, where he attended an array of social events and frequented rather disreputable areas of the city. Yes, he may say that he was looking for models but detractors could easily present it as something far more salacious. 'Leave Bombay and return to Kilimanoor,' advised Madhava Rao. 'Arguing with the Maharaja will neither serve to strengthen your case nor persuade him to see any error in his judgement.' If Ravi immersed himself again in the conventions and rituals of Kilimanoor, the Maharaja would not be able to find any grounds to excommunicate him from his family. Pride, Madhava Rao reminded Ravi, was a foolish reason to lose one's roots.

So Ravi left Bombay and returned to Kilimanoor. There, with much fanfare, he presented his uncle with a gurudakshina, the

ceremonial offering made by student to guru upon the completion of the former's training and apprenticeship. Some say it was Rs. 1,000 and other say it was Rs. 10,000; it was probably the former. Both amounted to a fortune and the news that Ravi was presenting his uncle with gurudakshina for having been his guide and mentor for all these years travelled far and wide. There is no doubt this event was organized to ensure Vishakham Thirunal got to know that Ravi was performing his duties to his family. The uncle and nephew had shared a close but private relationship, and this gurudakshina is the only instance of a public gesture that made a show of their relationship.

However, Ravi must have been thankful that circumstances had brought him to Kilimanoor because his uncle was frail by this time and it was obvious that he did not have too long to live.

Spending time with his uncle was strangely reminiscent of his early years and yet different. Now Ravi was the one with the stories, the experiences, and the knowledge of the greater world. He spoke to his uncle about the places he had seen, perhaps about the brouhaha with the Maharaja. He spoke about his three daughters and two sons, the mischievous antics of his eldest son Kerala who seemed to have inherited his father's artistic skills, his plans to ensconce himself once again in the favourable books of Mavelikkara Kottaram by painting portraits of Rani Lakshmibai and his old friend Kerala Valiya Coil Thampuran. He also painted a portrait of the old man, who had by then retired from public life. The portrait shows Raja Raja Varma looking a little nervous. His face is gaunt and the hollows in his cheeks are all the more prominent because of the rich, lush redness of the shawl he wears. A little more than a year later, in 1884, Raja Raja Varma died. Ravi Varma was devastated. He stayed in Kilimanoor long enough to complete all the rites and rituals that were expected of him. Then, unshaven and clad in the thin, raw cotton that was the garb of mourning, he made his way to Mavelikkara.

Part Three
Bharat Darshan

The story of Nala and Damayanti is one of the many branches of stories in the Mahabharata and it goes like this. Nala was the king of Nishada, a small kingdom nestled among the Vindhya mountains in central India. He was a handsome man and a good ruler. Among his skills were handling horses and cooking, thus going to show that in ancient India, the division of labour wasn't always so neat and men did enter the kitchen. A Brahmin once came to Nala's kingdom and was surprised to learn the king was still unmarried. He spoke then of the many virtues of Damayanti, princess of Vidharbha, a larger and more powerful kingdom, in what is now Maharashtra. The Brahmin painted a portrait of the princess and Nala fell in love immediately. But there was nothing he could do. The custom of the times stipulated that a woman choose her husband at a swayamvara. It was not done for a man to present himself to a woman without invitation. However, Nala found a way around this. He sent a swan to Vidharbha, asking it to tell Damayanti he had fallen in love with her and find out if she would ever consider him for a husband.

It took the swan a week to fly to Vidharbha and come back to Nishada, with the news that Damayanti too had heard much of King Nala and had fallen in love with him as well. She promised that she would subtly indicate to her parents that she was ready for her swayamvara, now that she knew Nala would come for her hand in marriage. Once the swayamvara had been announced, however, the couple's troubles began mounting. Vidharbha was

an important kingdom and kings far more influential than Nala made preparations to secure the princess. But Nala's competition wasn't only from the mortal realm. Descriptions of Damayanti's beauty had reached even the devtas who lived in heaven. Despite being surrounded by eternally young nymphs, four of the most important devtas decided to come down to earth in order to attend Damayanti's swayamvara. They were Indra, the leader of the devtas; Agni, god of fire; Varuna, god of the seas; and Yama, the god of death. Nala met the devtas just as he reached the outskirts of Vidharbha. The gods recognized him as the mortal whom the princess had given her heart to. The wily Indra managed to wrangle out of Nala the promise that he would tell Damayanti to choose one of the four devtas instead of himself. The mortal king, however, was able to convince the devtas to transport him secretly to Damayanti's chamber the night before the swayamvara, ostensibly to tell her she must pick one of the gods as her husband.

When Nala saw Damayanti for the first time in the flesh, he was enchanted as was she. However, he kept his promise to the gods. He told Damayanti that four devtas, among them Indra himself, had descended from the heavens to win her hand and he had been instructed by them to tell her that she should select one of them at the swayamvara. Having obediently delivered the missive, Nala embraced Damayanti, says the narrator of the Mahabharata coyly.

The devtas were furious when they realized how the couple had used them to rendezvous before the swayamvara and they decided to play a trick of their own on Damayanti. When she entered the great hall where her swayamvara was being held, Damayanti found five Nalas. The devtas had assumed his form and decided to win Damayanti by craft. But she was able to tell the real Nala and the two were married. When the disgruntled devtas were returning to heaven, they met two demigods, Dwapar

and Kali. This is not the Kali the goddess, but the god who lords over the last age, or yug, in the Hindu time cycle, while Dwapar is the master of the second age. Indra told Dwapar and Kali how Nala had tricked them and the two demigods vowed to bring about the king's downfall.

Nala was a good, devout man and it took Dwapar and Kali twelve years to find a moment of weakness in which they were able to exploit his only flaw: a love for gambling. Under the spell of the vengeful demigods, Nala played against his brother Pushkar and lost everything but his wife, whom he had the wisdom to not wager. Pushkar struck the two of them out of the kingdom without a single belonging. To humiliate Nala further, Pushkar ordered his brother should be stripped of his clothes and left with nothing but a loincloth.

A series of misfortunes befell Nala and Damayanti in the forest. Despairing and ashamed of himself, Nala ultimately abandoned a sleeping Damayanti when they were near the capital city of Vidharbha. He decided she was better off without his unlucky self. Before leaving, he tore a small part of her sari with which to cover himself and then crept away, convinced he would never see her again. However, Damayanti did not give up on him. She wandered into foreign lands, looking for Nala. A complicated chain of events landed Damayanti back in her father's home, while Nala was transformed into an ugly dwarf and found employment with King Rituparna of Ayodhya. Time passed and Damayanti continued to look for her husband, through spies. One of them came back with the report that there was a man in King Rituparna's employ who had all of Nala's qualities but was a dwarf and therefore could not be the erstwhile king of Nishada. Damayanti decided to have a mock swayamvara to draw Nala to her. Princes from everywhere gathered again, including King Rituparna, who took Nala as his charioteer. Damayanti was able to discover Nala despite the magical disguise and the kindly King

Rituparna offered Nala a home in his kingdom since they could not return to Nishada. Nala then asked Rituparna, who was such a skilled gambler that no one dared to play against him, if he would like to enter into an exchange: Nala would teach Rituparna about horses and in return, Rituparna could teach Nala gambling. Rituparna agreed.

So it was that when Nala returned after a year to Nishada and challenged his brother to a game of dice, he won effortlessly and so was able to become the king of Nishada again, with his faithful wife Damayanti by his side.

Ravi Varma loved the story of Nala and Damayanti. He never said that this story could be an allegory for his life, but like Nala, he too had suffered being exiled by one who was dear to him; he too had travelled across strange lands and been blessed by the kindness of a foreign king. Also, circumstances led to his closest relationship being one with another man: in Nala's case it was Rituparna while Ravi Varma had his brother Raja. Bhagirathi was his Damayanti. Her stand did not waver—not when he was enjoying the thrills of being a favourite of Nagercoil Ammachi, not when he was discredited because of the plots against Maharaja Ayilyam Thirunal, not even when he was threatened with excommunication from his family. She remained his wife and the mother of his children, silent and steady. He knew this and he cherished it, which was perhaps why he didn't come to Mavelikkara after the blighted meeting with the Duke of Buckingham. If he had gone to Mavelikkara from Thiruvananthapuram, the taint of royal disapproval would have spread to Bhagirathi's family and she may have found herself even more cornered and isolated. Perhaps staying away had been Ravi's attempt at protecting his wife. The fact that he sought her company after his uncle's death suggests that she was a source of comfort to him.

Of course, there were other consolations in Mavelikkara: his

children, whom he had seen little of, and Raja, who had been married into a respected Brahmin family there. While it isn't known who arranged Raja's marriage, it is likely that Ravi played a key role in it since he was the eldest of his generation in the family and their uncle had been increasingly less active over the past years. The brothers were known to be almost inseparable when Ravi began travelling around the country on his commissions. Raja's marriage to a Mavelikkara family shows that they were close long before the demands of Ravi's career ensured that they spent a great deal of time together. It's possible that what drew Ravi to Mavelikkara was the comfort of his brother's company, rather than his wife. She didn't share memories of growing up under their uncle's strict discipline, like Raja did. She had not been taught how to hold a brush by him. Their uncle hadn't told her stories. She had never been quizzed by him about grammar, a quatrain from the Mahabharata, or the progression of a raga. She may have had the best of intentions, but Bhagirathi could not offer Ravi much more than blind comfort and empty consolation. The companionship that he needed to mourn his uncle could only be provided by Raja.

Over the next few years, Ravi Varma did his best to settle into placid domesticity. He filled his days with conversations, letters, casual strolls, his children, and his wife. He read and he wrote. He listened to lecturing pundits and chanting priests. His sons and daughters grew taller and measured themselves against him, looking up at him with eyes that shone with affection. He was the father of five children, of whom the eldest, Mahaprabha, was fifteen and must have been married by this time. He had missed most of her childhood. The other two daughters were seven and three; young enough for him to play with and old enough for him to use as models for the sketches and practice drawings he was constantly working upon. His eldest son Kerala was ten years old at the time and showed great skill in drawing and painting.

Ravi saw in him a successor, one who would carry on the style of painting he had begun and perhaps earn greater acclaim. Rama, the second son, was five years old and Ravi began teaching the little boy the basics. He was an eager student who listened carefully and worked at the exercises that his father gave him. Kerala was often less obedient, but his paintings were impressive enough to make most people forgive his wilful behaviour. Some people have hazy memories of Ravi saying Kerala's work was better than his own had been at the same age. Unfortunately, nothing of the young boy's paintings remains.

For the year Ravi was in mourning for his uncle, he had pleaded off commissions, and it gave him a freedom he had not enjoyed in a while. He could paint anything he wanted—horses, gypsies, elephants—and he did. Some of the paintings were of people and sights he saw, and the canvases began piling up in the studio he had in Ulsava Madham in Mavelikkara. As the months passed, Bhagirathi must have noticed his images becoming more and more unfamiliar to her. One painting had neat green fields with benches in them and on those benches sat a man and a woman, close together. The woman wore her sari in a way that looked like a European dress. If Bhagirathi had asked Ravi, he may have told her it was a park he had seen in Bombay. The barber he painted looked nothing like any barber seen in Mavelikkara. There were paintings of a Muslim man at prayer, of a neighbourhood where women wore black shrouds, of camels. No date and palm trees reached skywards in these landscapes. The houses had no courtyards and their balconies looked out, not in. Out on to markets and roads with carriages and walking strangers. He had stories of palaces, durbars, grim-faced British men with flowing beards, and colourful saris. Those who knew him remembered him as a wonderful storyteller, and it is easy to imagine him talking, about the cities he had seen and the people he had met, to an audience of wide-eyed relatives that included

wrinkled matriarchs, open-mouthed children, and perhaps even Bhagirathi. They would have sounded like stories about magical kingdoms to most of his audience. But Bhagirathi would have known that it was not as if the places he spoke of were accessible only in daydreams. They were only days away and it was only a matter of time before these distances wooed him away from her again.

She may not have recognized the longing in his voice as he described these places with unfamiliar names. When he spoke of Thiruvananthapuram, she could relate to what he said because she had, after all, lived there. But these new cities and towns, with their different languages and curious people—these were only stories to her. For Ravi, the places he spoke of were more real in many ways than Mavelikkara. The two homes he had in Kerala—Kilimanooor and Mavelikkara—were his hideaways. Little of the outer world reached him here and even when it did, it reached late.

For the early months of that year of mourning, Mavelikkara's calm, unchanging ways of life was like an oasis. It proved to be a strangely contented time, in spite of the sadness Ravi felt at the loss of his uncle. The elder man's presence seemed to be all around him. Raja and he would spend hours remembering him; when they painted, every line they drew and every colour they dipped their brushes into reminded them of how their uncle had loved the way they painted. When Ravi sat with Kerala and Rama to teach them how to draw and paint, he must have been seared by nostalgia. A curious mix of sadness and fondness would have filled him as he imagined his uncle seeing Kerala's drawings. Watching the boy bend over his sketchbook and draw with quick, sure lines would have recalled to him his uncle's description of him as a boy, filling sketchbooks with unruly thatches of dark strokes that rushed to turn into a bird, a branch, a squirrel, the hands of a Kathakali dancer.

* * *

Between 1884, when his uncle died, and 1887, Ravi spent months at a stretch in Mavelikkara. He only took up two commissions in this period and both were to the nearby kingdoms of Pudukottai and Mysore. The decision to stay mostly in Mavelikkara seems to have been one dictated by custom, rather than any inclination to spend time with his family or retreat from the world that he had been introduced to by the Gaekwad of Baroda. In 1886, his mother, Uma Ambabai, died. Ravi had spent much of his childhood away from his mother but the remarkable woman was very dear to her eldest son. She was known for her impressive personality and was one of the people he looked up to. One of the books Ravi Varma printed upon setting up his printing press was 'Parvati Swayamvaram', an operatic work written by his mother.

To lose both mother and uncle so soon after one another was painful. Their deaths were also brutal reminders that the time of the older generation was passing. Although the eldest uncle who headed the family was still alive, Ravi was now one of the eldest among his generation of the Varmas of Kilimanoors. Now, few spoke of him as Raja Raja's nephew or Uma Ambabai's son. Instead, people were beginning to describe others using him as a reference: Raja and Gode were Ravi Varma's brothers; Kerala and Rama were his sons. This wasn't only about age, of course. His success had given him a stature that he wouldn't have received simply by virtue of being an elder brother.

Letters from friends and well-wishers like Seshayya Sastri and Madhava Rao, with their kind words and unfaltering faith in his talent, reminded him that he was an artist, not meant to remain cloistered in a small town in Travancore. Madhava Rao's letters mentioned that the Gaekwad of Baroda had spoken highly of Ravi, describing him as one the greatest talents of the land. Apparently, many friends of Madhava Rao were clamouring for paintings by Ravi Varma and the Dewan had an idea for the

painter: 'It would hardly be possible for you, with only a pair of hands, to meet such a large demand. Send, therefore, a few of your select works to Europe and have them oleographed. You will thereby not only extend your reputation, but will be doing a real service to the country.'

Madhava Rao knew Ravi Varma would never take the steamer to Europe, regardless of how much he wished to travel to the lands where he could see the works of his artistic heroes. In most of the country, the conservative Hindu belief that one lost their caste if they crossed the seas was one that was losing currency. Sayajirao described himself as both Indian and English, both because of his English education and because he spent many months of the year abroad. By the nineteenth century, it wasn't only princes who travelled abroad. Young men from the middle classes and even poor families were also taking that step. Ravi Varma's friend Dadabhai Naoroji, for example, began his life in 1825 as the son of a Parsi priest in a modest neighbourhood of Bombay. He was first offered a chance to go study in England because he was such a brilliant student, but the Parsi community refused to let him go. Naoroji ended up going anyway and spent much of his life between London and Bombay. By 1892, he was a member of the British Parliament and played an important role in making British politicians aware of the flaws in their colonial policy.

In Travancore and much of southern India, however, the adherence to tradition was stronger. Ravi didn't want to risk any more disapproval than he had already earned for himself by choosing to be a professional artist. He tried to make up for not being able to travel abroad by sending his paintings to colonial exhibitions in London and Calcutta. He also took Madhava Rao's advice and sent a few paintings to Germany.

It was Seshayya Sastri who pulled him out of the unchanging routine of Mavelikkara. When the new Governor of Madras

announced a visit to Pudukottai in 1884, Seshayya Sastri insisted Ravi Varma come and meet him, persuasively arguing that Pudukottai was too close for it to qualify for the kind of travel that strictures forbade during mourning. Raja accompanied Ravi to Pudukottai as his assistant. Ravi must have felt as though he had woken up from a long sleep. At Pudukottai, he met people and heard himself being introduced as the artist whose works had been gifted to none other than the Prince of Wales himself. The new Governor shook hands with him and said he was pleased to meet the man whom every respectable Maharaja in the Indian subcontinent wanted to invite to their palace. Ravi would have blushed and dismissed it as flattery but for the fact that he did want to believe it. Soon after this exchange, he was introduced to the Maharaja of Mysore, Sri Chamarajendra Wodeyar. The king wasted little time in asking him to come to his city and paint. Ravi agreed readily.

The Pudukottai commission kept Ravi away for a month. He returned only to make preparations for the long trip to Mysore. In 1885, Ravi and Raja set off for Mysore. The Wodeyars had been placed upon the throne by the British after they defeated Tipu Sultan, dubbed the Tiger of Mysore, at the Battle of Seringapatnam in 1799. Having won the battle, the British handed over parts of the kingdom to the Madras Presidency and the Nizam of Hyderabad and turned Mysore into a smaller state that would be easier to control. The Wodeyar family was picked because it had ruled the kingdom in the seventeenth century and had since been shunted into obscurity, so it had no political muscle to resist the British. The five year old Krishnaraja was declared king of an amputated Mysore.

In 1831, the East India Company annexed the kingdom after the unrest and over the next fifty years, the British administrators did much to improve infrastructure and systems in the state. The famine of 1876 hit Mysore brutally and the state lost almost a

fifth of its population. It led to much lobbying in London for Mysore to be made a princely state to make up for the callous behaviour of the British, whose famine policy for southern India had been a disaster. The British-educated Chamarajendra was the scion of the Wodeyar family and the ideal candidate because he was Anglicized. He became the Maharaja of Mysore in 1881 and it fell upon him, his Dewan, and the Resident to rebuild the kingdom. They fulfilled the task admirably. The king promoted women's education, set up agricultural banks to help farmers, and in 1881, India's first democratic legislative assembly, the Representative Assembly of Mysore, which had elected rather than nominated members, came into being.

Chamarajendra was everything that Ravi Varma admired. Like the Gaekwad of Baroda, he was artistically inclined, suave, Anglicized, while being well grounded in his own culture, and respected by both the English and Indians. He loved music and patronized many Carnatic musicians. Chamarajendra was himself an accomplished violinist and would often provide accompaniment to artists performing for him. When he and Ravi Varma met in Pudukottai in 1884 a rapport was quickly established between the two. When Ravi came to Mysore, a beautiful palace was given to him and almost every night was spent attending parties and concerts. After the quiet of Mavelikkara, attending Chamarajendra's glittering court must have been quite a heady experience. When he was to leave three months later, the Maharaja said that he wished to gift Ravi two elephants in addition to his fees, and the artist could choose which ones he wanted from the royal elephant stable. All across India, elephants were considered royal beasts and in southern India, they were generally reserved for kings. Aside from their immense stature and the grandeur that came from owning them, they were expensive animals to keep.

Ravi loved elephants and he picked a calf which lived in

Kilimanoor till the end of its days. He said his fascination for the animals stemmed from hearing stories about how his mother had dreamt of a white elephant when she was carrying him in his womb, much like the Buddha's mother. And of course, he liked elephants for what they symbolized: royalty. With this gift, Chamarajendra acknowledged Ravi Varma as an equal, and it is unlikely that any artist before him had been given such respect. It was the first instance of Ravi Varma being considered the Raja that he would declare himself to be in later years.

The portraits Ravi painted of the royal family of Mysore at this time are good examples of how cleverly the artist created works to suit the tastes and temperament of his patron. These first set of portraits show a careful incorporation of the Tanjore style of painting into Ravi Varma's European academic realism. The paintings have the flatness of the Tanjore style, and the colours he used to depict the glossy saris and gleaming jewellery are clearly taken from the south Indian painting tradition. Each pearl seems to have been given individual attention. The emeralds, rubies and diamonds have the rich lustre of expensive gems. As in Tanjore paintings, the jewellery seems to almost leap out of the canvas, while the contours of the background are flattened into one plane. The poses his subjects strike, however, are distinctly Western. A portrait of the toddler prince Krishnaraja and his two elder sisters has the three of them standing side by side, as though from a Victorian painting. Their tender faces are painted with such realism that the person standing before the portrait can almost feel the softness of their baby skin under their fingers. In sharp contrast to their youth, the princesses carry themselves with a certain dignity that is mature and telling of their royal stature. Each face is different. The sari-wearing eldest smiles sweetly, with just a hint of tentativeness. Her younger sister looks like a doll with beautiful, curious eyes that seem to be directed at the viewer. The baby prince, who looks a touch confused, is encased

in a bejewelled outfit that is very princely and adult, despite the rounded little fists that pop out from his sleeve. The blend of styles is awkward in places and there are errors in perspective as a result.

The decision to add noticeable elements from the Tanjore style—flattening the background, omitting depth of perspective—into the works must have been a deliberate attempt to fashion the portraits in a way that would acknowledge the artistic heritage of this area and make them distinct. The contrast between these paintings and 'Judith', for example, is striking. Painted in 1886, 'Judith' is a copy of a painting, but it shows the command Ravi Varma had over oil paints by this time, and that he was experimenting with different styles to develop his own.

'Judith' depicts a Jewish heroine who saved her people from the Assyrians when the two were at war. She seduced the enemy general Holofernes, found out about his army's plans, and then killed him. She returned to the Jewish camp carrying Holofernes's bloody head as proof of his death. When battle resumed the next day, the Assyrian army was in disarray and Judith's people were able to defeat them easily. Judith has inspired many European artists, from Michaelangelo to Gustav Klimt, possibly because of the visual potential of an image that has a seductive beauty and a decapitated head in the same frame. The painting that inspired Ravi Varma was by Jean-Joseph Benjamin Constant, a French painter born in 1845. Three years older than Ravi, the Parisian artist studied painting at the prestigious École des Beaux-Arts and was best known for his portraits and paintings showing romanticized images, particularly of Morocco. The precise date of Constant's painting is not known but 'Judith' was one of the early Europen paintings that Sayajirao acquired for his collection, the bulk of which would come together later in the 1900s. The Gaekwad of Baroda's collection of European art would finally arrive in Baroda in 1921, after being displayed at the Victoria

and Albert Museum in London, but as 'Judith' was among the first acquisitions, it came to India earlier. Ravi Varma saw 'Judith' during his first trip to Baroda and the painting must have made an impression upon him because a little more than four years later, he created a painting titled 'Judith' that copied Constant's.

Constant painted an Amazonian, sword-bearing woman with her face set in a determined expression. Unlike most depictions of Judith, Constant chose to paint her at a moment before she beheads Holofernes so that the macabre quality of the just-sliced head wouldn't intrude upon the work. She is beautiful, with milky white skin and a temptress' red lips, wearing a tantalizingly unbuttoned gown; but her determined expression and the hefty sword she carries make her a warrior. Although she wears jewellery and her silken dress is in a fetching pastel shade, there is little of the traditional feminine softness in her. She also carries her sword with ease and attracts attention to the almost masculine strength of her arms.

Like Constant's Judith, Ravi Varma's Judith also does not brandish Holofernes's head, and she too carries a sword. She stands in a room of shadows, not looking out of the painting but with her head turned to show her profile as though she is looking into an adjacent room. There's a squared-shouldered determination in her unnatural stance that you can see despite the dim lighting. The light in the room slips down the folds of her silken pants and the fabric that is rumpled around her waist, which leaves her upper body unclothed. She holds the large sword behind her as though she is shackled to it.

The pose is awkward. Even though her head is turned away, her body faces forward and the curiously placed light clings, like most people's stares, to Judith's bare breasts. She stands so proudly that it seems vaguely disrespectful to have one's gaze return repeatedly to her opened blouse, but Ravi Varma painted the light in such a way that it is impossible to look away from

158

Judith's torso. It's easy to imagine yourself as Holofernes seduced by this beauty. 'Judith' isn't one of Ravi Varma's best paintings, but it is a competent copy and its style is a far cry from the Tanjore-influenced portrait of the Mysore royal children.

It also shows why he worked so hard to find models:he wasn't very good at imagining a posture (this was a problem that would crop up repeatedly). When he painted without a visual reference, the body looked like a jigsaw puzzle in which pieces have been forced together to create an uncomfortable fit. But 'Judith' also shows how well Ravi Varma used the opaqueness and translucence of colours and shades. Judith may not be very realistic but she certainly is eye-catching. The painting hangs today at the Sri Chitra Thirunal gallery in Thiruvananthapuram and almost every visitor seems to be taken aback for a moment when they first see the work. With exaggerated casualness, men and women walk back to it after they've seen other paintings and linger for a few moments longer. For all its flaws, there's something arresting about the painting and when Ravi painted it in Mavelikkara, it must have caused some chatter.

- God in heaven! Is that a woman or a eunuch? Who modelled this one for him? His brother? Not even the women who work in the fields look like that!

- If it wasn't painted so lovingly, I'd have said he's painted a man with breasts.

- Maybe it is his brother. The other day, I saw the two of them trying to tie one of those saris that he brought back from his travels. It was hilarious!

- Did someone give him round fruits to eat when he made that painting? Is that why his Judith painting has breasts that look like unripe melons?

- If this is what white women's breasts look like, I can see why they want to wear blouses. The question is: how did he find out what white women's breasts look like under their blouses?

- Is it true that white women have pale pink nipples? In that painting, it's almost as though there are no nipples. Very unnatural.

* * *

In 1888, Ravi Varma was offered the commission that would draw him out of the salons and courts of privileged India and make him famous. He would become the first Indian artist whose paintings would be adored by both princes and commoners. India would know him as the prince among painters, the man who could bring the gods down to the earth with his brush, the artist whose works showed a country that for all its diversity, also shared a wealth of traditions and beauty. Up till now, Ravi Varma had been a gifted artist. With the second Baroda commission, he became a national hero.

By 1888, the Gaekwad of Baroda had a curious relationship with the British. On one hand, the young ruler had used his Victorian education to modernize his kingdom, making Baroda one of the wealthiest and most powerful princely states in India. The problematic aspect of this development was Sayajirao's unabashed support of the nationalists who claimed Indians were perfectly capable of governing themselves. Sayajirao pointed to the initiatives he had undertaken in Baroda as proof of this. He had worked towards setting up infrastructural projects like irrigation and roads, promoting women's education and ending the purdah system that cloistered them, extending education to those considered untouchable according to the Hindu caste system, and promoting harmony between the Hindu and Muslim communities. In many respects, his rule in Baroda was more progressive than that of the British in the Presidencies, much to the annoyance of the latter.

Sayajirao also managed to slip more than Rs. 100,000 out of Baroda's treasury in 1885 to give to the Indian National Congress, eluding the hawk-like attention of the Resident who would not

have allowed any such donation. Years later, in 1899, Sayajirao would admit to the Viceroy of India, Lord Curzon, that he had been giving the Indian National Congress Rs. 1,000 annually ever since it was established, aside from the starting amount he had given Dadabhai Naoroji, one of the founders of the Indian National Congress.

Ravi Varma was part of a larger project that Sayajirao had taken upon himself. He wanted to help build an Indian identity that was not fashioned out of the prejudices that the Orientalists had harboured. The India that Sayajirao wanted to present to the British was one that was capable of assimilating the advantages of Western education and culture into its own without dismissing its own heritage. In short, Sayajirao wanted to present a modern India that was progressive, yet keenly aware of its roots and lineage. Predictably enough, the British administration was far from supportive of Sayajirao's plans and a few years later, there would be some debate about whether he should be removed from the throne of Baroda and replaced by a more malleable candidate. However, Sayajirao was enormously popular and influential. Unseating him meant risking instability in Baroda and beyond.

The only thing the British administration could do was tighten their leash around troublemaking rulers. One way was to curtail their travel and rigorously implement the policy decision that a king had to get permission from the British to visit another kingdom or native state. When, in the summer of 1888, Sayajirao said he wished to visit Travancore, he was refused permission to do so. Undeterred, he planned a trip to the hill resort of Ootacamund in the Madras Presidency. There was some truth in Sayajirao's claim that he wished to escape the heat of central India, but the reason he travelled down south was that he had a plan and it involved Ravi Varma, whom he invited to Ootacamund.

Sayajirao was building a palace. But not just any palace, he explained to Ravi when the artist met him at the royal residence at Ootacamund. The palace would be one of unrivalled beauty; one whose grandeur would leave everyone breathless. It would be called Laxmi Vilas, the abode of the goddess of wealth. The way Sayajirao was planning it, the palace would be so dazzling that the goddess would never want to leave it. Of course, it would take a few years to build but once completed, it would be four times the size of the British monarch's home in London, Buckingham Palace. The design would be a blend of the many cultures that India was home to. His architect, Major Charles Mant, had created a design that blended the proud majesty of Rajput and Mughal architecture with Jain domes and Gothic features. The palace would rise like a charmed city out of a compound of 700 acres. Within it would be treasures like stained glass from Brussels, Italian marble, Venetian mosaics, elevators from Germany—metallic boxes that had recently been invented which mechanically carried one up several floors, saving one the exertion of climbing staircases—and there would be a Durbar Hall whose opulence would be unmatched by anything seen so far, anywhere in India or elsewhere in the world.

This was where Ravi Varma came in. The Gaekwad wanted to make fourteen paintings for the Durbar Hall. Sayajirao wanted paintings that depicted scenes from the Hindu epics of the Ramayana and the Mahabharata. He believed this was the culture that could bring together the bulk of India. It connected someone like the Gaekwad of Baroda to Ravi Varma of Travancore. This tie had been forgotten in recent ages, but it was important to keep in mind, now more than ever, that the British had not made or discovered India. They had merely helped Indians remember this ancient culture. Had Rama not gone from northern Ayodhya to Lanka that lay at the southern tip of India? And that too without the aid of British iron horses and railway tracks?

Sayajirao wanted these paintings to resonate with a sense of native antiquity but still be unquestionably modern. In the Gaekwad's mind, no one but Ravi Varma could do this. There were other, younger artists who were skilled in Western techniques. Some of them had studied in well-respected European art schools but Ravi Varma was the only one in whom Sayajirao saw the kind of grounding in Indian culture that he wanted in the paintings for his Durbar Hall. Wherever Ravi's paintings had been exhibited, they had captured the imagination of viewers from diverse backgrounds. Whether they were foreigners or Indians from other parts of the subcontinent, when they stood before a Ravi Varma painting, they were captivated by the beauty that was unmistakably Indian. To Sayajirao, this meant that the artist did not belong only to Travancore. If home was where the heart was, then Ravi Varma had homes across the country, for he was loved like a native in every kingdom that had one of his paintings. The many competitions and exhibitions in which he had taken part had shown him the country in a way few artists knew it. He had travelled through its heartland, seen the colour of the earth and the green of the leaves change. He had grown up with the old traditions and he had embraced the new. Sayajirao believed he had the potential to become India's first modern artist: one who could balance the old and the new that were so closely intertwined. And for this commission, Sayajirao would pay the artist a fortune: Rs. 50,000. A well-sized diamond cost Rs. 100 at the time, so to gauge approximately how much the amount would mean in today's terms, it needs to be multiplied at least seven to ten times over. It was unheard of that an artist would be paid such a sum, that too an Indian artist.

Having achieved a degree of acclaim at a young age, Ravi always kept his prices significantly higher than what other Indian artists charged. Money was a grubby thing, not something royalty concerned themselves with, but Ravi knew that the only way to

establish himself as a class apart from his compatriots was to be expensive. It gave out the message that he didn't need anybody's 'business'. If they wished to have a Ravi Varma painting, then they had to have it on his terms. We don't know how much he charged early on in his career, but his prices were never much lower than what a European painter charged and they began creeping higher as his work became increasingly coveted. The rates for European painters dropped sharply in the mid-1800s, possibly because the alumni of different art schools were giving the foreigners stiff competition. In the late 1890s, Ravi Varma charged Rs. 1,500 for a full-length portrait, Rs. 700 for a half-length and Rs. 300 for a bust. It was an astronomical amount for the times. His fellow artists generally charged Rs. 300 for a life-size portrait, and that too, if they were very well established. Even so, no one could have anticipated that Ravi Varma or any other artist would be able to earn Rs. 50,000 from one commission. Thanks to Sayajirao's magnanimity and wealth, Ravi became a legend even before he had made a rough sketch for any of the fourteen paintings. Determined to prove himself worth the extravagant amount the Gaekwad had offered him, he began his preparations immediately.

By the time he left Ootacamund, his mind was racing with ideas of which stories would make dramatic paintings. To epitomize India in a few paintings was a daunting idea. It made one realize suddenly how little they knew of this country. With Raja, he drew up a list of places that they needed to visit and spend time in to understand the range of the styles and traditions that existed in the subcontinent. There were so many cities in their first list that it looked more like a land surveyor's itinerary. It would take them years to cover all this ground. So they began whittling the list down to the bare minimum. As Ravi marked out the places that they could not, under any circumstances, ignore, it became clear that by the end of this tour the weight

of their notebooks and sketchbooks would be equal to their own body weight.

By the time Ravi began working on his Baroda commission, his brother Raja was well established as his assistant and secretary, despite being a gifted artist himself. He was a talented landscape painter and a member of the Madras Sketching Club. A number of his paintings had won awards at competitions and exhibitions. But his track record could not compare to that of his brother, and he was never tempted to compete with Ravi. He was convinced his elder brother, his Chetta, was the one to be revered and besides, they were a team. Ravi Varma's paintings had been bought by the most prestigious of India's royalty and those who didn't have one of his portraits clamoured for them. One of the ways of keeping up with the demand was having an able assistant and there couldn't have been an abler one than Raja Raja Varma. The two brothers became the brand Ravi Varma, signed at the right-hand corner of the paintings, and the younger brother was content with this arrangement.

According to the itinerary for the tour that they had had drawn up, Ravi and Raja would first visit the places closer to home in the southern parts of the country. Some time would have to be spent in Madras, but more importantly, they needed to visit the temple cities—Madurai, Srirangam, Chidambaram, Mayavaram—and they would need to keep aside some time for Thanjavur. The artists may have left the old city, but it still had some of the finest examples of architecture from the Chola era and it had the legendary Vijaynagara Fort nearby. The north was more difficult to decide because neither of them knew the region too well. They had to visit Agra for the Taj Mahal and Fatehpur Sikri and from there, Ravi suggested some time in the province of Oudh. Not only was this where they said the legendary Rama's Ayodhya used to be, it was also considered one of the great cities of Mughal culture. Delhi and Lahore were also unmissable

because of their rich history of art, architecture, and music. Then, to go so far up north and not make a pilgrimage to the holy city of Kashi made no sense, and it was added to the list as were some important kingdoms of Rajputana and Calcutta, the city so beloved of the British. It was a trip that the brothers hoped would allow them to see the finest of all that came under the umbrella of Indian culture, and would bring them a little closer to the distant kingdoms where Ravi was relatively less famous. The tour would also serve the purpose of some self-promotion. The decision to include Rajputana in the itinerary must have been guided to some extent by the prospect of getting a few invitations from its many kings and princes.

* * *

The Bharat Darshan of 1888 was the first time either of the brothers were embarking upon such an elaborate journey. They would mostly be staying in inns and at the homes of strangers who were friends of friends. Who could tell what could crop up? There was nothing that could be left behind: warm clothing for the colder nights in the north, cool cottons for the humid south, medicines for fevers and indigestion, notebooks, sketchbooks, ink, paints, canvases, easels, servants. It was quite a production. Their families must have considered them a little peculiar. No one had heard of such an expedition being undertaken for a few paintings. It sounded like the elaborate pilgrimages people undertook when they were old, and the brothers must have been asked repeatedly by various relatives and acquaintances how this trip was actually going to help. Were they going to paint what they saw on their travels? Was this tour a pre-condition of the commission? Their confusion was only deepened when Ravi replied that it was very unlikely they would paint scenes from their travels.

The curiosity wasn't limited to their families in Kilimanoor and Mavelikkara. Everywhere they went, they were asked why

they had undertaken this mammoth exhibition and what they had enjoyed most so far. Raja Varma generally didn't participate much in these conversations. He was more of an introvert who was happier to settle into silence with a book. Many found him quite intimidating because of his sombre expression and the fact that most of the books he read were in English. Ravi, on the other hand, was far more gregarious, whether he was at a party or travelling to a speck of a village. He spoke to people and picked up smatterings of local languages and dialects, sometimes making their local translator superfluous. Much like when they painted, the brothers made a good travelling team too. The ease with which Ravi made conversations with people gave them more access to and understanding of local culture while Raja was the scribe who documented things.

The first stop in their journey was Madurai. The ancient Hindu epics had characters like Hanuman who could become enormous at will. If the brothers could do the same, then, standing in Madurai, they could have risen far above the temples and seen the entire subcontinent stretched out ahead of them, a vast palette of browns and greens and blues that blurred into one another. Unaided by such miracles, all the human eye could see when standing in this ancient city whose recorded history went back two thousand and five hundred years were the triangular spires of its numerous temples. They were called gopurams and had been worked upon by generations of the most gifted artists, so that each of them was encrusted with sculptures and carvings that were astounding in their detail. Their intricate beauty rose above the flat southern city like a fence, beyond which the rested the bulk of the subcontinent with its hills, mountains, fields, and rivers. After exploring the lotus-shaped city of temples that had won the admiration of travellers from ancient Rome and Greece, the brothers went northwards. Most of their destinations were not connected by the rail network, so they travelled by bullock cart

and passed by fields of cotton and sugar. They halted at villages to let the animals rest, stretched their legs, sometimes chatted with a few locals before carrying on.

When they were asked in Madurai what they thought was the most spectacular thing they had seen, Chetta said smoothly that it seemed unlikely anything would match the intricate beauty of Madurai's gopurams. It pleased their proudly Tamil host greatly and he launched into a short lecture about the antiquity of the city. At Chidambaram, the same question received a different answer. How could one not be awed by a library that boasted of palm leaf manuscripts in a wealth of languages including not just Sanskrit but also English, French, and Latin? said Chetta. He would perhaps have waxed equally eloquently about the temples of Mayavaram but before he could, one of the locals in Mayavaram told Chetta about the nine yard sari that the weavers of this area were famous for. So they rented a bullock cart and went to Koorainadu, where these saris were woven. The saris were woven with silken threads and their colours were shining, rich, and dense, as though the threads had been dyed in liquid jewels. The looms were made of wood and they clacked rhythmically when the weavers were at work, their fingers cleverly tugging the threads into a taut, glistening sari that spilled like a river of colour. To their eyes, which were used to the white cotton and silks that their mothers and wives wore, it was blindingly beautiful.

By the time they had completed their tour of the southern part of India, Chetta and he were beginning to wonder about the question that everyone asked them. What was the most spectacular part of their travels so far?

'I think along with the Saraswati Mahal Library in Thanjavur, the Ranganathaswamy temple in Srirangam would be my most cherished memory of this part of trip,' said Raja.

'I'm not sure I can decide,' Chetta said with a laugh. 'Remember the Nataraja and the hundred and eight Karana carvings at Chidambaram? To think we were in the place where the ancients say

dance was created! And what about the craftsmanship of the goldsmiths and silversmiths of Mayavaram?'

'So will you dress all your heroes and heroines in their golden jewellery?'

'Do you suppose it will suit the face of a lady from the north, say Lahore?'

'Chetta, you won't find anything that can be found both here and up in the northern reaches of India.'

'Except us, you mean?'

Ravi and Raja Varma ended their southern travels with a stop at Madras, where they relaxed for a few days before taking the train to Bombay, their gateway to Upper India. The divide between southern India and the rest of the subcontinent is something that travellers note even today. Back in Ravi Varma's time, the difference was even sharper. As the train left the southern plains and puffed its way into the area around Bombay, the world outside the window changed like the pages of a flip book. Bumpy hills now broke the flat land. As the landscape changed, so did the air. It became sticky with dust and unfamiliar smells laced every breath. The languages that hummed around them had lilts and accents that had nothing in common with either Malayalam or Tamil, the two main languages of the south. Instead, here it was Marathi, English, and a chirruping mix of dialects and pidgin that came out of Bombay's years as a thriving centre for ship- building and repairing.

The city was unlike any other place the Varma brothers knew, an observation they would make repeatedly, even when it became a second home for them in later years. It was chaotic, prosperous; and crammed into it was a wealth of things to do and see. In contrast to the antiquity of the southern cities they had come from, Bombay was all about novelty. It was the place of new ideas, new money, and new buildings like the Rajabai Clock Tower, the Bombay Stock Exchange, and Victoria Terminus that occupied

pride of place at the heart of the city and was about nine years from being completed. Women, particularly the British and the Parsis, walked along public promenades, unobscured from public view and unperturbed by the presence of men. There were theatres that showed plays in English, Marathi, and Gujarati. Men on the street wore a combination of European coats and dhotis, showing the fusion of traditions. Flower shows were held in gardens. Bands played on the Esplanade. The newest of everything was here in Bombay, whether it was a book from England, a pianoforte, saddles, brandy, or even diamonds.

Bombay was only a stopover, so the brothers didn't spend too long in the city. Ravi spent many hours scouring the markets. He visited cloth merchants to see what kind of fabrics and patterns were available and if he could use them in his paintings in any way. He studied the clothes people wore and the fashions around him, hoping it would inspire him to decide how his painted heroes and heroines would dress. He needed them to be easily identified as Indian but not in a way that made them belong to a specific part of the subcontinent. After all, as the Gaekwad had pointed out, the stories that Ravi was going to paint belonged to the entire country.

The brothers also made friends among the city's elite. Ravi's friendship with influential men who regularly frequented Bombay, like Madhava Rao, Sayajirao, and the senior British bureaucrats he met at the various exhibitions he had participated in, meant that the artist had an enviable list of contacts in the city. Scholar, reformer, and judge Mahadev Govind Ranade was one of Ravi's more famous friends, as was Dadabhai Naoroji who at this time, had returned to England after setting up the Indian National Congress. Among the artist circle, Ravi Varma counted among his acquaintances the British artist Frank Brooks, who helped him find models on many occasions, the Parsi painter N.N. Writer, and John Griffiths, a professor of painting at the Sir J.J. School of

Art and longtime friend of Lockwood Kipling; father of Rudyard, Lockwood was himself a famous teacher and the one who had designed the unique carvings of Crawford Market. The company of these men helped to make Bombay all the more appealing to Ravi and Raja, who were in any case charmed by the city's vibrant cultural life—its salons, plays, concerts—and the thriving world of debate and enterprise.

From Bombay, the brothers continued their tour and entered what was known as Upper India. The northern part of the tour felt more demanding than the southern, possibly because the lands they travelled felt stranger to them. They were easily identified as tourists and the locals knew little of the place that the Varma brothers called home. People were mostly welcoming and hospitable, however, and few held any suspicion or ill will against them. Ravi Varma began picking up some Hindi and his accented efforts must have earned them giggling friends in a number of places, especially in Awadh and Kashi where great pride was taken in the mother tongue. Unlike in Bombay, however, the brothers never felt like they could belong to these wonderful cities and towns they were visiting. Both brothers fell ill repeatedly, their bodies unused to the harsh, dry climate and the food.

Everything was different here. Even the taste of water changed. It was sweeter here than what they drank in Travancore and it didn't seem to suit them as well. There was dust in the north like they didn't have at home. Buildings rose out of the earth differently. They stood like planted guards, standing out partly because of their height and because their colours and their detailing were designed to keep them distinct from their surroundings. Forts stood solidly atop hills, often looking like jewels mounted upon rings. One's eyes needed time to settle down here. The sun's heat and light were piercing. Men and women covered themselves up more securely here to protect

171

themselves from the insidious dust and the burning sun. Women of all backgrounds protected their heads with their upper cloths, often holding on to the looped material with clenched teeth. It was an unusual sight for the Varma brothers since there was no such practice in southern Indian. They might have seen women with their heads covered occasionally during the Baroda trip but since women were rarely seen out in the open, particularly in the city, the difference would have struck them most strongly during this trip. Now they were going through villages and it meant they got to see much more of the people who made their homes in Upper India.

As they travelled across all of western India, Raja must have wondered how his letters read to his wife Janaki, who had seen little beyond her hometown of Mavelikkara. Did his letters convey anything of the vastness of this country they were seeing? Did she understand what he meant when he wrote about the the earth beneath them changing colour and turning into fine sand when they reached Rajputana? Could she imagine there was a place that had no trees and which was only a few hours away from the forts and palaces that had pretty green gardens and fountains that scattered crystal drops of water all around? The colours here seemed to have the heat of sunlight mixed in them. There was no moisture in the air, and houses and palaces were not just white and wooden. They were made of stones and these came in many colours: a rich yellow; a pale red like the colour of the sky when evening blurs into night; or veined, opalescent marble. The landscapes Raja saw as they made their way through deserts and then the more fertile plains fascinated him. Like Ravi Varma, he too painted quick sketches of things he saw as they travelled: a woman at a roadside shop, a house with an open door and a brightly coloured cockerel grazing outside. When he would return to some of these places, like Udaipur, a few years later, Raja would find the time to paint some delicate, mirage-like

watercolours showing the palace on the lake that was so precious to the locals.

They travelled extensively through Upper India, but certain places made a deeper impression than others. One was Rajputana. The name meant the land of kings but it should have been called 'the land of forts'. There seemed to be a fort in every village, every hamlet in this proudly Hindu territory; and these structures made an exhibition of opulence intertwined with military strength. No one could doubt this was the land ruled by kshatriyas. Pride was everything among the people here. There were many who had not forgiven the royal family of Jaipur for having sided with the Mughals more than two centuries ago; so much so that even a humble vegetable seller would prefer to not marry his daughter to a boy from Jaipur. The palaces here were exquisite. They had marble screens, curling enamelwork, halls with mirrored walls, and ceilings that sparkled with hundreds of reflections. But the way to these palaces was through villages that were terribly poor and had seen little development. An old feudal system was at work here and was like an invisible monolith that was everyone's touchstone, no matter how high or low they were in the social hierarchy.

Even though Ravi took little from either the Mughal culture of Awadh, which fused elements of Persian artistry with the local art forms, or the traditions of Rajputana, the brothers spent time studying miniatures like the Ragamala paintings which depict the mood of different ragas through images. When meeting the kings of Rajputana, Ravi was diplomatic and had to be careful that he wasn't getting embroiled in their disputes and ego tussles. They worshipped the same gods, shared an artistic heritage, and nursed a common sense of mistrust about the Muslims who had planted their roots in Rajputana because of the Mughals. Yet rivalries coursed through the different families. They nursed grudges for generations and there was virtually no sense of unity in the region.

Another place that would have been of importance to the Varma brothers was Kashi, the ancient city by the holy Ganges. In late eighteenth century, Kashi was not the crumbling and crowded place that it is today. The same lanes that are nowadays layered with a glutinous mix of dung, mud, crushed flowers, and garbage were not crowded or filthy then. The ornately decorated homes were not festooned with wires and laundry; instead they stood proud and beautiful. For Ravi, Kashi was important for its religious value but also because the Ganges offered him a chance to study a thing of beauty that he was hard-pressed to find anywhere else in the country: the female nude.

Like the scores of people who came to visit Kashi, Raja and he also hired a boat to take them up and down the river. There were fourteen ghats, enclosures with steps running all the way into the river, and they were lined one after the other. The best way to see them all was by boat. It was the least strenuous and offered the viewer a wonderful view of Kashi with its many temple spires rising above the river. It was peculiar and poetic to see the flames and black smoke of a funeral pyre just a stone's throw from a ghat where devotees clustered on the steps to bathe in the holy river. From their boat, they could see the seemingly endless stream of pilgrims who came to the ghat and then gingerly made their way down the steps to take a dip in the swirling saffron waters.

Hindus believed that the waters of the Ganges washed away a believer's sins. Whatever the waters touched, they purified. They also turned cotton transparent and made silk cling to the skin, but here at the ghats, modesty was forgotten even among women. Widows, prostitutes, wives, and daughters all came to the ghats and let the waters reveal them because it was believed that the blinkers of faith protected women from the lustful stare. Perhaps it was true because it seemed as though no one cast a second glance at the bodies, whose every line, crevice, and detail was outlined by the wet sari. Or perhaps the watchers hid their interest well, like he did as the brothers scanned the

174

ghats from their vantage point. If one of the girls at the ghat looked up, she would just see a boat, like so many others, drifting past, albeit a touch slowly. She wouldn't know that from the boat, an artist was studying her form, how her body was sculpted, how the cloth hung from it, and the mechanics of different feminine poses. The brothers stared at the emaciated widows with shorn hair and hunger-bent bodies with the same intentness as when the dimpled curves of the pink-cheeked prostitute came into view. It wasn't quite the kind of study of a nude that Europeans were used to, but the ghats allowed Ravi a chance to see many poses that he could use his paintings. The women walked out of the water and up the steps. To pick up their dry saris, they bent down. Many sat on the steps to wash themselves. The challenge for the brothers lay in applying what they saw in these bodies to the figures of their painted heroines.

The royal families, however, were not so trusting of faith and the faithful. There is the story of a newlywed bride from Bengal who had married into one of Kashi's aristocratic families. Being a devout Hindu, the girl was excited about belonging to a family from the holy city and after about a year of marriage, she shyly told her mother-in-law that she would like to take a dip in the Ganges. Her in-laws agreed readily; the young bride sat in a beautifully bedecked palanquin and made her way to the ghats. But the bearers of the palanquin didn't stop once they reached the top of the steps. They kept walking down the steps, further and further. They didn't even stop when they reached the first step that touched the river's waters. They climbed down the steps until they reached their midriffs. Then they lowered the palanquin into the Ganges until it vanished. No one paid any attention to the vanished palanquin. Sitting inside the curtained box was a girl who was getting her Gangasnan, or holy dip. The water slithered in and rose; perhaps the currents of the river tugged at her and threatened to drown her. Then the bearers pulled the palanquin up again and returned the way they had come.

It is unlikely that Ravi Varma saw a woman as beautiful as the one he painted in 'At the Bath' at the ghats but it's very possible that the idea for the painting came to him there. After completing the painting, there were many romantic stories he spun to explain it. The one that the younger Rani of the house of Travancore knows goes like this: 'At the Bath' came from a dream. Ravi Varma dreamt a scene that felt so real that he thought he had been transported to the ancient times that the legends speak of. She was a young girl, blessed with the heavenly beauty of goddesses. Pure and virtuous, she had devoted her life to worship and prayer. Then one day, when she was at the bath, she heard the sound of hoofs and looked up to see a prince. He had been going past the bath but the sight of this girl had made him stop. When he woke, Ravi immediately began sketching so that the perfection of his dream was still fresh in his mind. And so, he said, the painting was born. While he may have had this dream, it seems more likely that it is among the women he saw at the ghats that he found his inspiration. As he gleaned from his observations how the female form could be fashioned in myriad ways, he had probably desperately wished that there was one woman—one beautiful woman—who would let him watch her and understand the way her body moved. Of course, she would be shy at first but they were at the bath and it was acceptable for her to lower her sari so he could see her. 'At the Bath' shows the moment when the girl has not revealed herself. She's still tremulous and he's yet to convince her but from her smile, it seems she's ready to give in. It took years for this painting to go from thought to canvas. Even after he started the painting, Ravi Varma found his imagined heroine shying away from being realized in his drawing. Ultimately he found her and persuaded her to trust him. However, the woman who brought the painting to life was not a damsel from his dreams but a prostitute from Hyderabad.

People, particularly the British they met, must have asked the Varma brothers what differences, if any, they found between the different parts of India. Unfortunately, these are the everyday conversations that few keep records of, and so we don't know how the brothers explained the curious combination of familiarity and complete alienation that they must have felt after their first tour of India. The strong Mughal influence that marked significant tracts of northern and central India would have been something of a revelation. Being conquered and ruled by an outsider had left a stain upon the land, like skin that was burnished due to being in the sun for too long. Even though Mysore was nearby, the Varma brothers had little knowledge of Mughal aggression in sheltered Travancore where the presence of the British was a yoke upon the Maharaja, yes, but not a terribly oppressive one. They had no conception of how it must have been for the people of Kashi to see their temples being razed by Ghori, Ghazni, and then Aurangzeb; or to have to flee the place of their birth to hold on to their culture.

Yet, it wasn't as though the Mughals were barbarians. One had to reconcile the violence they had inflicted upon some places and people with the beauty of their monuments, like the abandoned city of Fatehpur Sikri; the delicacy of their miniatures; the graceful allure of their chamber dances. Raja, who was the more Anglicized of the two, may well have wondered how places like Bombay, Madras, and Calcutta would feel if the British stayed in the subcontinent long enough, ruled, and mingled as determinedly as the Mughals had in places like Lahore and Delhi. What would be the citadels of British culture and would they be able to compare with the exotic beauty of monuments like the Juma Masjid in Lahore, for example? Would Ravi Varma's paintings, fêted by British judges in exhibitions, belong to their artistic canon? With the gathering strength of the nationalist movement

and their determination to maintain a certain divide between Indians and themselves, it seemed unlikely that the British would blend like the Mughals into Indian society.

The word India meant different things in the nineteenth century. For the British and the Anglicized, it was the name they had given a colony that was made up of many kingdoms and regions. India was the jewel in the crown, a source of raw materials and cheap labour, the place from where soldiers could be picked up to be deployed to other parts of the British empire. For those who were born into this colony, however, the events of the past hundred odd years had wrought a change in what India symbolized. It was no longer just a term of convenience fashioned out of foreign languages. Now it united different kingdoms. To Indians, India stood for a nation. Their nation.

In a *Times of India* article on the fifth meeting of the Indian National Congress, the writer reported that there were six thousand 'listeners' of whom two thousand were members of the political party. 'Ethnologically, there is no unity but endless variety,' said the article. 'Not a single test of nationality is fulfilled.' This was true to some extent. India was indeed many countries but the boundaries of these countries were not decided only by language, dress, and custom. The colonial yoke was blurring those lines and the country was fast being divided into the Anglicized and the non-Anglicized, the rich and the poor. Travelling through the Deccan, the Varma brothers must have seen the recently begun tea estates, perhaps from a distance. If they stopped and spoke to any commoner in the villages, they might have heard about the horrific conditions in which the menial workers were kept in the tea gardens. It's estimated that one third of the workforce of a tea garden died within six months of joining. But the Varmas' society was far removed from these people. They belonged to the multicultural elite that knew their Dickens and mother tongue equally well. This was what Digby called Anglostan, and its

brown residents were no longer happy being useful porters to the British Raj. Although predominantly Hindu, peopled by the educated elite, and yet to gain the popularity it would in the twentieth century, the Indian National Congress made a historic decision in 1888 to bar discussion of any subject that could be defined as 'social'. Instead, their focus would be on economic and political concerns, which meant the party was going to focus on issues that concerned people beyond the boundaries of Anglostan. These were the first tentative steps towards self-governance.

Ravi Varma's importance lay in that social realm that the Indian National Congress didn't want to discuss. With the Baroda commission, it fell upon him to claim the nationhood that popular British opinion denied Indians by pointing at the differences between the various local cultures. If Ravi Varma had set off on the India tour with the hope of finding that elusive symbol that united India, he would have soon realized that it wasn't there to find. He was going to have to create it out of all the different Indian cultures he came across.

The hunt for this essential Indianness was an exhausting affair. None of the traditional outfits they saw appealed to Ravi Varma. They all spoke of one region. He needed something that wouldn't make a viewer think that the women were from one particular place. Looking at the painting, the viewer needed to feel as though this could be his wife or daughter or the lover he dreamt of, depending upon the painting. So he went to bazaars and village squares, hunting for the material and the colours he could drape his women in. In Kashi, he spent hours in a gloomy, dark lane, watching weavers make the elaborately patterned silk saris that were traditional to the area. In Bombay, he went to the wholesale cloth market and made sellers pull out mountains of material. He made shop boys drape the fabric waterfall down the front, hang it so that the cloth made a 'v' in front and other curious combinations that mimicked the dresses they'd already

seen on their travels. Apparently, it was in Calcutta that Ravi Varma decided that his heroines would wear saris. The Bengali style of wearing the garment, with the pleats in front and the aanchal trailing behind almost like a train, was a combination of many traditional women's outfits. The hugging skirt of the mundu that they wore in Kerala, the flowing upper cloth that protected the modesty of northern women, and the blouses that the Europeans had introduced, all came together in the Bengali sari.

The city of Calcutta was not as dear to Ravi as Bombay. He was never tempted to stay here for extended stretches, perhaps because it was too far away from Mavelikkara and Kilimanoor, or maybe because the city was too emphatically Bengali for the Malayalam-speaking Ravi. The Bengal Renaissance had made Calcutta a vibrant and modern city. Some of the finest classical musicians performed here; there was a glittering theatre district. A thriving culture of literary salons had made the city well known for its writers like Bankim Chandra Chatterjee, Michael Madhusudan Dutta, and Rabindranath Tagore. It was not a city of royal families like Rajputana. Here in Calcutta, the elite were the ones who were modern and educated.

In the late 1800s, when Ravi Varma visited the city, Calcutta was home to artists who would be hailed as the future of Indian art after his death. One such artist was Abanindranath Tagore, nephew of the celebrated poet Rabindranath Tagore, who would become one of the most important artists of twentieth century India and whose uniquely Indian style would make critics savagely criticize the Eurocentric aesthetic that Ravi's paintings espoused. But at this time, Abanindranath and the other men who would become Ravi Varma's successors were still too young. Ravi probably saw the works of some student artists at the Calcutta School of Art during his stay. Until the end of his days, he was eager to see what was new in art and wherever he went, he

asked after local artists, so it is unlikely he would have made an exception for Calcutta. The artist in him would have wanted to see what the next generation was doing. The father in him would have wanted to know his son's competition, because waiting for him in Mavelikkara was his eldest son Kerala, the one whom he imagined would follow in his footsteps.

* * *

It took Ravi two years, including the four-month Bharat Darshan, to complete the Baroda commission. He and Raja did some of the paintings in Mavelikkara, but many were also done in Kilimanoor where aside from Raja, Ravi took the help of a local artist called Khunjan Varrier, and Mangalabai, the youngest of the Varma siblings. She was eighteen years younger than Ravi Varma and little is known of her even though she and her nephew Rama would be the second generation of the Ravi Varma school of painting. It's unlikely that she had seen much of her brother as a girl, but like him, she too was interested in the art of oil painting. She learnt from her uncle, as Ravi had in his childhood, and then her brothers may have stepped in very occasionally as teachers. Her later works suggest she was a gifted portrait artist. However, her talent wasn't given as much encouragement as Ravi's because of the unavoidable pressure on her to follow the established pattern of matrimony and motherhood. As a man, Ravi was less constrained and it was acceptable for him to leave behind his family in Mavelikkara to pursue his dreams. No such liberties extended to Mangalabai, who was groomed to be an aristocratic wife who remained within the boundary walls of Kilimanoor Palace. In fact, it was considered forward enough that she assisted her brothers when they were working on the Baroda commission in Kilimanoor. Once married, it was considered improper for a woman to spend so much time alone with her brothers. But Mangalabai managed to balance social mores and her personal

ambitions, and went on to assist Ravi in a number of important projects over the rest of his career. Even though she is largely forgotten now, she must have built quite a reputation for herself because she became a sought-after portrait artist after Ravi's death. The most circulated image of Ravi Varma is the portrait she painted of him when he was awarded the Kaiser-i-Hind in 1904. In fact, she was more in demand than her nephew, and she managed to achieve this without any of the controversies or scandals one would have expected about a married woman of an aristocratic family choosing to become a professional artist.

At the time of the Baroda commission, Ravi Varma was forty years old, Raja was twenty eight, and Mangalabai was twenty two. They worked together with smooth efficiency. Supervised by their elder brother, Raja and Mangalabai would paint the surroundings and any props that the scene may have, after the initial sketch was completed by Ravi. On occasion, Raja helped to draw the figures. Ravi kept the painting of the figures for himself, particularly the faces. Mangalabai, who died in 1953, told biographers that if Ravi felt unsure about a painting, he would ask her opinion and would generally take her suggestions. Theirs was a collaborative process, and not only did it let Ravi produce paintings quickly and efficiently, it also allowed three distinct artists to use their best skills to create one work of fine art that carried the name Ravi Varma, much like a brand.

The Gaekwad of Baroda had told Ravi that he wanted fourteen Puranic paintings, and he had left it to the artist to decide which of the thousands of stories should be translated to the canvas. Ravi's selections have three themes running through them: strength, separation, and children. The epic heroine who shows fortitude and strength of character appears in eleven out of the fourteen paintings. Even in the painting titled 'Disrobing of Draupadi', the heroine is the one who embodies strength despite the violence that is being inflicted upon her. The men in

182

the Kaurava court where Draupadi is almost raped are the weak ones. 'Kamsa Maya' shows the mighty king cowering with fear while in the sky hovers the barely discernible form of a goddess in a glowing orb. Most of his heroes are flawed men who lack the fortitude of the women. Aside from Radha in 'Radha and Madhava', the paintings with women generally show them as the ones with power. Mangalabai has said nothing about being involved in the selection of the stories but one look at the heroines and it seems fitting that a woman was part of the team that created these paintings.

The sage Vishwamitra attempts to look rigid and stern in 'Vishwamitra and Menaka' but ends up looking almost comical in his efforts to resist the smiling Menaka who only has to sit next to him to seduce him. Like Menaka, the nubile Satyavati just has to give Shantanu a teasing look and a smile to bring the warrior king to heel. She stands like a child, apparently too innocent to know the allure of her bared adolescent breasts, and the contrast between her childish stance and Shantanu's adult moustachioed face is almost disturbing. In 'Arjun and Subhadra', once again it is Arjun who reaches out eagerly for Subhadra, who coyly looks away from him.

'Sita Swayamvaram' shows the happy beginning of Rama and Sita's marriage. The role of the husband is the one thing at which Rama fails spectacularly. Not only is he unable to protect Sita from Ravana, but when he does finally win her back, his unjust behaviour as a suspicious husband earns him a reprimand from the same gods who praised his strength when he broke the bow and won her hand at her swayamvara. The painting 'Nala and Damayanti' shows Nala at the moment when he is at the nadir of his life. He is a husband who has not only failed to provide for his wife but is robbing her of half her sari, so risking the loss of her modesty. In the story, when people see Damayanti in her ragged sari, they fail to recognize her as a princess and instead

think she is a mad woman. Her strength lies in her not letting their jeers and taunts rattle her as she continues to look for the husband who abandoned her.

Another intriguing feature of the Baroda commission is that of all the tales that may be found in the Mahabharata and the Ramayana, Ravi Varma picked few that had happy endings. Despite the mannered beauty of his canvases and the brightness of his colours which remain vibrant even today, almost every story he picked has in it a brooding sadness that comes from separation. Radha's outstretched arms in 'Radha and Madhava' seem to foreshadow the many years she lived with only the memory of Krishna to keep her company. In 'Keechak and Sairandhri', Draupadi has to suffer Keechak's leering advances because she is separated from her husbands.

Children, and sons in particular, show up repeatedly in the paintings for the Baroda commission. 'Young Bharat and the Lion Cub' shows a precocious young boy, recklessly provoking a wild beast and confident of his strength even though all he has in hand is a twig. 'Devaki and Krishna' shows another boy, Krishna, and he too radiates confidence. He knows he is special and he accepts his mother's adoration easily. He isn't embarrassed by her falling to her knees before him; he expects it of her. The most powerful of the child-themed paintings is perhaps 'Shantanu and Ganga', where Ganga is seen rushing into waves dragging a boy—her son—with her into the watery depths. Far in the distance is a tortured Shantanu, unable to protect his son from being taken away from him. There are many flaws in the painting, not the least of which is in the way Ganga is drawn. Below the sweet face and above the slender legs is a torso that has the solidity of a man's body. She seems to have no waist and as with many of Ravi Varma's painted women, the breasts, visible through the semi-transparent sari, seem to be awkward afterthoughts. But despite these problems, the painting has a certain energy to it. Even though the anchal is

bent like an origami flap, you can feel Ganga's urgency from the way her sari is whipped by the wind. And then there is the sweet smile upon her lips, which is so terribly at odds with the fact that she is about to drown her own son.

The Baroda commission paintings are not the most accomplished of Ravi Varma's works if one considers the span of his career, but they are among the best examples of his work until 1888. The Gaekwad of Baroda displayed them with all the pomp and grandeur he had promised Ravi. However, if he had questioned the artist about his choice of subjects, no one could have blamed Sayajirao. He had asked for paintings that celebrated the glory of Indian culture. The artist gave him fourteen paintings that were hardly uplifting. On the contrary, most of them were weighed down by bitterness and melancholia. These were not emotions that one expected to see in the works of an artist hailed as India's greatest painter. Perhaps the choices Ravi made when picking stories to paint contained hints of his own personal turmoils.

* * *

Between 1888 and 1890, Ravi came to Mavelikkara a few times, but he didn't stay long and the days that he did spend in the palace of Ulsava Madhom were mostly devoted to painting in his studio. Were the many troubled and unfortunate lovers he painted for the Baroda commission his way of dealing with his own strained relationship with Bhagirathi? Did he see himself as the failed hero in his story? Ravi Varma was not a man who admitted to self-doubt, but the past few years had been hectic; and while they had been rewarding, they had also left him with very little time for those who waited for him in Mavelikkara. It is very likely that Bhagirathi held the separation against him. Perhaps she didn't understand that it wasn't just that he felt bored with the life of a country aristocrat. There was a charisma to the

world beyond her home that she probably couldn't appreciate. He had walked over a Japanese bridge; he had dined in the light of Belgian chandeliers; he had talked with governors and kings. After all these experiences, what charms could Mavelikkara hold for him? Yet he did seem to have made an effort to remain within the confines of this little town, watching elephant fights and the swaying leaves of the coconut and palm trees. He did so because he wanted to watch his children grow. He wanted to be to Kerala and Rama what his uncle and father had been to him. But the world beyond called him out repeatedly and he couldn't refuse. He was meant for a different life and it was one he wanted to pass on to his sons in particular.

In 1889, Kerala, Ravi's eldest son, would have been fifteen years old. By this time, he should have been married and preparing for the responsibilities of adulthood. He should have been accompanying his father as an assistant, as his brother Rama would a few years later. Instead, Kerala Varma slips out of the story of his famous father's life and disappears, like the infant sons whom Ganga drowned and Shantanu was unable to save.

In his early years, little Kerala seemed to be following in his father's footsteps. He was a cheerful child and showed an early talent for drawing. Ravi Varma became his teacher and passed on to him the techniques of oil painting that he had taught himself so painstakingly decades ago. He proudly told friends that the gods had blessed him with a son who would continue his life's work and take it to greater heights. His son did indeed become a portrait painter like him, but that was Rama Varma, his second son who eventually came to be known as his only son.

Kerala Varma, the son who was meant to be the standard bearer for his illustrious father, is dismissed in the biographies with one line: 'He turned profligate.' That same word is used repeatedly by various authors from around the world and none of them offer answers as to what kind of profligacy could be displayed by a

teenaged boy and be so serious that a family would wipe him out of their records. Nowhere is it explained what Kerala Varma did to earn this tag. No one who knew him is alive any more. Almost nobody remembers him. There are a few descendants of Ravi Varma's friends and family who have dedicatedly collected the gossip of past generations, but they too have very little to offer.

Some say he became an alcoholic and so was a black mark upon Bhagirathi's family. The growing dependence on alcohol became an embarrassment to the family and the boy died young, as a result of his drinking. To prevent any slurs being cast upon them, the family hushed up his death and pretended he had never existed. Becoming addicted to alcohol would certainly meet the definition of profligate but this story isn't a satisfactory explanation for Kerala's disappearance. Aristocratic families have often had vice-riddled scions. Their actions tend to be remembered by those who were scandalized by them, rather than be expunged from memory. If he did die so young, it should have been easy enough to absolve the family of his sins by fabricating a cause of death, like a mysterious illness. However, there is no date or even a year to indicate when he died.

There are other variations to Kerala's story. It is said that the boy, who was so promising as a child, grew up to be a troubled and troubling youth. Some conjecture that the absence of a father figure led him astray and far from displaying his father's instinct for discipline, he became reckless and uncontrollable. He began drinking, sank into a stupor of unsavoury habits that he was unable to shake off, and died in the early 1900s, a little after Ravi Varma himself. Since Ravi Varma breathed his last in Kilimanoor while Kerala was in Mavelikkara, no one remembered him when the obituaries were being written.

Yet another version of the boy's life begins in the same vein but changes when Kerala reaches his early teens. In this one, the story continues with him running away from home at about the time

when the Baroda commission was near completion, around 1889. It is said that he did so because he couldn't take the cruel jibes he had to hear about his father being an artist who cavorted with Muslim and Christian whores. So he ran away to find his father and bring him back home. Or perhaps he ran away to escape the taunts and join his father.

The only things that are certain about Kerala Varma are that he was born in 1874, showed a talent for art, was taught at least the basics of painting by his father, and by 1890, was no longer mentioned. It is difficult to determine exactly when Kerala fell from grace. It seems unlikely that the Varma brothers would have gallivanted so enthusiastically across the subcontinent if they knew something had happened to Kerala. Of course, they may have found out late because, while the postal service existed in the nineteenth century, letters took days, sometimes weeks, to reach people, depending on the distances. But the entries in Raja's diary don't suggest the Bharat Darshan tour was cut short or that they were summoned home when they finally made their way back to Travancore.

If Kerala did leave home—and this seems a more credible explanation for his disappearance than alcoholism—he may have done so in 1889 when Ravi had almost completed the Baroda commission and was shuttling between Mavelikkara and Kilimanoor. Ravi probably made a trip to Mysore during this time as well because he painted three beautiful pieces—'Galaxy of Musicians', 'Lady in Moonlight', and 'Malabar Lady'—at the Maharaja of Mysore's request. Around the end of 1890, Ravi spent lavishly on the temple inside the palace complex of Kilimanoor. Perhaps it was a desperate plea to the gods to convince them to return his son. He had always been religious but from now onwards, his faith in soothsayers and superstition grew to the point where he would decide dates of travel depending upon astrological advice. It was one of the few areas where he

and his brother Raja veered in sharply opposite directions. Raja was much more pragmatic and had little time for such practices, but the childless Raja quietly accepted his brother's idiosyncrasies. It was perhaps a concession to a man who had clutched on to superstition to help him deal with the trauma of losing his son.

The stories of lost sons, weak men who could be easily tempted, and failed husbands that Ravi Varma chose for his Baroda paintings reveal themselves as a sad, poignant set when seen through the prism of his personal life. Suddenly, it isn't a random selection of legends but one that teems with possible personal connections. Compared to the Baroda paintings, the ones he painted for the Maharaja of Mysore are much less emotional. It's almost as though he retreated into paintings that sought to be nothing more than beautiful and found comfort in their meaningless, uncomplicated calm. However, his imagination didn't always cooperate with him.

The pastoral serenity of 'Lady in Moonlight' has a distinct air of melancholia as the anonymous lady looks back at the viewer. She sits alone by the side of a lake. The shy smile that is almost characteristic of Ravi Varma heroines is absent. Instead, her expression is serious and her hand, holding her anchal to her chest, gives her posture a certain wariness, as though she doesn't trust the person on the other side of the canvas. In contrast to this lady is his 'Malabar Lady' who smiles obligingly and strikes an elegant pose. Delicate, sensual, feminine, and soft, this vision in white and gold is perhaps the most technically accomplished painting that Ravi Varma made during this period. It is also remarkably bland. There is no story and no hint of emotions beyond the pretty pose.

Traces of the concerns that showed up in the Baroda paintings can be seen in the Mysore ones as well. 'Suckling Child' takes an image often seen in the Thanjavur paintings of Yashoda and Krishna, but Ravi doesn't name the mother or the child. 'Galaxy

of Musicians' shows eleven women musicians from all over the country. Against the dark background, these professional musicians are jewel-bright. One row is seated and the remaining women stand behind them. Thematically, it continues Ravi's project of projecting a pan-Indian culture. There is a woman wearing a European hat, with a curling blue feather. Right next to her, in stark contrast, is a woman who has her head covered and her large gold nose ring suggests she is from western India. The veena-playing Malayali woman occupies a prominent spot as do the Carnatic violinist, the Marathi singer, and the elegantly draped Muslim courtesan. Most of the women in this imagined scene are looking at one another but for one girl in the second row, who looks out of the painting, at the painter, at us. Her face shows a distinct resemblance to that of the woman in 'Lady in Moonlight'. We don't know who she is. Perhaps she was someone from one of the households in Kilimanoor or Mavelikkara who modelled for him. Perhaps she was a musician he heard at Mysore or maybe hers was a nameless face that remained in Ravi Varma's memory. The particular lady in 'Galaxy of Musicians' and 'Lady in the Moonlight' seems to turn the relationship between artist and subject around. Instead of being the one watched, it is she who has her eyes trained on the artist and her gaze appears to follows him on the other side of the canvas, like an unhappy conscience.

It seems Bhagirathi and Ravi grew increasingly distant in these years. He had excellent excuses. After all, he was the eldest son, and although he didn't head the family, he had some responsibility towards the management of Kilimanoor's estates in addition to the demands of his artistic career. Kerala Varma's name doesn't appear in any diaries or letters. In the coming years, Rama Varma, who was five years younger than Kerala, filled up the space left by his brother. He first became his father's assistant, around 1894 and then, after Ravi's death, gained a respectable reputation as a portrait artist himself. Kerala Varma became an

entry in faded ink, a name with only a birthdate, barely visible in a moth-eaten book of family records.

From 1890 onwards, Ravi Varma became obsessed with the idea of making his paintings publicly accessible. In 1891, he worked relentlessly towards organizing public exhibitions of the Baroda commissions. Then in 1892, he set up the printing press that would spread the images of his paintings all over the country. He would also open up his studio, whether it was the atelier in Kilimanoor or the floor he rented at Khotachiwadi in Bombay or the high-ceilinged workshop he had in Baroda, and visitors and young artists were welcomed. He unsuccessfully tried to set up a museum of art until his last days.

This concept of making art accessible to those who did not belong to the moneyed and the elite was unheard of in India at the time. All over the world, art's exclusivity was one of the main reasons that it enjoyed such favour among the privileged set. India was no different. Like priceless jewels, paintings were kept away from the public eye and shown only to those one trusted or wanted to impress. Now Ravi Varma wanted the Baroda commission, for which the Gaekwad had paid a small fortune, to be shown to anybody who cared to see them. He had seen how much interest there was among Indians to see paintings at annual exhibitions, generally open only to invited audience. His British friends had told him of public galleries in England and Europe that were visited by a staggering variety of people. The rich, the poor, the middle classes—everyone could stop by and enjoy the paintings. Visitors to a city would stumble upon an exhibition, see the paintings, and carry the memory of their messages and beauty with them.

To organize the exhibition of the paintings for Baroda, Ravi began getting in touch with everyone whom he thought may be able to help him. Public exhibitions of art were extremely rare but Ravi had a network of important friends who helped

191

him with securing venues, framers, and other nitty-gritties. The most delicate part of planning the exhibition must have been asking Sayajirao for permission to show his paintings to all and sundry. The Gaekwad would have had no problems with showing the paintings in Baroda but Ravi wanted to exhibit them in Thiruvananthapuram as well. This meant Ravi had to present his idea of an exhibition in such a way that neither Maharaja felt his ego was being slighted.

After Vishakham Thirunal's death in 1885, his nephew Sree Moolam Thirunal had ascended the throne of Travancore. Sree Moolam Thirunal did not continue his predecessor's hostility with Ravi Varma, and the artist was invited for the coronation. However, while the relationship between Sree Moolam Thirunal and Ravi Varma was not antagonistic, it was not particularly warm either. They were distant but cordial with one another. Now, in 1890, Ravi made his overtures to the young Maharaja and asked him to allow an exhibition of the fourteen paintings he had made for Baroda, in the Trivandrum Museum. He also got in touch with the Bombay Arts Society to see if they would like to exhibit the paintings in Bombay.

These were delicate negotiations. Sayajirao could have refused to let his paintings be seen in Thiruvananthapuram before he himself had seen them. If he had insisted that he had paid for his paintings to be exclusive, Ravi could not have argued the case. Sree Moolam Thirunal could have rejected the idea of turning the state's museum into a showcase for another Maharaja. The Gaekwad of Baroda's patronage of Ravi Varma could have been presented as a snub to the Maharaja of Travancore for not recognizing talent, or worse, for not being able to afford Ravi Varma's talent. However, none of this happened, and with an unusual display of royal egos being set aside, both Maharajas agreed to Ravi's request of public displays. It is possible that Ravi's request that the people of Thiruvananthapuram be able to see his

paintings spurred the Gaekwad to open the doors of his grand Durbar Hall to the common people. Sayajirao, who was good friends with the Governor of Bombay, may have helped Ravi organize an exhibition for the paintings in Bombay as well.

Thiruvananthapuram, Bombay, and Baroda were the three cities Ravi Varma knew intimately, and he loved the times he spent there. In their pretty, affluent neighbourhoods was the life that he admired and enjoyed. Perhaps that was why he chose these cities. Maybe it was a calculated move to bring his work more exposure than ever before. But if this was the only reason that Ravi Varma had his exhibitions, then it is unlikely he would have had the easy compliance that he did from the two Maharajas. Sayajirao was fond of Ravi but it's unlikely that he would have been kindly disposed to the works he had commissioned being used to promote the artist, rather than the palace into which he was pouring a significant amount of money and effort. Also, Thiruvananthapuram was an odd choice if it was acclaim and popularity that Ravi Varma was looking for. Madras was a much bigger city and a show there would get the artist much more publicity. But most roads in Travancore would lead to the capital and people from nearby villages made regular trips to the city. Perhaps it was his runaway son Kerala who triggered in Ravi Varma the desire to show his paintings publicly. Perhaps he thought this was how he would reach his son, and that among the many who came to Thiruvananthapuram, one might be Kerala.

If the few unconcerned whispers about Kerala Varma were true and he did leave Mavelikkara hoping to reach his father, there was the possibility that he would try to make his way to Bombay eventually. There would have been many hazards on the way. He was, after all, just a boy of not more than fifteen with little more than the clothes he wore, his natural intelligence, his ability to paint, and his knowledge of Malayalam, Tamil, and perhaps some English to help him make his journey.

Once he left Mavelikkara, his name would mean little to the strangers he travelled with, but it would have raised eyebrows because Kerala was a name that few commoners gave their children. If he made it out of Travancore, he would have been anonymous and alone. His name would have left no impression upon anyone. He was old enough to work in factories, even by the amended Factories Act of 1891, which raised the legal age for a child worker from six to twelve and made the hours less excruciating.

It would not have been easy to survive but if he managed it, he would have seen an India he had never imagined within the boundary walls of the palaces of Mavelikkara. The independence movement was far away but something angry was rumbling in India. Something that scared one Viceroy of India enough to think that all vernacular press were plotting to end the British Raj.

* * *

Word that Ravi Varma's paintings were on display spread to the most unexpected reaches and people queued for hours to see them. It was the first time an exhibition of paintings had been made open to the public in Thiruvananthapuram, and the Napier Museum saw crowds throng to see paintings by the man who could capture apsaras in his canvases. The scenes he had painted were magical to them, and no doubt the sight of so many beautiful women, albeit two-dimensional, fired the enthusiasm of the capital's men. Many who came to see the exhibition had seen little of the country beyond Travancore. The colourful saris with their contrasting blouses must have seemed very exotic to the people who had been wearing white for centuries.

The exhibition remained open in Thiruvananthapuram for a few weeks. Curiously, within months of the exhibition closing, 'Shantanu and Ganga ' and 'Shantanu and Satyavati' were copied by two little-known artists. R.D. Chitari copied the first while

D.V. Pandit attempted the latter. They even signed as Ravi Varma, and the paintings found their way to the princely state of Aundh in the Deccan. The problem of telling originals from fakes would become an increasingly complicated problem over the years and not the least because Ravi Varma's signatures changed over time. Sometimes he didn't even sign his works. In the portrait he made of Sethu Lakshmi Bai, his signature isn't at the corner of the painting but can be spotted mischievously inserted in the letter she holds in her hand. The bit that can be seen of the letter reads, 'Wishing you all happiness. I am, Yours Sincerely, Ravi Varma.' Some paintings he signed as Ravi Varma. Some he signed as RRV or RV. Occasionally, RRVCT, which stood for Raja Ravi Varma Coil Thampuran, showed up, like in the portrait he made of one Sir Prendergast in 1891. Incidentally, this is one of the first instances of Ravi Varma adding the prefix of Raja to his name. In reality, he had no right to call himself Raja since his mother's maternal uncle was still alive and consequently Ravi wasn't even in line to head the Varma clan of Kilimanoor at the time. The changing signature made forgery and plagiarism quite easy. The swiftness with which copies were made are an indication of the huge demand for Ravi Varma's works at the time, and that forgery was already a well-established career option for young, unsuccessful, but trained artists.

After closing the show in Thiruvananthapuram, the fourteen paintings came to Ravi Varma's studio in Kilimanoor. It was time to start planning the trip to Baroda. Organizing this journey took the better part of 1891. The paintings were enormous, and thanks to their frames, they were extremely heavy. They could not be sent by cart because not only would it take too long, but the roads were also unsafe. They could be stolen or be damaged because of careless handling. With paintings worth Rs. 50,000, one could not take such risks. This meant the paintings would have to be carried like luggage on the train. Aside from the

195

amount of room they would take, it also meant that the entourage travelling to Bombay would expand significantly. The Varma Brothers left for Bombay in November since the paintings would be shown at the prestigious winter exhibition that the Bombay Arts Society organized. There hadn't been time for an extended stay at Mavelikkara. As far as they knew, life was continuing its humdrum pattern for their wives there. That may have been true for Janaki, Raja's wife, but Bhagirathi's world must have changed with Kerala's disappearance.

Whatever Kerala Varma's sins were, Bhagirathi must have blamed herself, as any parent would, particularly if they were raising the children as single parents. Mothers in Kerala's matrilineal system generally were single parents and Bhagirathi's husband, the painter prince, was very much a visiting father. It was her mothering that was at fault. Some said that Bhagirathi died of a broken heart. Perhaps she did, but it was a mother's heart, rather than that of a wife. Bhagirathi died in 1891, a couple of years after her son was either lost or disowned by her family. She was less than forty years old.

The news of her death reached Ravi Varma soon after the opening of the exhibition of the Baroda paintings in Bombay. It came as a shock to him and left him in a blank stupor for a month, during which the man known for his irrepressible energy could not bring himself to move. Of course, Raja and he left for Mavelikkara immediately, leaving behind the exhibition and the city they so loved. For Ravi Varma, it must have been unbearable to see the failed heroes he had painted. They would have reminded him of the unhappier times he and Bhagirathi had seen in their marriage. In most legends, one could move on to a future chapter that was happier and without misunderstandings or hurts. But Bhagirathi had changed her role. From Damayanti, she became Sita. She wrapped herself in her misery and left him.

Even though it may have burdened him with some guilt,

Bhagirathi's death freed him to pursue not just art but also the models whom he needed for his painting. By the end of his life, the rumours of his affairs were almost as well known as his paintings. One of the whispered, unverifiable 'secrets' that has been passed down the generations is that all the portraits of women that Ravi Varma left untitled or didn't attribute a specific name to were paintings of mistresses. The face that looks so nervously away from the painter, the smiling nude who isn't bashful of being naked, the bejewelled hands that hold a lush fruit: these were all believed to be fragments and portraits of different lovers.

There are dozens of Ravi Varma paintings that showed unnamed women and there are certain faces that seem to recur. Whether this is because he was using the same photograph as a reference or because he was painting his lover, no one can tell. One of his skills as a painter was being able to paint distinctive features taken from different faces in a way that created one that was almost generic. She would have either a round face or an oval face. Her hair would either be wavy and frame her face or thick, straight, and coiled into a bun. The eyes below thick eyebrows were limpid, and while the lushness varied more often than not, the same smiled lingered on their lips. There is no shortage of women whom Ravi Varma took off the streets and into his studio. During his travels around the country, there were singers in Varanasi and dancers in Lucknow who caught his eye. When he settled into Bombay, actresses from the Parsi theatre enchanted him as did Marathi women singers who tied their saris in a way that emphasized their voluptuous hips. In Hyderabad, Ravi found the girl who would model 'At the Bath' for him among prostitutes. Everyone imagined he was having relationships with them and he probably was, with some. However, most were cajoled and wooed because they had in them something he needed for a particular painting. Whether or not they would become lovers,

all the women who came into Ravi Varma's studio were models first. All these women's faces contributed in small and large parts to create the Ravi Varma beauty. There might have been something of Bhagirathi in there as well but if there was, he never told anyone.

* * *

Ravi Varma's paintings remained on view for two months in Bombay, during which time the artist went to Mavelikkara for his wife's funeral and then returned to the city. He missed whatever sensation his paintings created. One of the first biographies of Ravi Varma in Malayalam calls the exhibition a phenomenal success. Word of mouth spread like wildfire and people came to the city from all over the Bombay Presidency to see these highly praised paintings. There were photographs taken of a number of the paintings, and these found their way all over India. In black and white, they had little of the original paintings' richness but apparently, hundreds and thousands of them were sold.

It is possible that the early biography was overstating the case because the *Times of India* did not grace the exhibition with a detailed report. The biography was written while Ravi Varma was alive and on the basis of interviews with him, and it seems the artist didn't mind tweaking the truth a little going by his claims to have participated in the 1873 Vienna Exhibition. While the exhibition may not have been quite as spectacular as portrayed by that biography, it certainly did get talked about among the Indian community of Bombay. There must have been much excitement among middle class families in particular. The Bombay Art Society was known for making purdah arrangements so that Indian women could come to see their shows as well. More than the excitement of seeing a painting, what would have drawn many to the exhibition was that Ravi Varma had painted the gods as though they were mortals. They didn't look fantastical, like the

traditional temple carvings. They didn't strike poses taken from classical dance; they stood, sat, leaned as people did naturally. The heroines were dressed like the viewer's wife or sister or daughter and the legendary heroes sported the curling moustache of present-day kings. No one had imagined the Puranic tales like this, stripped of magic and yet all the more astonishing because, thanks to the way Ravi Varma had painted them, the stories had turned more real than ever before.

For the *Times of India*, a newspaper run by Englishmen and directed primarily at the British population of Bombay, Ravi Varma's paintings were unfamiliar terrain. Art exhibitions enjoyed a lot of coverage in the publication. Paintings by English ladies who were mostly amateur artists would be described in detail and praised when they were shown at the art society's exhibitions. However, Ravi Varma was a 'native artist' and, perhaps more crucially, the subject of his paintings was also entirely native; and therefore, it would have been presumed that such a show was of little interest to non-Indians.

Finally in February 1892, the fourteen paintings arrived in Baroda and were hung in the Durbar Hall, which was made open to visitors for a few weeks. The next time the Durbar Hall would let itself be used as an art gallery that allowed anyone in would be more than two centuries later. Those who lived in Baroda knew of the Gaekwad's ambitious and expensive Laxmi Vilas Palace and there must have much excitement at the thought of being able to enter the grand Durbar Hall that was meant to be for only the most privileged audiences. Once inside, the wonder of the palace vied with the charm of Ravi Varma's paintings. There were those who felt they were in the presence of something divine and in the short time that the paintings were on display in Baroda, it wasn't unusual to see visitors solemnly folding their hands and paying their respects to 'Radha and Madhava' or 'Sita Swayamvaram'. Standing in the gorgeous Durbar Hall with its

elaborate ceiling and marble floors, Ravi must have missed his long-time champion and friend, Madhava Rao, who died in April 1891. Seeing the different reactions to the paintings and the eager curiosity that made people peer closer at different paintings would have reminded him of Madhava Rao's unflagging support for him as an artist ever since he was a teenager in Thiruvananthapuram. Without the Dewan's encouragement and intervention, Ravi would not have been standing here in Baroda watching strangers fall in love with his paintings, noting the photographs being taken of the hall, and feeling his pulse race. He was on the brink of greatness and he could feel it.

Part Four

The Ravi Varma Fine Art Press

The year 1891 was a turning point for Ravi Varma. In his personal life, the one thing that remained constant was the close relationship he shared with Raja. His ties with Travancore had weakened when his mother and uncle had passed away, and when he lost both his longtime mentor Madhava Rao and his wife, they virtually snapped. There was nothing in Travancore to keep him there. There was a new Maharaja whom Ravi barely knew. He had one friend in court, Bhagirathi's brother in-law Kerala Varma, but Kerala was deeply involved in Travancore's educational policies and a distance seemed to have crept into their relationship as well. The artist's children were being raised in Mavelikkara by Bhagirathi's family as was the practice, and he was expected to do nothing more than visit occasionally. The other man who had been an anchor for Ravi Varma in southern India, Seshayya Sastri, was forced to retreat from public life for a while when it was discovered that he had wooed another man's wife in Madras and taken her to live with him in Pudukottai, where they were discovered by the woman's husband. The incident was scandalous enough to receive a substantial paragraph in the *Times of India* in Bombay. All these changes must have been difficult for Ravi Varma.

At the same time, he had been little more than a visitor to his native states for decades. While he would have missed the guidance of people like Madhava Rao, he was forty three years old by this time and in both Kilimanoor and Mavelikkara, he

was now among the elders. It was now his job to give advice to the next generation. He had nephews who were young men and they touched his feet. Young men, relatives, and even strangers on occasion, came to him with admiration in their eyes and questions in their minds. To a large extent, this respect had come to him as a result of the two Baroda commissions, particularly the second one.

The second Baroda commission heralded perhaps the most significant change in Ravi Varma's life. It marked the year from which he became known not as the painter of princes and maharajas but as the artist who had been given a commission of Rs. 50,000. One of the reasons the second Baroda commission became so memorable was its public exhibition. People spoke about the works, recommended them to their friends and family—like the reformer and religious leader Vivekananda, who was in Baroda at the time that the paintings were displayed and wrote in a letter to a friend that Ravi Varma's paintings and the library were the only things worth seeing in the city. And so the memory of having stood before the beautifully framed canvases that were meant for a royal audience was passed on by word of mouth to countless people. Not all of them came to see the paintings but the name Ravi Varma became better known and it created a demand for his paintings. There is no doubt that the decision to set up a press had its roots in Ravi wanting to make his name more widely known. When Sayajirao had offered him the commission, it had been an honour but also a challenge to prove that he could be a national painter, rather than one whose horizons were limited to Travancore and the places he had visited. He had risen to the challenge and now he sought to cement his position as the first artist whose paintings were known to all of India. The printing press was the medium he chose to achieve his goal.

It was a quick decision, but not impulsive. The idea of setting up his own printing press had been suggested to Ravi by Madhava

Rao more than six years ago, when the Dewan had recommended it to him as a viable alternative to making copies of his paintings for those who wished to own one of his paintings. At that time, Ravi sent a couple of his paintings to Germany to get prints made of them. The paintings and the prints would have reached him within a year. They must have pleased him because when he ultimately decided to enter the printing business, he bought the press from Germany. He chose one of the most modern models of the times, one that he was sure would be able to produce the finest quality of art prints. He was, after all, paying Rs. 50,000 for it.

In nineteenth century Europe, publishing made good business. Newspapers, pamphlets, books, and Bibles had modest runs, but there was growing demand as literacy levels rose. Aside from text, there was also the increasingly profitable business of printing images, because companies wanted their advertisements to have pictures. The invention of the lithographic technique of printing in 1796 had made it possible to replicate the painted image as a print without losing too much of its nuances of colour and shading. However, the world of printing was not considered an artistic one. It was one of mechanics, engineers, and craftsmen. There was a small market for prints of paintings but the technology was only suited to sketches. There was a clear divide between an artist who made paintings and an artisan who made prints. Some, like Rembrandt, seem to have been closely involved in the etchings that were made out of their drawings, and in the 1800s, artists like William Blake and Eugene Delacroix were quite excited by the possibilities of a technology that allows reproductions without an artist having to copy his works repeatedly. However, while the existing printing techniques were adequate for words, they reproduced paintings crudely on most occasions.

The history of the printed image goes back a long way. Inscriptions and seals can be found as far back as the ancient Sumerian civilization, dating back to the third millennium BCE.

Printed images can be found on the papyrus manuscripts of the ancient Egyptians. The Chinese and the Japanese created the art of woodcut printing, a technique by which letters and designs were cut into the face of a block. Ink was coated on the raised pattern and a design with clear outlines and solid colours was the outcome. In Europe, there were techniques like intaglio, in which the design was cut into a printing plate by etching or engraving so that the ink would collect in the incisions. This is how the etchings of Rembrandt were made, for example. None of these techniques, though, were well suited to reproduce oil paintings, with their blend of many colours. The ability to translate the nuances of colour to print and the fact that its basic equipment was cheap made lithography popular very quickly. It proved to be a far more sophisticated method because it took less time and was well suited to steam-driven machinery; and it was discovered because a widow named Mrs. Senefelder needed her laundry bill to be written down.

Mrs. Senefelder's son Alois was something of a worry to the poor woman. He had been a bright student as a boy and both she and her actor husband had had great dreams for him. Unfortunately, her husband died young and the family couldn't afford the luxury of twenty year old Alois's university fees. He had eight younger brothers and sisters and their father had left no inheritance. Alois tried becoming an actor like his father to support the family, but he was entirely unimpressive and it was clear there would be only humiliation for him on stage. So he turned to writing and declared he would be a playwright, which was all very well except that none of the publishers seemed to want his writing even though the first play he had written was rather successful.

So he decided to set up his own press, but the impoverished Senefelders could barely afford the expensive copper plates and other equipment that printing required. Undeterred, Alois kept

tinkering in the room that he called his workshop, practising writing backwards since a plate printed a mirror image of what was engraved upon it. He was trying to find a cheaper, simpler alternative to the established method of printing for his unpublished play *Mathilde von Altenstein*. So far, his experiments had yielded a new mixture of wax, soap, and lamp black that was very greasy but worked well as printer's ink; but he was unable to modify the actual process of printing with any degree of success.

One fateful day, Mrs. Senefelder came into Alois's workshop and asked him to write down the washerwoman's bill. Alois had no paper or ink handy so he quickly scribbled what she recited to him, using his own concoction of wax, soap, and lamp black upon one of the slabs of limestone that he used to practise writing in reverse. It then struck Alois that the stone slab could be a cheaper alternative to copper plates. At first he tried to outline the words he had written with acid so that they were raised, like in woodcuts. It was probably while he was trying to do this that he realized his greasy ink wasn't getting washed away with water. In that realization of the age-old fact that oil and water don't mix and the demands of Mrs. Senefelder's washerwoman lay the birth of lithography or what Alois termed 'stone printing' or 'chemical printing'. The name lithography came about because the process used stone tablets and lithos is the ancient Greek word for stone.

Lithography used plates made of stone that were polished smooth. The novelty in this process was that both the image area and the non-image area of the printing plate lay on the same plane, unlike in intaglio. This meant that an artist could draw the image on the plate much like they would on a canvas. Using an oil-based pigment, the image would be drawn on the stone, which would then be washed with a solution that created a hydrophilic layer, or one that rejects ink and mixes with water. When printing, the stone would be kept wet with water and ink would be rolled

over the surface. Water would repel the ink from the non-image areas while the image areas would soak up the ink. Then a damp sheet of paper would be brought in contact with the plate and the image would be transferred. Several hundred copies could be made before the ink absorbed by the stone plate was used up.

Alois Senefelder's invention was an immediate success, and it is unlikely Mrs. Senefelder had to worry about laundry bills ever again. Senefelder patented lithography and continued experimenting with printmaking techniques until his death in 1834. Meanwhile, lithographic presses mushroomed all over Europe and London, in particular, became something of a printing hub. The next innovation, which was critical for printing paintings, came from a man named Godefroy Engelmann, who learned lithography in Paris. He came up with the idea of using multiple plates for a single image. Instead of printing the entire image using one plate, Engelmann suggested each plate reproduce only one colour from a painting. This meant all the plates for a single painting had to be very carefully drawn so that the different image areas came together properly to create the final print. It also meant that lithography became significantly more expensive but finally, printing technology could replicate the colours and shades of an oil or watercolour painting. One could use as many plates as they wanted to recreate colour effects and there were those who used twenty five or even thirty plates for one print or lithograph.

Modern printing technology came to India in the early nineteenth century, soon after it became popular in Europe, and it offered Indians a means by which to express themselves without much interference from the British government. Of course there were censorship laws, some of which became increasingly strict as the independence movement gathered ground in the late nineteenth and early twentieth centuries, but there were ways of evading the legal lasso. Comic magazines run by the English

in India, like *The Indian Charivari* and *The Delhi Sketch Book*, were inspired by the English satirical magazine *Punch* and took potshots at nationalist Indians. To counter this racial malice, publications were set up in regional languages, particularly in Bengal where there was a surging wave of anti-British sentiment. There emerged many small newspapers and magazines, like *Modern Review* whose focus was art and nationalism, and the unabashedly irreverent *Basantak*, which claimed to speak for the Bengali everyman against racist officials and their supporters.

Cheap lithographic prints printed in Germany and Austria had been coming to India from Europe since the 1820s. Soon enough, the multicoloured lithographs, often called chromolithographs or oleographs, also made their way to the subcontinent. The Indian public, particularly those belonging to the lower economic classes, seemed to enjoy them, and some presses began to adapt the Western images to make Hindu icons. An 1832 lithograph titled 'Interior of a Native Hut' showed an obviously poor family inside a crude little house where, on one wall hung a mass-produced print. Hindu gods and goddesses in particular became hot favourites and many modest households would decorate the walls with lithographs showing characters like Ganesh and Krishna. Many of these horrified European missionaries and the British, particularly those that showed what would have been considered grotesque violence, like the goddess Kali who wears little more than a necklace of skulls.

From the 1870s, a number of local presses turned away from importing prints from Europe and got into the business of producing their own. They were mostly set up around Bombay and Calcutta. The decision to locate presses near the two major port cities was probably determined by their constant trade with the West and the fact that they had graduates from local art schools who were looking for employment. Also, the two cities were well connected by rail to the rest of the country, so the

presses could easily send their prints to retailers elsewhere by train. Setups like the Calcutta Art Studio and the Chore Bagan Art Studio began churning out lithographs with steady regularity and most of their images were very obviously figures from classical Western art, cursorily obscured with Indian accessories and clothes. The lithographs from these mechanized presses were so cheap that they were able to outprice the Kalighat drawings that used to be the least expensive. The area around Poona also saw a large number of printing presses being set up. The most famous of them was Vishnu Krishna Chiplunkar's Chitrashala Press, set up in 1878. One of Chitrashala's first prints was one titled 'Rampanchayatam' (Ram's Assembly), which showed Rama with Sita, Lakshman, and a coterie including Hanuman. The oleograph sold two thousand copies in a month, which was quite a feat. Predictably, other religious images followed quickly, from both Chitrashala and other smaller presses.

But these prints didn't charm the country's British or Indian elite. By the late 1890s, when Ravi Varma was finalizing his deal with the German manufacturers, the term 'Poona Pictures' had become synonymous with images that were considered garish and crudely made. Although they weren't the only culprits, the Poona-based printing presses were known for their barely decent figures, which were copied off European paintings of nudes and whose modesty was occasionally protected by the Indian addition of a floaty, wind-whipped veil. These faced the criticism of virtually every Indian intellectual for bastardizing European art, being vulgar, and corrupting popular taste because, predictably enough, these images were enormously popular. One of the reasons why many applauded Ravi Varma's decision to enter the printing business, even though it ultimately thrust him close to bankruptcy, was that the introduction of his images and their popularity pushed other presses to follow his aesthetic and opt for less obscenity.

However, it's also worth noting that the lithographs of semi-nude women did not make up the bulk of most print portfolios. Especially in case of the Poona presses, a number of them were actively involved in the Hindu patriotic movement that was gaining ground in Maharashtra. Chitrashala's first print, for example, was of Nana Phadnavis, a legendary minister in the eighteenth century Peshwa court who was dubbed the Maratha Machiavelli by the British, and who held together the Maratha empire in the face of the growing strength of the East India Company. Images of Shivaji and later, of Bal Gangadhar Tilak were produced by these presses and even their lithographs of religious icons carried undercurrents of patriotic fervour. Narasimha, the frightening avatar of Vishnu as a ferocious half man-half lion who rips out an oppressive king's guts, became popular, and the figure of Rama became the embodiment of a muscular Maratha faith that was readying to fight the oppressive regime, just as Rama had fought Ravana. Chitrashala's patriotic imagery was often extremely subtle. Not wanting to risk closure by upsetting the British, Chiplunkar used the Chitrashala Press to print postcards showing caged parrots, which were symbols of India restrained within a cage made by the British. 'It is a great disaster when a bird whose God-given power is to move wherever he pleases, unrestrained on the strength of his beautiful wings, must remain always chirping in a confined place! The same applies to a nation,' wrote Chiplunkar in an article titled *'Aamcha Deshasi Sthiti'* ('The State of Our Country') in the newspaper *Kesari*. Of course, he did not mention his lithographs, but the caged parrot showed up in many Chitrashala prints and his message was easily deciphered. There was no way to penalize the press for such imagery and so it slipped past censorship laws. The only recourse for the British was to dub the lithographs from the Poona presses as tasteless and unsophisticated. Ravi Varma's lithographs, on the other hand, were far less problematic.

Ravi Varma was at a crucial point in his life when he chose to enter the business of printing. His ambition of becoming India's most celebrated artist had been achieved, but now the path that he would choose for himself as an artist would decide how he would be remembered by later generations. There was the option of creating more interest for paintings of 'social scenes' that looked to be relevant to contemporary times and chronicled a changing country in a relatively unromanticized manner. The printing world offered him the chance to contribute to the nationalist movement by using the imagery in his lithographs to create a sense of awareness about the unfairness and oppression of the colonial project. Ravi, however, chose personal glory, and it is ironic that while the printing press made his images famous for decades to come, it also played a crucial part in fading his name out of popular memory.

* * *

Ravi came to Bombay in 1892, after showing his paintings at the grand opening of the Durbar Hall in Baroda. This time it was not a short visit. He and his brother would spend the better part of the year in the city, working energetically to set up his printing press. He had decided to put all of the money he had received for the Baroda commission into this new venture. While this was enough for the initial expenses, like importing the machinery and its technicians from Germany, Ravi would need a financial partner who would be ready to sink some money into the project and help the artist with both the running costs and the management. Raja and he couldn't be expected to take responsibility for the everyday decisions that needed to be taken when running a business. Ravi was entering the world of business eagerly, and there is no doubt that one of the attractions of this venture was being able to stay in Bombay.

The city had changed significantly from the place Ravi

had seen even a few years ago. More land had been reclaimed from the sea and the islands that made up Bombay were better connected. Meanwhile the city itself was a set of tightly constructed neighbourhoods that were still largely segregated from one another. The southern area around Colaba and Fort had seen enormous development in the past decade. New buildings had risen and well-paved roads snaked their way through neighbourhoods. There were more libraries, schools, theatres, and hotels. The British had been working energetically to improve the city's infrastructure and by the nineteenth century, Indians were part of this project. The 'Cotton King' Premchand Roychand is said to have donated more than Rs. 400,000 to the Bombay University library. The Sassoon dockyard was built entirely by the initiative of Alfred Sassoon, Sir David Sassoon's son. The roads connecting Mahim Causeway to the Church of Mount Mary in Bandra were bankrolled by Sir Jamsetjee Jeejeebhoy, who had also gifted the city the art school that Ravi Varma so admired.

The capital of western India was considered a city that could rival London in both beauty and cultural riches. Its Governor Lord Reay described it as 'one of the most beautiful towns of the Empire—if not the world'. Entertainment included outdoor sports like cricket, open air concerts, and spectacles like hot air ballooning off the Esplanade, which is today called Marine Drive. Bombay's theatre scene, which Ravi and Raja patronized regularly when they lived in the city, was thriving at this time. There were advertisements of visiting European performing troupes and operas in the newspaper. The military band performed regularly at Apollo Bunder. The area around Grant Road had become the city's theatre district and there were regular shows of Hindi, Marathi, Gujarati, and Urdu plays. Parsi theatre groups were known for their delightful productions of Gujarati and English plays. For English plays by British theatre groups, both visiting

and local, one mostly had to go to Gaiety, Novelty, or Alfred, which were all near Victoria Terminus.

The British had their clubs, like Byculla Club and the Bombay Gymkhana, and once inside those gates, one could have been in London because everything had been imported. The Bombay Hunt Club, founded in 1862, actually imported all its hounds but unfortunately, the dogs didn't survive and the club was forced to shut down for a while; it was restarted in the 1870s, again with imported hounds. This time they survived and by the 1890s, there was another hunting club in the suburb of Santa Cruz. When the Watson Hotel was started in the late 1880s, the house maids and waitresses were brought from England to give the hotel's guests, who were mostly European travellers, a 'home-like' feel.

For Ravi, who could not visit London, Bombay was a more than adequate substitute. He rented a studio in Khotachiwadi in South Bombay, close to the pretty mill neighbourhood of Girgaon that had views of the Girgaum Bay. Once it was a village of Pathare Prabhus, a group of Maharashtrian Brahmins, and East Indians; these original residents were joined by eminent Gujarati families. It was a charming little area that was quiet and close enough to the parts of Eurocentric southern Bombay that the Varma brothers frequented for entertainment. A balance between Indian identity and British and European aesthetics was something that Ravi aspired to in his own life and admired in others. One of the reasons that Bombay was such a favourite with the artist was that it had many who straddled these two cultures and did so with grace. It was a tight community of men and women who lived between these two worlds, which were increasingly being pried apart with the growing nationalist fervour that expressed itself by standing doggedly opposed to everything that the British did or supported. Whereas in Travancore or even Baroda, Ravi would have found few who understood the charms and complexities of such a life, Bombay offered him a society of

212

Anglicized and artistically inclined people who formed a society that he fit into quite easily. And friends like the photographer Lala Deen Dayal, who understood what it was like to tread gingerly between cultures.

Lala Deen Dayal and Ravi Varma probably met in Bombay, and soon struck up a warm friendship. Ravi had nursed a fondness for photography for many years. Imported photographs of models, particularly nude studies, had been the only means by which he could study the female body for his paintings and from around this time, he seems to have got into the practice of taking photographs of models and using those images as his reference rather than asking the models for repeated sittings. It's very likely that Deen Dayal was instrumental in getting Ravi acquainted with the camera and its potential.

Photography reached India in the early 1800s and was used initially by the British as a device to make a visual record of places. The cameras of the time were bulky, yet fragile. The process of taking a photograph was complicated and lengthy, because the glass plate negative had to be prepared with a photosensitive chemical solution called collodion. The picture would be as big as the glass plate, so if one wanted a bigger picture than normal, the size of the camera increased correspondingly. After the picture was taken, the plate had to be exposed while it was still wet, which meant that the photographer had to be near a darkroom. The invention of the dry collodion process, where the glass negatives came coated with the solution, allowed the plates to be developed later. Aside from the processing, taking a photograph was a delicate and almost intuitive process, because it demanded from the photographer a keen awareness of the limited perspective of the camera and the result of colours being translated to black and white.

Deen Dayal was born into a middle class family that lived near Meerut in central India in 1844. He had no idea of

213

photography as a boy. He studied engineering in Roorkee and joined the Department of Public Works in Indore, where he was employed as a draughtsman and estimator. It was here that he discovered the camera. His eye for a good frame and ability to capture details was noticed by his superiors who encouraged him to keep taking photographs. By the time he was given the task of photographing the Prince of Wales' visit to India in 1875, Deen Dayal had become a well-established photographer with studios in Indore and Bombay. He was being hired for portraits as well as documentation projects, for sites such as the Khajuraho temple complex and the Ajanta and Ellora caves. By the time Ravi met Deen Dayal, he had retired from his government job because his studios were doing great business. For those unable to afford portraits like the ones Ravi and his fellow artists painted, the photograph was a cheaper and easier option. Deen Dayal's portrait photography won him much praise and in 1885, he was appointed the court photographer for the Nizam of Hyderabad. His time was spent mostly between Secunderabad, which had an enormous military cantonment and therefore, many men who wanted portraits taken of themselves to send home, and Bombay.

In the 1890s, Deen Dayal was not as awe-inspiring a figure as Ravi Varma, largely because the medium of photography was yet to be given the kind of respect that oil painting had. But there were enough similarities between the two men. Both were ambitious and confident; both were considered pioneers in their chosen fields; and both were hungry for greater glory. In one area, however, Deen Dayal was ahead of Ravi Varma. He was already a very successful businessman, with his many studios scattered in Indore, Bombay and Secunderabad, where, aside from a regular studio, he also set up a zenana studio where women could come to get photographed by a 'lady photographer'. In comparison, Ravi Varma was still a few years from seeing his business take off.

Deen Dayal's portrait business also kept him in contact with senior British officials, to many of whom he was familiar because of the praise he had received from people like Viceroy Lord and Lady Dufferin for the photographs he had taken of them. It is very likely that Deen Dayal was the one who told Ravi of the exhibition in Chicago in 1893 to which he was sending photographs. Whether it was Deen Dayal or another friend in Bombay, there is no doubt that Ravi found out about the exhibition late because he completed the paintings within a couple of months, working on them with manic speed and intensity. Sending anything to America, two oceans away, meant months by ship and if Ravi had known about the exhibition in Chicago well in time, it is unlikely that he would have ended up painting five, of the ten he finally submitted, over just one month, in December 1892.

* * *

The World's Columbian Exposition was held in Chicago in 1893 to commemorate 400 years of Christopher Columbus's arrival in America. Usually held in Europe, these exhibitions showcased manufactured products from all over the world and celebrated technological innovations. Art was a very small part of these exhibitions, which were mostly about spectacle. However, since the idea of an exhibition was to offer visitors windows into other worlds, these were among the few fora that encouraged participation by artists from the colonies. To host a world exhibition was a fairly prestigious affair, and when the Chicago exhibition was being planned, America wanted it to be a statement of the young country's strident progress and wealth. Each of the forty six participating countries would have their own pavilion and visitors were expected from all around the globe.

The arrangements were elaborate. Approximately 600 acres in the city of Chicago was taken over for the exhibition and

turned into what was known as the White City. New buildings of classical architecture were built. Canals and lagoons were landscaped into the area. The fantastical world of Oz in L. Frank Baum's *The Wizard of Oz* is believed to have been inspired by the White City and, much like Dorothy, many of the participants who were part of the exhibits soon wanted to go home rather than stay there. A major draw of the Chicago exhibition was that it had 'living exhibits' from the Arctic to the tropics, all dressed in their 'native' costumes, which meant that despite the fact that the exhibition was held in the summer, the Inuits were forced to wear their furs. A number of people who were brought to be exhibited fell sick and some even died because of the substandard living arrangements there. One area was called 'Street in Cairo' and it had an exotic dancer belly dancing to modified American tunes. Norway sent a replica of a Viking ship, which was another favourite of the fair.

It was the East India Company that had a pavilion at the Chicago exhibition and visitors recall that it was a lavish display of Oriental pageantry. The towering gate had minarets and was decorated with arabesque designs. Inside liveried waiters, or khidmatgars, served a blend of tea leaves that the Lipton Tea Factory called 'Darjeeling'. It was priced at five cents a cup, which must have been quite expensive for the times. Lala Deen Dayal's photographs of places and people of the subcontinent and ten paintings by Raja Ravi Varma were not shown here or in the Fine Arts Pavillion. They were part of the Ethnographic Pavilion. Later generations would be outraged that these two artists were not considered good enough to be included among the artists, but at the time, for both Deen Dayal and Ravi, the fact that their submissions had been accepted by the exhibition's judges was an enormous source of pride.

Having found out about the exhibition and what was being planned, Ravi did not send the religious paintings that had made

him so popular in India. He recognized that these stories and characters would not resonate with a foreign audience. Astutely, he picked a subject that had been in the European imagination for centuries and was a key element in the ideal of Oriental exotica: the Indian woman. Mining the sights he had seen while on his tours of India, Ravi, with help from Raja and perhaps Mangalabai, created a suite of ten paintings that showed women from different parts of India. Just like the paintings for the Gaekwad of Baroda, these paintings needed to showcase India and they needed to draw in an audience, but this time, it was an unfamiliar set of viewers that Ravi Varma was trying to woo. He needed the set to be a revelation to the Chicago exhibition but he also knew that there had to be elements that were familiar to them or close to the image they had of India, so that they were drawn to look more closely at the paintings.

Ravi titled the series 'The Life of Native Peoples'. With Raja's help, he wrote a pamphlet to accompany the paintings, in which he described himself as a self-taught artist who was known for his paintings of historical and mythological lore, so establishing himself as a chronicler of his times. He also wrote that the reason he had chosen the Indian woman as a subject was that he wished to present to America the elegance and beauty of the many dresses worn by women in the subcontinent. The implication was that these were real women, rather than creations spun out of his imagination. They had been drawn from life. His daughter was in one of them and most of the others were women he had seen and managed to get into his studio over the years. Perhaps some of them were women people had imagined him with and gossiped about. Some he had only been allowed to glimpse and some he had studied, but either way, they were his muses: some fleeting and others more longstanding. The Indian woman, famed for her beauty and written about by many an English author, had been taken out of the protected cloister of her home and brought

before her admirers. Ravi Varma's paintings showed her in myriad avatars—rich and poor, from the north and the south—and they were life-sized, as though the ornate frames were windows into a subcontinent that lay two oceans away.

Thematically, the suite of paintings for the Chicago exhibition is reminiscent of the painting titled 'Galaxy of Musicians' that Ravi had painted for the Maharaja of Mysore. In that painting too, he had tried to create a sense of India using women, but its scope was smaller. In that painting, Ravi had fixed his attention on one profession and tried to show the variety in the country by showing how the different parts of India defined the word 'musician' among women. The focus in that painting was the same as that which Ravi concentrated upon in the ten paintings for Chicago: how Indian women dressed, the differences in the clothes they wore, their jewellery, their postures. But whereas in 'Galaxy of Musicians', he had crowded all the women into a single canvas, this time, he let each woman have her own canvas, and he included women from a wide range of social strata. An aristocratic Malabar beauty, dressed in her traditional white and adorned with gold jewellery and flower garlands, played the veena. The Parsis of Bombay, many of them knighted by the British and others belonging to the professional classes, appeared in 'Bride Being Led to the Marriage Pandal'. Ravi neatly slipped in a hint of the magical world of soothsayers and miracles with 'Kuravas in Southern India'. The nomadic community was not going to be familiar to foreigners so he added a detailed description that read, 'A model of a tribe whose profession is to wander from house to house telling fortunes.' The love between siblings was shown in 'Remembering the Sister', set in a Marathi household where the women wore saris in the rich jewelled colours that Ravi Varma liked so much. 'Near the Well' showed the age-old stereotype of a cantankerous mother-in-law and a mutely suffering daughter-in-law. 'The Bombay Singer' depicts a performer who came and

sang at weddings or could be hired for concerts. Ravi Varma had attended a number of such concerts in Bombay and it's possible that the alluring singer, with the courtesan's customary betel leaf at her side, was modelled on a real woman.

Perhaps the most famous of this set was 'There Comes Papa', in which he painted his daughter carrying his grandson. The accompanying note said, 'A Keralite mother clad in white cloth is preparing to go to the temple with her son at her arm. A dog is following. She can start as soon as her husband comes. Looking at the child (she speaks) "There comes Papa".' From this painting, it's clear that the paintings did have a generous dash of Ravi Varma's imagination, despite his pamphlet's emphasis on his role as a documentarian rather than a creative artist. The dog, to begin with, was an entirely unrealistic addition since the animal was considered dirty and was not allowed in homes. However, the pet was a symbol of domesticity that he had seen in many European paintings and he decided he would use it to fill a corner of the canvas. More significant is the way he drew Mahaprabha, now twenty four years old, and her son. He used a photograph of her with her toddler son as his reference but the figure in the painting and the one in the photograph are certainly not the same. Her skin is lightened, her face is oval instead of round as it actually was, her figure is made more svelte; in fact, the only thing the mother in the painting shares with Mahaprabha is the pose of carrying a child on her hips.

The other interesting painting in the Chicago set is one that shows two maids helping a woman ready herself for her bath. It was titled 'A Muslim Lady at the Bath'. Ravi Varma placed her in a palace like those built by the Mughals in the north. Unlike the women he and Raja had seen at the ghats, this aristocratic begum bathes in a marble pool. The painting 'At the Bath' was still some years away but clearly this subject was one he had already begun thinking about. It was one that required great discretion from the

artist. Just the slightest brushstroke could take the painting from seductive to erotic. There was a tantalizing voyeurism to the idea of capturing on canvas a woman about to engage in a very private act. In this painting, he had added the maids to give a sense of regalia, but it also took away the intimacy to some extent. Yes, it was an imagined glimpse into a zenana and the fact that a place behind purdah was being shown had its share of sensationalism. But the setting and her entourage made the Muslim begum in the painting unapproachable. In contrast, the girl in 'At the Bath' stands with the shy nervousness of a lover. With the warm light and soft shadows offering a sense of seclusion from the rest of the world, the way she holds her body, lowers her eyes, and clutches her white sari or upper cloth conveys a sense of anticipation.

The American audience was suitably charmed, even if they did hang the paintings in the Ethnography Pavilion. All ten paintings were accepted for the exhibition, and Ravi Varma was given two certificates of merit, which praised his observation and his command of academic realism. It must have impressed the American panel of judges that a man of his stature knew the lives of nomadic gypsies and beggars and could paint them so sympathetically. One certificate said, 'This exhibit of ten paintings in oil colours, by Ravi Varma, court painter to several presidencies of India, is of much ethnological value; not only do the faces of the high caste ladies who are portrayed give the various types of localities, but the Artist's careful attention to the details of costume and articles used in the social and ceremonial life he has depicted, renders the paintings worthy of special commendation.' The other applauded his painting style: 'The series of well executed paintings give a good idea of the progress of instruction in Art. They are true to nature and in form and colour and preserve the costumes, current fashion, and social features.'

Predictably, newspapers in India lapped up the news that Ravi Varma had received certificates of merit. Deen Dayal

too had received a certificate praising his photography. The photographer and the painter's names featured prominently in newspapers across the country. The *Malayala Manorama*, which was the most important news publication in Travancore, exulted over Ravi Varma, whom they still referred to as the prince from Kilimanoor. His prize was declared a cause for 'great jubilation to not only the Keralites but to all the Indian people'. The fact that these certificates commended his work for their ethnological value rather than their artistic excellence is something that later critics would point out. It is true that Ravi Varma's work was not included in the fine arts section of the exhibition but considering the strong racial bias that was evident in the way the Chicago Exhibition was organized, the fact that his paintings were noticed at all was significant. But it was ironic that one of his certificates said Ravi Varma's paintings showed how well fine art was being taught in India, considering the fact that he had received no 'instruction' of any kind from any European artist.

Although the Chicago paintings marked the height of Ravi Varma's fame, in them lies a hint of what would end up discrediting the artist within a few years, and it had little to do with his technique, which is what he had always been so careful to perfect. It was the blandness of his paintings and his determination to not let politics tint his works. In his paintings, Indian women were simply pretty women. Sometimes they were mothers or companions but they didn't stand for anything more. Already, the next generation of artists were using their art to voice their politics. Ravi Varma's paintings made a great impression upon viewers for their beauty and his attention to detail, but there seemed to be nothing more to imagine as a subtext to the paintings. Their power was in their vividness, not their symbolism.

The Indian gods and goddesses whom Ravi Varma painted so often would soon be taken up by artists to become symbols of the

motherland, rather than just beautiful and imaginary characters from ancient stories. Chitrashala was already attempting to do this in some of its prints. In 1905, a year before Ravi Varma's death, Abanindranath Tagore would paint the legendary 'Bharat Mata', with the same goddess Lakshmi that Ravi had once painted. But Tagore's was a solemn woman, clad in an ascetic's garb and painted with delicate watercolours in a style that was unique and emphatically not Western. As the years passed and nationalism gripped the nation, Ravi Varma's carefully posed paintings started to feel irrelevant to many. It is possible that he would have become one of the many names of early modern Indian art whose names stopped being memorable because their art was not much more than decorative, but unlike them, Ravi Varma was about to start a printing business in 1894 that would make his images immortal.

* * *

When Ravi came to Bombay from Baroda in 1892, Dadabhai Naoroji, who was on the verge of becoming a member of the English Parliament, was also visiting the city. Naoroji had been introduced to Varma before by the Gaekwad of Baroda and warmly met the artist when he called upon the elderly statesman. He was happy to hear of Ravi's plans to turn to printing. Both men agreed that prints like the Poona Pictures were destroying public taste and in the current times, it was important for the Indian public to have art that they could proudly claim as their own. But Ravi needed more than agreement and encouragement from Naoroji. He asked the elder man for help in finding a financial backer for the printing press. The ever resourceful Naoroji introduced Ravi to Govardhan Das Khatau Makhanji, a young man from a prominent business family who was eager to make a name for himself. The Makhanji family had amassed a fortune with the cotton trade and could easily afford to spend

some of it to indulge Govardhan Das's youthful ambitions. In any case, the publishing industry seemed to be a sound one to invest in because every shop seemed to be selling lithographs like hotcakes.

The meeting with Govardhan Das went well, and the brothers began looking for a place where they could set up the press. Ravi Varma didn't want to have it in Poona because of the disrepute of the prints produced by the presses over there. Besides, part of the attraction of the press was that it would give him a very good reason to stay in Bombay for extended stretches. After some hunting, they found a place in an area called Kalbadevi. It was very centrally located in southern Bombay and a major office area for Indian merchants and trades. Considering Kalbadevi's proximity to two major wholesale cloth markets, it was probably Govardhan Das's family connections that found them the place. The Varma brothers were hoping Govardhan Das, with his family background in business, would take care of the daily nitty-gritty. Ravi Varma was keen to be involved in the artistic side of the business. He was particularly curious about how a painting was drawn on plates and actually printed.

The year 1893 was spent getting things ready for the press to go into production. The most important part of this process was getting the lithographic stone plates ready for the prints. Most lithographs of the time used either a single colour or at best, a palette of four basic colours that could be modified to create a few more shades and tints. Ravi Varma wanted his prints to be of a far better quality. He made it clear to Fritz Schleicher, the German printmaker who headed the technical team that had been brought down to India with the machine, that he didn't care how many plates were needed per painting—the prints had to look rich and vibrant. Depending on the amount of detail in colours, the painting had to be copied on to a number of plates. While local presses rarely went above four plates per print, the Ravi Varma

Fine Art Lithographic Press used as many as thirteen for a single painting. It wasn't simply a matter of how expensive this process was but also that Ravi had technicians who were skilled enough to be able to use so many coloured plates properly.

When importing the machinery, Ravi had also hired another German artist who would be responsible for the drawings. His name was P. Gerhardt. Not much is known about Gerhardt, but he stayed with the press for many years and much of the credit for the early Ravi Varma prints goes to him. His curiosity about Indian art pleased Ravi and in exchange for introducing him to traditional Indian arts, Gerhardt told the Indian painter about contemporary European art. It was the age of Édouard Manet and Edgar Degas, of shimmering Impressionist paintings. Paul Gauguin was painting his exotic beauties and lush landscapes in solid, earthy colours and there was the steady realism of artists like Gustave Courbet. Conventional romanticism, with its emphasis on sentiment, was being dismissed by the young artists of the time who were inspired by what they saw around them, and they rediscovered an admiration for Renaissance painters like Caravaggio, who stripped mythology and gospel of their pretty spiritualism and told those stories as gruesome, painful tales that could be related to the lives of real people of any age. But critical appreciation was still for the tight brushwork and unblemished beauty as seen in the works of William Adolphe Bourguereau, whom everyone thought would be the most celebrated artist of the nineteenth century. Ironically, his paintings lost favour within a few decades, just as Ravi Varma's would. In the 1890s, however, he was considered among the greats, for the perfection of his painted Aphrodites and nymphs.

To Gerhardt, the Ravi Varma paintings would have seemed to belong to the Bourguereau school, and from the few examples we have of the German artist's work, it seems he liked romantic paintings. Like most artists who worked in lithographic presses in

Europe, Gerhardt was an artist of middling talent who could copy works very competently and whose skill at creating backgrounds with greenery was outstanding. The situation in India was different, particularly at the Ravi Varma Fine Art Lithographic Press. Bombay had a large number of unemployed or struggling artists, many of whom were graduates of the Sir J.J. School of Art. The news that Ravi Varma had opened a press in the city and would need artists sent these young men flocking to the Kalbadevi property. Ravi's friends on the faculty of the art school also recommended their students. Happy to encourage young talent, Ravi sent the ones he thought were promising to be vetted by Gerhardt. By the time the press started production in 1894, the workshop was almost like a salon that had some of the most promising young talent in the city. Among those who worked at the Ravi Varma Fine Art Lithographic Press at different periods of time were the immensely talented artist M.V. Dhurandhar and the man who would become the father of Indian cinema, Dadasaheb Phalke. The talent at the press showed in the prints that were finally produced with the first run in 1894.

When news of Ravi's press began to spread, his competitors were more concerned about the printmaking industry, and while some wondered why he had chosen to get into it at this point, others debated endlessly about what the artist's entry into this area would mean for them. They were struggling to hold on to their market because there were prints from Europe that were becoming more easily available. The other competition was photography, which was steadily growing in popularity. Everyone in the business wanted to know how Ravi Varma was going to make room for himself, especially since a couple of the presses had already started to create prints that showed images that were heavily inspired by his paintings. In 1894, the Ravi Varma Fine Art Lithographic Press produced its first three prints: 'The Birth of Sakuntala', 'Saraswati', and 'Lakshmi'. His competitors must

have bought the first copies they could get their hands on to see just what the famed artist had done. The prints would have reached Annada Prasad Bagchi at the Calcutta Art Studio office within days of being released in Bombay, and it is easy to imagine how he and the others of the studio must have fallen upon the prints.

'Does Ravi Varma make prints with wings or did you have someone steal the first print the moment his machine spat it out?' asked Annada Prasad Bagchi's friend and partner Nabakumar Biswas.

'I have three, not one,' was Annada Prasad's reply.

'You're dangerous.'

'No, I'm just curious.'

And that really was at the crux of it all. Annada Prasad wanted to know what Ravi Varma was going to do to the oleograph. Ever since one of their other partners at the Calcuta Art Studio, Krishnachandra Pal, brought them the news that Ravi Varma had imported a set of machines along with their operators and an artist from Germany, everyone at the studio had been speculating about what these prints would be like.

'How much money does he have that he can bring down a whole team of foreign technicians?' Nabakumar had asked during one of their gatherings.

'He charges about four times what any other Indian artist does,' their friend Phanibhushan reminded him.

'I don't understand why anyone pays him that much. It's not as though he's doing something unique. There are other painters who use oils and make portraits, after all,' said a disgruntled Krishnachandra Pal, whose money had been key in setting up the Calcutta Art Studio and who had the most to lose if they didn't make more money out of the press. His comment about other painters was quite obviously directed at Annada Prasad, who many felt had as much right to celebrityhood as Ravi Varma did. He had also exhibited to great acclaim in Madras and was one of the most respected names in Calcutta's art circles. The

Lieutenant Governor of Bengal had called him the Joshua Reynolds of India and that was no mean praise. Not that the British painter's name meant much to most people but being likened to a foreign artist was quite obviously a certificate of excellence.

Annada Prasad was not interested in these petty, imaginary competitions. For him, the portraits he painted were distinct and separate from the commercial art his studio produced. But Ravi Varma did not make these distinctions, and Annada Prasad wanted to know how he was going to turn his paintings into prints. The subjects Ravi Varma painted were perfect for the Indian audience. Annada Prasad had acknowledged that long ago and the Calcutta Art Studio had picked up on this by producing its own versions of Damayanti and Sita, for example. Except, of course, these prints looked nothing like what a respectable artist would draw. Annada Prasad had been appalled to see the print that showed a classical European nude masquerading as Damayanti, by virtue of a clumsily drawn sari around her form by one of the boys they employed.

But he appreciated the difficulties of making prints and that was really what made him all the more curious to know what Ravi Varma's press would bring to the public. He had seen the artist's work, and it was obvious that much of their beauty came from Ravi Varma's shading and clever use of colour. To finely replicate those nuances would be an extremely expensive venture because, given that each colour had its own stone plate, the process would need dozens of plates. So when the first prints arrived, Annada Prasad opened the package with the swiftness of an excited boy opening a birthday gift.

'His German lad is good,' Nabakumar Biswas said, looking at the prints.

'He's very good,' Annada Prasad agreed. "Look at the background here, for Sakuntala, Saraswati, and Lakshmi. Instead of creating a sense of depth by painting these trees and mountains in different shades, he's played with their sizes."

'The lines are also very fine. From a distance, you wouldn't think it's

227

a print.' Looking closely at the print of Sakuntala, he said, 'He's a clever one, that Ravi Varma. Smart to begin with the image of a lovelorn heroine gazing sadly into the distance as though it's you she's waiting for. Is she wearing a blouse?' He peered closer and saw she was. 'He'll have to bare more skin to survive in this market.'

'Don't be crass. It's a beautiful print. That's what will sell it.'

'You watch. He'll find reasons to make them drop their anchals.'

Krishnachandra Pal, on the other hand, seemed to be quite delighted that the prints were so beautiful.

'You don't mind that a competitor makes prints that are far superior to ours?' Nabakumar Biswas asked him.

'Mind? I'm thrilled. First of all, if he keeps making prints of this quality, he'll be bankrupt in no time because it's not possible to spend this much on each print and make profits. More importantly, maybe now those damn plagiarists will get off our backs, leave our Radhas and Krishnas alone, and turn to the prints from this man's press.'

* * *

Ravi Varma's 'Lakshmi' and 'Saraswati' would become two of the most popular prints ever produced in India. They would appear in households, shops, advertisements, posters, and calendars, and they would remain there for more than a hundred years. The calendar art that is seen today and often applauded for its kitsch value has its beginnings in these prints, which were modified versions of paintings once considered fine art. To make an oleograph, paintings had to be simplified. To make a popular oleograph, they had to change slightly. The lines had to be bolder, the expressions needed to be a bit more exaggerated, the women had to be more obviously seductive. Ravi Varma was not disinclined to do any of this. In fact, in the early years of the press, he helped to tweak a number of his paintings so that they were more suitable for print. He also didn't mind the younger artists working on his images. He even commissioned paintings with the

intention of making prints of them. The name Ravi Varma was a brand now and he wanted it to be successful and spread across the country. What was important to him was that the oleograph that emerged from the press should look attractive without being crude and, at the corner, it should have the name 'Ravi Varma Fine Art Lithographic Press' with the address in Bombay.

At the time that Ravi Varma chose to become a businessman, he was at a pivotal point in his life. His work had been appreciated and he had seen enormous success. People looked up to him and he had the opportunity of moving away from catering to clients, as he had been compelled to as a portrait artist and one who worked on commissions, into moulding their tastes to art that was less escapist and more responsible. As a young man, he used to enjoy painting 'social scenes' more than the works he was commissioned to paint, and years later, he had the chance to make India's royalty and elite see the people who made up this country in a less romanticized light. Too few of the country's privileged had any idea of what life was like for the masses, and Ravi's travels made him the perfect person to depict these realities. He had all the makings of a national hero. He had transcended the boundaries of presidencies and petty kingdoms. He was proudly Indian and he had painted Indian stories that spoke of a culture that was not indebted to the British, even though he did paint in the Western medium of oil paints. His network of friends included some of the most powerful people in India. His clientele were glad to imagine the country as he did—and what he chose to show them was the unreal world of myths because it was an established favourite, thus opening doors for critics to attack him for creating art that was naïve, irrelevant, and therefore lacking a potent, contemporary Indian identity.

Perhaps it was the fact that he reached the height of his career just at the time when many of his friends and family died that made Ravi so determined to make his name be known. Widening

his audience base became of critical importance to him in these years. At around this time, he began writing to the Maharaja of Travancore, urging him to build an art gallery where his paintings could be showcased for the public. The press seemed to be part of this project of making his name known widely. It was as though he desperately wanted to reach out to people he didn't know and let them know, through his paintings, that a man called Ravi Varma existed. It was an enormous departure from the painter's attitude in earlier years, when he did his best to disassociate his art from the grubby world of business (even though he minted money with his thriving portraiture business). Making art for earnings and profits was what commercial artists did, that lowly group who made art that commanded little respect. All this changed in the late 1880s, and the business of creating a name became of primary importance to Ravi Varma.

Deeply involved with the starting of the press, he did not paint much between 1893 and 1894. He did a few portraits and painted a durbar scene for the Maharaja of Pudukottai. In November 1894, a few months after the press had printed its first few prints, the artist set off on yet another tour of northern and central India. Ostensibly, he undertook this tour because the second Prince of Travancore, Aswati Thirunal Marthanda Varma, wanted to see the country but was not given leave or the money to do so by his uncle, the Maharaja. It seems a flimsy reason to undertake the considerable expenses of a tour that would cover places he had already seen, particularly since having a prince as a travelling companion meant that everything had to be of a certain quality. Ravi could ill afford to spend freely at this time because running the press was proving to be quite a drain on his finances despite the partnership with Govardhan Das. Whatever the reasoning, between the months of November 1894 and April 1895, Ravi and Raja Varma took the second Prince of Travancore and a retinue of seventeen servants on a tour of Upper India.

Ravi Varma did his best to give the young Prince a taste of the best of India. In Bombay, they watched plays and attended parties. In Baroda, he was shown the traditional pleasures of a northern king: nautch girls and a cheetah hunt. They visited temples, mosques, and museums. In Gwalior, they watched a parade by the famous Scindian regiment, which was known both for its discipline and its stylish uniforms. They rode on elephants, drove carriages, took trains, and travelled up and down rivers by boat. Sometimes they lived in palaces and bungalows; at other times they lived in dharamshalas and inns. The Prince met other royalty and also common men, like a Muslim man from Gaya who was travelling to Bombay from where he would take the ship to England, to study for the Bar. The weather changed from wintry cold to the blistering heat of April. In short, it was as comprehensive as a trip could have been.

Marthanda Varma was suitably impressed by the grace with which they were received by royalty in different parts of the subcontinent. No doubt, seeing Ravi Varma accompany the second Prince like a chaperone confirmed to many that the artist was indeed part of the royal family of Travancore.

While in Bombay, Ravi called upon his usual group of friends. One of them, Justice Ranade, told him about a case concerning obscenity in oleographs that was being heard in the High Court. The case had the judge in quite a quandary because the lawyers were putting up convincing arguments. Plus the effect of this judgement might be a momentous one; it could end up affecting how graphic elements in art were defined by law for years to come. Ravi asked Justice Ranade if it was permissible for him and his brother to bring the Prince with them to see the proceedings of the case. The judge readily agreed, and the three were allowed to sit on the bench with the Honourable Justices Jardine and Ranade.

'It was an appeal from the City Magistrate of Poona who had convicted the accused for having sold obscene pictures which were cheap German oleographs, representing nude figures of females,' wrote Raja Varma in his diary. Marthanda Varma dutifully attended one day, but Ravi Varma followed the case closely and attended more sessions.

It was understandable that the young prince didn't want to spend the days in a court room and had it not been for the press that was at work a short distance away, Ravi too would perhaps have not bothered to come back. But his interest in this case was professional and personal. There were persuasive arguments made by the print sellers' lawyer, who said the prints being sold showed no more nudity than much of classical Hindu and Buddhist art. He cited the examples of the many temples that are adorned with nude figures, the many erotic miniatures, and the voluptuous boldness of the sculptures in the Karle caves near Poona. Moving on to the tradition of painting nudes in European art, he asserted that the offending German prints were not actually obscene but simply a continuation of an artistic legacy that included every great name of European art.

Ravi Varma may well have felt a cold trickle down his spine when he heard all this. The prints showed two nudes in a forest scene. The original artist had perhaps meant to capture the moment when the women disrobed before bathing. The print now had an umbrella dangling from the branch of a tree and one of the nudes was sitting on a silken shawl that looked very much out of place. But if this was deemed obscene, how indeed did one defend classical art, because figures like this could be found all over the Western art canon? And would Ravi Varma's own carefully coy maidens also be seen as obscene by the law? Urvashi, with her diaphanous veil artfully lain across her breasts, or Sachi in 'Indrajit', whose clutched sari is unable to protect her modesty entirely—would they and their sisters be considered offensive? If

those who had brought the case against the press in Poona ever visited Ravi's studio and went through his albums, they would probably want to rip him apart. His collection of photographs of nude European models and prints of European paintings would infuriate and scandalize them. There was a part of him that wondered how they would react to seeing the print of Ingres' reclining Venus looking into the mirror and the nude he had painted after seeing that painting. Would these people be more offended by the rounded derriére Ingres showed or the breasts and belly he had painted when he had turned Ingres' Venus to look out of the canvas?

It isn't known whether Justice Ranade had any conversations with Ravi about the case but Justice Jardine and he pronounced a judgement that was reasoned, modern, and no doubt, a relief to Ravi Varma. They declared that the naked pictures of classical subjects were not obscene in their opinion because the artists creating these paintings and sculptures 'had higher ideals than those of merely exciting the sensual appetites of the spectators'. The images in the prints could have been classed among them had the printing press not added the modern silk umbrellas and such accoutrements. Ravi Varma must have come out of the courtroom making mental notes of how he could make sure anything that could be deemed scandalous was presented in a way that it represented 'higher ideals'.

The prints came in big, fat stacks that coolies dropped on the roadside, as they waited for shop owners to find space in their godowns. Most would be tired and if you were swift enough and the packaging wasn't very good, you could ease one out and get out of sight before someone caught you. Or if you were lucky, one print would fly out in an errant wind and the shop owner would cry out asking someone to catch it. Somebody would and unless they were one of those irritatingly honest people, they could have a print for free. The easiest way to get a print, however, was to be a shop boy. You couldn't have it for

yourself, true. But you could see it before anyone else. The two boys who manned the shop of art supplies in Baroda decided that this was good consolation. They reached the shop earlier than usual on the day that the Ravi Varma prints from Bombay were supposed to arrive. The moment they came and were put in their place, the boys carefully took out one of the new prints, holding it carefully, so as not to leave any grubby fingerprints.

'I think it's beautiful,' one said.

His friend was less convinced. 'It's pretty but...' He looked at the thick lines and the exaggerated expressions. 'I think I could draw like this.'

'You're an idiot. This is a Ravi Varma Print! No one paints like Ravi Varma.'

'Except Ravi Varma himself. This just looks the same. It's always the same sad-faced woman. Only the colour of her sari changes.'

'You're not just an idiot, you're also an ass.'

'Ravi Varma Fine Art Lithographic Press, Kalbadevi, Bombay.'

'That's the address.'

'How far is it to Bombay?'

'Why? You want to tell the press you can do better than Ravi Varma? Fool!'

From Bombay, the trio travelled on to Calcutta. Among their social visits, one was significant. Ravi went to Jorasanko, the family home of the Tagores who were legendary in Bengal. The family had given Calcutta some of its most fashionable and erudite people. Its terraces and balconies had played host to literary soirées, philosophical debates, concerts, and all sorts of cultural activities. When he was there, neither the Nobel laureate poet Rabindranath Tagore nor the artist Abanindranath Tagore were present, but Jorasanko and the Tagore family impressed Ravi greatly. He particularly enjoyed seeing the works in young Abanindranath's studio.

In the late 1890s, Abanindranath was not yet a talked-

about artist but a young man with much promise. He had just received praise for the illustrations he had drawn for his uncle Rabindranath's operatic retelling of the myth of Chitrangada. He was in the process of developing the style that would make him one of the most important figures of Indian art. The Calcutta School he would become a part of would replace Ravi Varma's European realism within a few decades, with the latter dismissed as too materialistic and lacking in spiritualism. Ravi saw Abanindranath's paintings with their fine lines and shimmering colours, and he was full of praise. To him, the subtle Mughal influence, Abandnindranath's refined lines, and delicate use of watercolours all made for a style that was modern and unique. He realized that something new was brewing among young artists here in Bengal.

It was too early to foresee that what would emerge from the experiments and experiences of these artists was, to a large extent, a reaction against what had been established as the Ravi Varma style. For those who were born into an India with art schools and easier access to Western traditions of art, the careful, posed scenes and perfectly formed faces painted in oils meant nothing. They simply sold the idea of beauty. The realism of the canvas was a disguise that misled viewers into thinking these were truths that had relevance in people's lives when they were actually fakes. These paintings copied the Western culture that regarded India with disdain. They lacked originality for a generation that had not had to discover a sense of India as one people and one culture. To them, the Ravi Varma style stood for paintings that sought only to be enticing, and they symbolized a time when Indians, eager to please colonial masters, copied the West to depict themselves as modern—a time that the new patriots were ashamed of.

Meanwhile, Raja prepared to become a published author. Before setting off on the second Upper India trip, he, inspired by the Victorian diarists, had decided to keep a journal recording

the Prince's tour. The diary he kept for the six-month tour was published as 'A Narrative of the Tour in Upper India of His Highness Prince Marthanda Varma of Travancore' in 1896. It was probably the first book of its kind by an Indian. There is almost no mention of the press in this diary, perhaps because Raja hadn't intended it to be a record of personal events. But it seems being a diarist appealed to him and from 1898 onwards, he would regularly make entries in his diary until his death in 1905. Not all of his diaries have survived but some have been painstakingly put together by family members and some researchers.

The diary Raja kept during their tour of India contained details of every place they visited and almost every person they met. Some of it is unremarkable—he meticulously noted what time they reached places, the distances between towns, and details of people who can't be identified any more—but the diary gives charming little snippets of information about the trip. The brief entries tell us how much they enjoyed watching *A School for Scandal*, performed in Bombay by a theatre company from London; how the northerners laughed at them, wrapped up in woollens as though they were setting out on a Himalayan expedition; and how while the Prince was taking photographs at the mausoleum of Itmad-ud-Daulah, there was a group of American tourists who took pictures of him. It also gives us wonderful little details such as the fact that the Gaekwad of Baroda's idea of dressing up simply meant wearing one emerald necklace. The singing parties and plays that the Varma brothers enjoyed so much are also mentioned, as are performances that they saw at parties they were invited to, like the dinner where they saw someone turn an earthen pot into a human head and then into a glass fish bowl. 'The illusion was startling,' wrote an unnerved Raja. The details of every temple, fort, and ghat they saw were recorded. The diary also confirms that Raja and Ravi found Delhi beautiful and liked Bombay better than Calcutta. It

seems the eastern city was not as 'well-watered and cleaned' as Bombay, which is ironic because it was in Bombay that plague would strike in 1896.

After completing the tour, Ravi came home to Kilimanoor for a while and was joined there by his son Rama, who was now almost fifteen years old. The rest of the year was spent working on plans to renovate the palace at Kilimanoor to create a more Western structure, which is what stands today, and trying to convince the Dewan of Travancore to set up an art gallery. He also found time to complete a few paintings. One was a classic portrait of his friend Kerala Varma, who had been awarded the Star of India in 1895. The portrait shows Kerala proudly wearing the decoration and the robe.

* * *

The year 1896 began badly with Ravi and Raja Varma losing a maternal uncle. This meant that the year was spent in mourning, with neither brother being able to leave Kilimanoor. Ravi used this time to continue pursuing the Dewan about opening an art gallery in Thiruvananthapuram which would be devoted to paintings. He broached the idea of making for the Maharaja of Travancore, a series of paintings based on Hindu legends, which would be displayed at this gallery. The Dewan was able to convince the Maharaja and the brothers began work on four of the paintings. While Ravi was looking forward to making his paintings accessible to the public, the Maharaja of Travancore was possibly excited by the idea of having Puranic paintings like the ones the Gaekwad of Baroda had. Ravi charged Rs. 1,500 for the two large paintings and Rs. 1,000 for the smaller ones.

In the first few years, the press didn't worry Ravi much. He divided his time between completing the renovation of the palace at Kilimanoor and occasional trips here and there. As far as he was concerned, he had done what he could for the press in the

initial period when it was being set up. Now, its daily running and financial affairs were not his to bear but Govardhan Das's. But like Ravi, it seemed Govardhan Das was also not interested in the everyday affairs of the press. The responsibility of the press fell squarely upon Fritz Schleicher. Schelicher's past before he came to India is about as shadowy as his colleague Gerhardt's. He was from Berlin and judging from the quality of the press's earliest oleographs, he was extraordinarily talented. Why he came to India, no one really knows because, although he lived in India until the end of his days, he also did his best to surround himself with all things German. Since the team of technicians that actually ran the steam-driven machinery was German, that was the language spoken in the press. The original lithographic stones were marked in German, and Ravi Varma even picked up a smattering of the language, thanks to his years with Schleicher. In the fortress-like house Schleicher built in Malavli, he had a beer cellar where he stocked German beer and wine. In the area around the house and the press, he had pine trees planted because it was the closest he could get to German fir trees.

Yet, Schleicher stayed in India and remained with the Ravi Varma Fine Art Lithographic Press. He ran it strictly and efficiently, and brooked no interference in technical matters. Without Schleicher, the business would have collapsed by 1898 when the scare of the plague forced Govardhan Das to relocate the factory from crowded Kalbadevi to Ghatkopar, which was a little further out on the eastern side of Bombay. It must have been a difficult decision for Govardhan Das because the idea of dismantling the press, shifting all the equipment, and then reinstalling it must have been cumbersome. These were delicate machines with no replacements available in India. He delayed moving the press for two years, hoping that the epidemic would be contained but by 1898, he had to temporarily shut it down.

The first instance of the plague was recorded in October

1896. By the end of the year, it was estimated that approximately nineteen hundred people were dying every week. The major problem was that the disease was difficult to diagnose and there was no specific remedy. Hygiene and better ventilation seemed to be two solutions to the problem. Those who could afford to shift to higher ground, like Malabar Hill and Cumballa Hill, did so. Meanwhile the city's municipality built new roads and restructured crowded neighbourhoods, hoping this would help. Neighbourhoods deemed unsanitary were razed. Citizens were told to keep an eye out for people with 'suspicious symptoms' and if someone had these symptoms, they were placed in hospitals and segregation camps, both of which became nightmarish places where close to 80 percent of the patients didn't survive.

To combat the plague, many parts of Bombay were remodelled, some for the better. A Plague Research Laboratory was set up and the City Improvement Trust was given the responsibility of reclaiming land from the sea and expanding the city. For those who saw their homes razed, this was not much of a consolation. Outside the city, the plague became an excuse by which the underprivileged could be mistreated further. In areas like the Nasik district, lower caste communities and prostitutes were blamed for the epidemic, rather than rats. Unsurprisingly, resentment against the British administration grew sharply in this period, especially since their measures were unable to contain the epidemic, which lasted all the way until 1906.

Bombay had been a largely peaceful city until the 1890s. There were few recorded instances of local violence and these had all been easily contained. Then on August 11, 1893, there was a clash between Hindus and Muslims near Jama Masjid in Kalbadevi. A small police party tried to break things up but in no time, both groups turned on the police. There followed a week of violence and the stunned administration had to request military reinforcements. Street gangs formed in neighbourhoods

and fought one another as well as the police. Shops were looted. Mosques and temples were attacked. More than fifteen hundred rioters were arrested before the situation calmed down. However, the calm was temporary.

Since the 1880s, there had been a steady growth of anti-British sentiment among the middle classes. The Bombay Presidency had seen famine and now the plague. University graduates couldn't find jobs. Yet, the British flourished in their clubs and homes. Their neighbourhoods were pretty and well ordered but that was a small part of the city. The Indians who were not wealthy lived in appalling conditions. At night, the streets of Bombay were covered with people who slept there because they had no homes. There were congested localities of mill workers and labourers that the administration steadfastly ignored until the plague scare. At this point, their response was to peremptorily raze the slums.

In Maharashtra, among the most active agents of the anti-British fervour was Bal Gangadhar Tilak, a journalist and good friend of Vishnu Chiplunkar, who owned the Chitrashala Press. The two of them joined hands with a few more friends to set up two newspapers. The English one was called *The Maratha* and the extremely popular Marathi newspaper was called *Kesari*. In *Kesari*, Tilak wrote fiery columns that sought to remind his readers of a glorious Hindu culture that was being denigrated by the British. His first attempt at bringing together the fragmented and caste-ridden Maharashtrian society was by giving them a hero: the seventeenth century Hindu king Shivaji who had expanded the Maratha empire and held off the British and the Portuguese. Using *Kesari*, he raised Rs. 20,000 to repair Shivaji's tomb in Raigad and began urging people to organize Shivaji festivals in towns all over Maharashtra. His efforts were successful, and the figure of Shivaji helped create a sense of pride about the Maratha identity.

Once the plague administration got into action, there were reports of harassment of locals in Bombay and Poona by troops

authorized to enter homes under suspicion of harbouring people with the disease. These soldiers picked up valuables, desecrated temples and altars, spoke offensively; and there were accusations of them touching people inappropriately when they were supposedly examining them for signs of the plague. Tilak criticized the behaviour of the troops angrily in his columns and went so far as to suggest to his readers that it was their duty to react violently against this. Damodar Hari and Balkrishna Hari Chapekar took Tilak's advice, and on June 22, 1897, they and a few accomplices killed the Special Plague Committee Chairman Lieutenant Ayerst. Tilak was charged with incitement to murder and sentenced to eighteen months' imprisonment. The case was reported widely and served to make Tilak a national hero.

Tilak, who joined the Indian National Congress in 1890 even though he didn't agree with its moderate attitude, commanded a large following and his boldness inspired many. With his own angry defiance of British instructions and his staunch refusal to mutely accept the racial bias in colonial policy, he spoke for a dissatisfied generation of middle class Indians who had been educated in the British system and then found it turning against them. All this political fervour meant unrest in Bombay and Poona, which in turn had its effect upon business. Trade with Bombay was paralysed and merchants suffered enormous losses. Local businesses, like the Ravi Varma Fine Art Lithographic Press, found it increasingly difficult to operate because all of them had at least a few workers who came from plague-ridden areas. The plague administration also cracked down on crowded areas and consequently, neighbourhoods like Kalbadevi, where Ravi Varma's press had its office and workshop, were among those that operated under the threat of being shut down. Schleicher managed to keep the press running until 1898, when the discontent and plague reached alarming proportions.

Fritz Schleicher knew the boys in the press all wondered about him.

Had he come all the way from Berlin to Bombay only to walk down Grant Road and spend hours at these dingy dens where the local roughs spent their time? If anyone had actually come up and asked him the question, he would have had a question in return: what else was he supposed to do while this city went to hell, thanks to this bloody plague? Especially when the press he was managing seemed to be run by a spoilt buffoon who had as much arrogance as he had money. He had written to Ravi Varma and told him that his press would be run to the ground if it was left in Govardhan Das's hands but what could Ravi Varma do sitting in some southern village? And if he didn't want to come up to Bombay now, who could blame him? First there was that Tilak causing a ruckus and being a nuisance with his angry, rabble-rousing speeches. The man managed to turn the age at which girls are married into a question of Hindu identity. And people cheered him on, uncaring of how idiotic it sounded to say that the strength of your faith—no, your entire identity—depended upon whether a girl was married at ten, which was apparently the Hindu way, or twelve, which was the British suggestion.

But Tilak had an awesome power to draw the crowds. In fact, he worried Schleicher more than the plague. Whether it was at the festival that he started celebrating some local king who had defied the British or that Hindu elephant god, or just a call from him to take to the streets, people came swarming out. More than one of his artists at the press was a Tilak supporter and if Tilak was making a public appearance, there was no way they would miss it. The British didn't help their own cause by burning down houses, even streets, once the plague reached Bombay. They couldn't contain it and it became an epidemic, except now it was an epidemic in a city with more people who were filled with vitriolic hatred for the white rulers who had left them homeless and destitute.

None of which would be of any concern to Schleicher if it didn't mean the press remaining idle for months at a time. It didn't frustrate him because he was left with far too much leisure time. He was happy to go off hunting near Lonavla and spend time in those villages,

though admittedly it was tiresome to have to get a medical check-up every time he came or left the city. What irked Schleicher was that Ravi and that incompetent Govardhan Das were losing out on a fabulous opportunity. Ravi Varma's paintings, particularly the mythological ones, were perfect for the mood of the people. They were steeped in the Hinduism that Tilak was so full of, respectful of local traditions, and appealing to the eye. In addition, they were considered modern here in India. Other studios had picked up on this. Just the other day, Joshi, their distributor, showed him a Calcutta Art Studio print called 'Krsna and the Gopinis'. It could have been painted by Ravi Varma—that same old-fashioned European romanticism—if it had been better composed. But there it was: a scene of happiness and one that every devout, nationalistic Hindu would be happy to own. Well, perhaps not every one of them but certainly all the men. It showed a profusion of nubile nudes as gopinis and that, Schleicher knew, was another canny way of attracting viewers—and buyers.

He saw some wisdom in Ravi's opinion that rather than going for blatant exhibitionism, like in this print of Calcutta Art Studio's, it was wiser to opt for a more subtly titillating approach. But the kind of artists that Ravi Varma kept sending to work at the press seemed to be annoyingly uneasy about making those adjustments that would turn a painting from respectable to alluring. Fortunately, there was Gerhardt who had few of these compunctions. Whether you wanted him to draw a tree or an unwound sari, the man did it efficiently and competently, though his trees were certainly better than his saris. Except now, with the damn press shut down since Kalbadevi was deemed unsafe, Schleicher had neither tree nor sari to print and only wretched Indian alcohol to drink. As he hollered for another round, Schleicher decided that if Raja Varma did actually come down to settle the business of the press, he'd take a stab at buying it.

Approximately six years after Govardhan Das and Ravi Varma entered into a partnership and four years after their press started production, Raja Varma found himself travelling to Bombay

243

because relations between his brother and Govardhan Das had reached breaking point. The business was not making enough money especially since Bombay was reeling under the plague. Govardhan Das wanted out of the partnership. Ravi Varma was now fifty years old and beginning to feel his age. In a couple of years, he would be diagnosed with diabetes. At this time, the only signs of the disease were his tiredness, which was unusual for him. When he asked Raja to complete the formalities for him, the younger brother couldn't refuse and the ownership of the press was transferred to him. This meant he had to organize Rs. 20,000 to buy out Govardhan Das's shares. The Varmas didn't have so much money at this time. Ravi Varma had been taking fewer commissions in the past few years, first because he was concentrating on the press and then because he had to go into mourning. Even if he had been painting, to raise the money Govardhan Das wanted, he would have had to paint exactly twenty two life-size canvases. Most commissions were for a couple of paintings. To make that many in a year was virtually impossible. The only option open to the Varma brothers was to borrow the money from friends in Bombay and hope that the press would recover it in some time. Raja wasn't looking so far ahead as recovering the money. His first objective was to meet Govardhan Das and complete the formalities that would end their short-lived relationship.

Once Raja reached Bombay in the sweltering heat of May, all his days seemed to be filled with two activities: chasing after Govardhan Das and dealing with the worries of Narayan Aiyar, who was hired to manage the press's accounts. On certain days, variety came in the form of Schleicher and his complaints. There must have been times when Raja wished he could conjure up Dadabhai Naoroji and make the old man command Govardhan Das to behave. After all, the only reason he had been taken as a partner was Mr. Naoroji's recommendation and now the man

was proving to be an albatross that even Coleridge could not have imagined. On one hand, he had made it amply clear that he wanted to have nothing more to do with the press. Yet, when Raja asked to meet him to complete the formalities, he kept avoiding him. He dithered endlessly and refused to come to any sort of agreement to end the partnership, which was infuriating and frustrating because there was nothing Raja could do in response except persevere.

He spent a lot of his days painting, and one model—a Parsi lady of elegant bearing—appears in a number of his paintings. Unfortunately, her name isn't mentioned but she was probably related to one of the many Parsi friends that the Varma brothers had. Each night, he recorded everything that had happened in the day in his diary and often, as he wrote out the details of yet another day when he failed to get hold of Govardhan Das, he must have felt a rising despair, not just at how slowly this whole affair was moving but also at how the diary was progressing. Re-reading the diary from their tour with the second Prince had made him think that it would be entertaining and relevant to keep records of things that happened. But who would find any interest in this? From Sunday, July 3, to Wednesday, July 13, all he had done was chase Govardhan Das and met the man who had kindly agreed to lend them the money, if this deal with Govardhan Das ever worked out. Raja couldn't understand what Govardhan Das wanted. It was as though there was one Govardhan Das who wanted to get out while another wanted to hold on to the press. The second one had hired a solicitor who had modified the agreement and laid down impossible terms that Raja refused to agree to. If Govardhan Das believed Raja would accept anything he said just because this press was something that his Chetta held dear, he had another think coming. As far as Raja was concerned, in July 1898 he was prepared to leave the press to be sold off by Govardhan Das if the latter didn't stop being so difficult.

Meanwhile the plague had reached epidemic proportions and the British attempts to combat it seemed to have little effect. Raja heard that entire neighbourhoods had been razed to the ground upon suspicion of the plague and the city had seen much unrest. In some parts of the city, there were guns and soldiers on the streets. It should have been impossible to go anywhere and yet, somehow, crowds kept gathering at the seashore. Schleicher, probably frightened by the plague, kept suggesting to Raja that they shift the press to Lonavla, which seemed somewhat exaggerated a reaction to Raja, even if it would certainly prove to be cheaper and safer. But it was too far away. Even Ghatkopar, where the press was now located, was a fair distance and Raja didn't want to go through the process of dismantling and reinstalling the machinery another time. With the press in Lonavla, they would never be able to spend time in Bombay, and the city had been his only comfort in these trying times. Walking along Chowpatty, the sound of the sea in his ears and its teasing wind swirling around him, had calmed his spirits on many an evening. The prettiness of the Fountain and the distractions in the shops in the Fort area; riding through the city on the meandering trams or watching the fishing boats at Apollo Bunder; the curve of the Esplanade, sensuous as a woman's waist—he would miss all of this and he would miss the people who had unveiled this city to him.

The best thing to have come of this affair with Govardhan Das was that Raja had discovered who their true friends were in this city and it was a blessing to know how many fit that description. Taking a loan of Rs. 22,000 to pay Govardhan Das off for his shares was perhaps a small price to pay, perhaps, for that knowledge and the assurance that he would never be part of their world again. Raja did not want to ever imagine going through such a time without the support of friends like Bapuji and Mathai, the gentlemen about town who had, on so many

occasions, lifted Raja's spirits when they were low. Thanks to them, Raja had seen a beautiful Urdu rendering of *Hamlet* by a Parsi company and *Harishchandra* at the Royal Theatre on Grant Road, whose scenery was so gorgeous and realistic that it seemed as though one could walk into it. But by August, when the deal was ultimately finalized and Raja was able to borrow the Rs. 22,000 from one Dr. Balachandra Krishna, he was ready to return to Kilimanoor and get away from all the conversations about accounts, debts, and business dealings. Not that leaving Bombay would let Raja forget that he was now the owner of a printing press and that he and Chetta were Rs. 20,000 in debt.

* * *

At fifty one, Ravi Varma found himself back to the grind of meeting people and looking for commissions. The brothers returned to Bombay, this time accompanied by Rama, Ravi's nineteen year old son who was preparing to be an artist. Raja Varma's diary betrays little tension about the enormous debt that the two brothers carried upon their shoulders. A few orders are mentioned but by and large, their days seem to have been spent completing paintings and leading a rather idyllic life. Friends visited, took them to concerts, invited them to parties, and many trips to the theatres are mentioned. In January 1899, with Gerhardt and Schleicher in tow, the Varmas went up to Karli, a few hours outside Bombay, where Schleicher would eventually set up the press. At Karli, Raja had a chance to paint the landscapes he so enjoyed, while Ravi and he worked on completing paintings like 'Hamsa Damayanti' and 'Lady Giving Alms'. They took photographs, read the Poona Gazetteers, and the Germans went hunting. But running as an undercurrent to these pleasant events were the tensions of finding the money to not only repay Dr. Balachandra Krishna but also to keep the press running.

Despite the successes of the past years, there weren't as many

commissions for Ravi Varma as he needed at the time. Mysore and Travancore kept buying his paintings, and these orders would have been enough along with the occasional portrait, but considering the financial strain he was in, Ravi had to find more commissions. Curiously, the brothers don't seem to have approached the Gaekwad of Baroda, who had been such a pillar of support in earlier years. One reason for this could have been Ravi's ego. Sayajirao had gone on to patronize a number of young artists but had not courted Ravi Varma as he used to after the Baroda commission. It may also have been a far more practical problem of being unable to contact the Gaekwad, who had begun to spend the better part of the year in Europe. Both brothers sent paintings to Madras for the Fine Arts Society exhibition but neither of them won any medals. Raja's paintings were praised for their excellent technique and Ravi was given a mention, but not winning a medal at Madras must have been a shock to him. The year ended with their father's death in his village of Ezhumavil. Although it was not customary to mourn one's father in the matrilineal system, Ravi spent a few months in mourning. It gave him an opportunity to retreat, regroup, and plan how he was going to recover his position.

With the old connections proving to be inadequate, Ravi had to forge new relationships, and circumstances seemed to favour him again. In 1900, the new Viceroy, Lord Curzon, came to visit Thiruvananthapuram and was most impressed by Ravi as was the rest of the British contingent, including the Resident G.T. Mackenzie. Soon after this visit, it seems Ravi decided to use his newfound clout. The royal family of Travancore found itself in a crisis because the ruler had no nephews who could inherit the throne after him. After meeting Ravi, Mackenzie broached the idea of the royal family adopting two princesses from the house of Mavelikkara, Bhagirathi and Ravi's granddaughters to be precise. Ravi never admitted to having been eager to see this adoption

take place. In fact, he suggested to early biographers that he was entirely disinterested in the matter and it was actually upon the efforts of Mackenzie and the Viceroy that the adoption took place. However, it seems more plausible that Ravi did actively work for this adoption. He may have been attempting to forge this connection with the royal family of Travancore in the hope that it would open doors to other Maharajas in the country. Even if it didn't do so directly, with his granddaughters in the royal family, it would raise his status and there would be more people he could turn to for financial help because, by extension, he too became royalty. He had been using Raja before his name for a few years now even though he didn't technically have any right to use that title. With his granddaughters adopted into the Travancore's royal family, his adopted title would have been accepted readily by everyone within and outside Kerala, which is precisely what happened. The painter is known to most as Raja Ravi Varma till today, and the explanation given for the title of Raja is that he is related to the ruling family of Travancore.

The Maharaja of Travancore was dead set against accepting Ravi Varma's granddaughters and he strenuously protested against Mackenzie's proposition. It was probably this attitude that made Ravi present a nonchalant façade. He was a proud man and it was beneath him to show eagerness, particularly when the Maharaja was doing the opposite. After a few months of watching the dissent between the Maharaja and the Resident, Ravi decided to make a trip to Calcutta. There, he stayed with Surendranath Bannerjee, a noted political thinker and one of the most respected men in the Indian National Congress. The British called him 'Surrender Not Bannerjee' because of his determination, and he was a towering personality in Calcutta. Not much is known about Ravi's trip to the eastern city but we do know he called upon the Viceroy. It was not a social visit because, despite the favourable impression Ravi Varma had made upon Lord Curzon, there

wasn't the intimacy of friendship between them. This was patently obvious from the fact that when the Viceroy visited Hyderabad in 1902, although Ravi was also in the city, the two only met briefly at a party thrown by the Nizam for his British guest. In Calcutta, however, Ravi secured an appointment with the Viceroy. The only matter that the Viceroy and Ravi Varma could have had to discuss at that meeting was the future of Ravi's granddaughters and it is a fact that soon after this, the Viceroy decided that the girls would be adopted by the house of Travancore.

Back in Bombay, Ravi, accompanied by his son and his younger brother, began looking for commissions and agents who would be able to get him these commissions. The diary that Raja kept at the time provides us details about some of the paintings they were working on, but there are two more important bits of information that it supplies. First of all, it was in 1901 that Schleicher made the first bid to buy the press and by the end of January, they had already drawn up an agreement as to how the property and deeds would be transferred. Schleicher was to pay Ravi Varma Rs. 25,000 and take on the press's debts, including the personal loan of Rs. 20,000 that Raja had taken to buy Govardhan Das's shares. After having sunk so much money and effort into the press, it seems Ravi lost interest in the venture within a couple of years of it being set up. He had told early biographers that his intention behind setting up the press was to improve the tastes of the Indian public, which he felt was ill served by the existing presses. If that really was the reason he started the press, then he lost that resolve very early.

Schleicher and Gerhardt, on the other hand, ran the press enthusiastically. They had an excellent machine, a set of popular paintings to make prints of, and a batch of very talented artists. Schleicher began expanding the press's portfolio by securing jobs to print textbooks and photographs. He also began producing oleographs of Shivaji and Tilak. Gerhardt worked on training

the younger artists and teaching them how to turn a painting into the image they needed for a print. The two Germans stayed true to much of Ravi Varma's vision for the press, although one of the first things Schleicher did was to cut the number of plates down from thirteen to eight for a print. They didn't succumb to the temptation of producing the crude images that were termed 'Poona Pictures' but produced coy ladies who sought to tease their viewers rather than titillate them.

* * *

From 1901 onwards, both brothers seem to have suffered from fevers, indigestion, and other chronic illnesses. Raja Varma writes repeatedly about fevers and doctors' visits. Living in a city that was afflicted with plague, this would have been most worrying and his diary entries in Udaipur show that Raja, in particular, did not fare much better in the little Rajasthani kingdom. They still continued to paint, barely slowing down either their socializing or their pace of to paint. The deal with Schleicher would take two more years to be settled and executed. Until then, the press made claims upon Ravi Varma's finances. He wasn't bankrupt by any means, but he was significantly in debt and the press was not earning enough to repay that debt and meet its running costs. This was why Ravi began looking for agents who could get him generous commissions.

A good agent was often a key element to a commission being completed satisfactorily. He ensured there were no miscommunications between the two parties and took responsibility for getting the artists everything they needed. Back in those days, being an agent was not a standardized profession, but if hired, an agent secured a fee that was proportionate to how generous a commission was. When acquaintances chose to perform the role of agents, as was often the case with Ravi Varma, they were generally doing so because they felt that

bringing the celebrated artist to the royal court would improve their own positions in some way. It took a few months, but Ravi and Raja's efforts did yield results. Fatehlal Mehta, whom the brothers had met in Bombay, was a confidant of the Maharana of Udaipur and after some strenuous campaigning, he was able to secure for the brothers an invitation to come to Udaipur and paint the Maharana. The Udaipur commission was one that they felt triumphant about because Maharana Fateh Singh was known for being a robust supporter of his court painter Kundan Lal, who also painted with oils but whose paintings had none of the finesse that Ravi Varma's did. The Maharana's decision to invite Ravi Varma seemed to be an indication that he was willing to look past any sort of imagined competition between Kundan Lal and Ravi Varma. But as it turned out, the tussle had only just begun, and it was between the Maharana and Ravi.

Once Ravi reached Udaipur with Raja and his son Rama, they were taken to their accommodation and there, they received the first clue that this commission was not likely to go very smoothly. The Maharana had put them up in a bungalow whose only likeable feature was that it was on the Udaipur Lake. He did not receive them particularly warmly when they appeared before him and after one hasty sitting, he left on a tour, leaving instructions for Ravi to copy portraits of the dead Pratap Singh, Amar Singh, and Jai Singh. They should be in the the miniature style rather than his own. Until this was completed, the Maharana would not be available to give the brothers a sitting for his own portrait. To be asked to copy a painting, that too in accordance with a style that was not natural to them, was to effectively remind Ravi Varma that he was a commercial artist, a painter on hire who was honour-bound to follow orders. If he had any ego about being India's most famous painter and one who had been fêted by the British, that was of no consequence to the Maharana. Here in Udaipur, he had to prove himself all over again and his first

test was to show whether he had the skill to copy Rajputana's traditional painting style. Ravi had to mutely accept this even though it verged on being offensive, because he needed the money that came from the commission.

To make matters worse, Ravi, Raja, and Rama fell seriously ill during their time in Udaipur. Rama contracted smallpox while the other two came down with fever. He may have been feeling cantankerous but Ravi did not let himself get emotional. He recognized this as a trial that he had to pass in order to win the Maharana's favour. So he copied the miniature style and with Raja, he made the portraits that the Maharana wanted. While waiting for the Maharana to return, he made sketches of the people in the countryside and completed a few smaller portrait orders.

With equal professional calm, Raja made note of the Maharana's power play in his diary. He wrote that the Maharana spoke no language other than Hindi, sat on a gaddi, and received them in the 'old style'. With that one phrase, Raja subtly communicated both the king's patriotic pride at his own heritage and Raja's perception of it as outdated and conservative. Two weeks later, he mentioned that they were copying a portrait of the legendary Rajputana king Rana Pratap, who was famous for his spirited resistance to the Mughals. Raja noted that the miniature style of painting lacked realism and was flat, but he also wrote pointedly that they had only been asked to copy and therefore, they were doing so diligently. A little more than a week after they had finished copying the painting, Fatehlal Mehta visited them and asked to see their work. He praised their copy and must have informed the Maharana because two days later, they were granted a royal audience at which they were to show the painting. The Maharana said nothing in criticism and agreed to sit for Ravi Varma but only after he had come back from another tour.

Since they had a lot of free time in Udaipur, the Varmas were

able to see the city and its surrounding areas, and they enjoyed this greatly. The city's beauty and the generosity of some of its residents like Fatehlal and G.E. Lillie, a senior official of the Udaipur State Railway, went some distance in making up for the Maharana's standoffishness. The palaces and the people charmed Raja Varma, as his diary entries show. There were a few portraits they painted, like the one of Rai Pannalal Mehta, who was a friend of Ravi Varma's and one of the Maharana's more important courtiers. Although they had visited the area before during the India tours, both Ravi and Raja were happy to spend time exploring it again, and the grandeur of Udaipur's palaces and temples amazed them. They visited the zoo and were awed by the tigers, which Raja said were the biggest he had seen. Fortuitously, they had come to Udaipur at a time when there was a local festival, which involved a procession that they saw from their balcony. The lights of the procession, reflected upon the waters of the lake, were so beautiful that Raja ended up writing about this scene more than once and attempting a painting of it from memory. His landscape artist's eye made Raja particularly appreciative of the completely different colour palette that nature presented him with here.

While the Maharana was away, Kundan Lal decided to pay Ravi a visit at the studio where he, Raja, and Rama were working on another set of copies that had been given to them. Kundan Lal came with a few friends and made disparaging remarks about the painting that the Varmas were working on. Despite being unwell, Rama did not take to this rudeness quietly. He challenged Kundan Lal to come and paint with them and prove he could do better. Raja Varma wrote in his diary that this was enough to quieten Kundan Lal who slinked away when faced with Rama's ire.

News of this incident must have reached the Maharana when he returned and perhaps it was the graceless behaviour of his

court artist that made him realize that Ravi Varma needed to be shown more respect. The Varmas were quickly shifted to much nicer living quarters. The Maharana made himself available for sittings, although often grudgingly. Mangoes were sent for the artists from the royal palace. From the irritated tone of his diary, it seems Raja was not too mollified by the Maharana's behaviour. Ravi kept his party's tempers in check and seemed to be appreciative of the delicate politics involved in the staunchly pro-Rajputana Maharana Fateh Singh commissioning a portrait done in the western style, and that too by an artist from the south. It could be interpreted as a rejection of his local culture and the politics he espoused in his public life. Raja and Rama, however, were far from sympathetic to the Maharana and seemed to have been counting the days till this trip came to an end. Not wanting to let this irritation be known to their hosts, when it was time to take the Maharana's measurements for the portrait, Ravi went alone. Relations between him and the king thawed enough for the latter to do a proper sitting in full dress. The gesture didn't go very far with Raja, who noted that the Maharana felt tired soon after and they were able to complete drawing only a few of his ornaments.

The portraits were finally completed on June 29 and Ravi left Udaipur on July 1. Just the portrait of the Maharana had earned him Rs. 1,800.

* * *

The Varma entourage returned to Bombay from Udaipur, and Ravi began the working on a canvas that would eventually become 'At the Bath'. The painting didn't come off with the ease with which he had painted other beautiful women. Ravi struggled for more than a month just trying to figure out basics like posture and positioning. He went through many photo albums and European prints, hoping for guidance. This tactic had proved helpful to him

when he was attempting to paint 'Indrajit'. This painting shows Ravana's son standing proudly victorious after defeating Indra, the king of the devas. See the painting or the oleograph next to a print of the little-known wood engraving by Enrico de Serra titled 'Spoils of War', and it's obvious that Ravi Varma turned to the European for inspiration. The victors in both paintings have the same pose and their hands imperiously gesture for the woman to be brought to them. It isn't exactly a copy: Ravi used the way the scene is arranged in the engraving like a map for his own painting. Unfortunately, with 'At the Bath', the available prints proved to be of no use. Like the models he photographed for the painting, most were too coy and obviously looking to tempt the viewer. That Ravi would take so long to complete one painting was incredible to those who knew him. After all, this was the man who had completed five paintings in a month just a few years ago. Everyone would have hoped that this was just a temporary effect of their recent Udaipur trip but Ravi Varma was slowing down. He knew he could no longer paint as he used to. He needed more help from Raja when drawing on the canvas. His lines were becoming less steady. Even though he knew exactly what he wanted the paints to do, it took him much longer to work the colours so that they created the effects he needed.

Almost as though to balance this, Raja seemed to be coming into his own. Now in his early forties, Raja was still the reserved, quiet one, but his work was increasingly getting noticed. He was asked to write articles for different publications and often they didn't have anything to do with art. *The Indian Ladies' Magazine*, for example, published an article he wrote about the status of the Namboodiri women of Malabar. The paintings he had sent to different fine arts societies over the past couple of years had been praised. His landscapes and sceneries were particularly appreciated. His style was distinct from Ravi's, especially in the lightness of his palate. Whereas most of Ravi's paintings showed intense

and rich colours, Raja preferred using colours so that they had a near-transparency and brightness, as though they had been mixed with sunlight. In a few portraits, Ravi insisted they both sign the canvas. It was almost as though he wanted to prepare his clientele for the man who would be carrying on the job he had started.

In December 1901, another agent came through for Ravi Varma and he was an old friend. Deen Dayal invited the artist to visit Hyderabad where he was the official photographer to the Nizam. Deen Dayal didn't commit to Ravi getting a commission but he did drop many hints that if the artist came to Hyderabad, the Nizam could ask him to make a couple of portraits. The Nizam was a fascinating individual, said Deen Dayal. This man had entertained the Czar of Russia, the Prince of Wales, the Archduke of Austria. Like the great Mughal Emperor, he went out at night incognito to know what preyed upon the minds of his subjects. In his collection were priceless works of art from Persia and precious Mughal miniatures. The photographer waxed eloquent about the city of Hyderabad, the elegance of its people, and the excellence of its cuisine. Women here had the faces of goddesses and the bodies of nymphs, he said, and he should know since he had set up a photographic studio for women. The culture was sophisticated and modern. In short, it was the perfect place for Ravi. Once letters of invitation came from the Nizam, Ravi set off for Hyderabad with Raja.

Two months into their stay in Hyderabad, Raja wrote in his diary the two words that he felt best summed up Hyderabad and its people: hypocrisy and unpunctuality. It began well enough. They were received warmly by Deen Dayal who insisted they stay with him for as long as they wished. But within a few days, it became clear that when Deen Dayal had asked them to come to Hyderabad, he hadn't quite prepared the ground as a good agent should. There was no meeting arranged with the Nizam and it seemed as though they had arrived unannounced. To keep

257

them occupied or perhaps to save Deen Dayal's face, the Varma brothers were given an assignment. A large, dark painting by an unknown artist was shown to them and Ravi Varma was told to improve it. Somewhere in its gloomy mess were the images of a procession that the Nizam had graced some time ago. It was the kind of job one gave a young art student. Raja took on the responsibility of attempting to salvage the painting, and Ravi decided that they needed to move out of Deen Dayal's home and find their own quarters.

The Nizam's courtiers kept stonewalling Ravi Varma. Ever polite, they were always ready with an excuse for the Nizam's absence or inability to see the painter. There was a neat and rigid social hierarchy in place in Hyderabad, and Ravi soon realized he was not being able to reach the people he needed to in order to approach the Nizam. His only contact in Hyderabad, Deen Dayal, was proving to be a touch recalcitrant, now that they had answered his invitation and come to the city. Left to their own devices and receiving only empty, saccharine courtesy from the Nizam's representatives, Ravi and Raja spent their time exploring Hyderabad and meeting people. The Nizam seemed to be loved by his subjects, but he was also known to be something of a playboy and a dandy. Rumour had it that he never repeated an outfit and an entire wing of the Falaknuma Palace acted as his wardrobe. The brothers found friends among others who were not from Hyderabad, like Miss Sabrina who ran a photographic studio for women in the city. She had a fascinating set of photographs of beautifully bedecked nautch girls and women from the Nizam's zenana. When she heard how difficult it was to find models for painting, she offered to ask some of the girls she had photographed if they would like to model. Nothing came of this, but hers were kind words at a time when few were offering any real warmth to the Varmas. The other friend they made in Hyderabad was an artist named Calastry. Calastry was the one

who came to them with the gossip that Deen Dayal was jealous of Ravi Varma and was subtly trying to make sure the painter didn't make any headway with the Nizam.

The Varmas decided they would not let themselves to get mired in the rumour-mongering that the city seemed to enjoy so much. Since they didn't have any commissioned work, Ravi decided to return to 'At the Bath', which had been started a month back in Udaipur. In Hyderabad, Raja decided to try and find a model, and perhaps upon Miss Sabrina's advice, he went looking among the prostitutes of the city. As usual, the girls had no compunction coming with them in the night but the moment they were asked to come to the studio by daylight, they refused. Two girls promised but never presented themselves. Raja noted in his diary that apparently nobody in Hyderabad kept their appointments, making an oblique reference to the Nizam whom they had been waiting to meet for over a month.

Ravi finally managed to win over one of the prostitutes. He convinced her to come to the studio the morning after and surprisingly, the girl came. She was as pretty by day as she had been by night, but in the studio she could not give Ravi the pose he needed. There was something too provocative and fake about her, but at least she was able to inspire Ravi to have a slightly clearer idea of what he wanted in the painting and how much of the girl he wanted visible. There was, of course, a sense of taboo about using a prostitute as a model, particularly for this painting. Prostitutes were considered to be among the lowest and most unclean in society. Once upon a time, there was a tradition of the courtesan who was a cultured woman rather than a whore, but that notion had long given way to a more Victorian disgust which saw prostitution as a social evil. The girl in the painting was supposed to be the stuff of a Hindu legend—virginal, pure, devout—and Ravi Varma had ultimately come closest to finding her in a Muslim prostitute.

After a month and a half of wasted time in Hyderabad, Ravi Varma decided to paint the portrait of the Nizam from a photograph and be done with the commission. When they received a letter from Kilimanoor telling them a cousin back home was very unwell, it was the perfect excuse to give to the Nizam's courtiers as an explanation for the photograph-based portrait. Interestingly, the photograph Ravi Varma used was not one taken by Deen Dayal. Considering the fact that Deen Dayal had been the Nizam's official photographer for more than a decade now, Ravi Varma must have taken some trouble to find a photograph that wasn't taken by him. There are no reliable explanations for what happened in Hyderabad. The Nizam's determined avoidance of Ravi Varma is odd, as is the lack of hospitality he showed the artist. Ravi was not allowed to see the Nizam's art collection and when the Viceroy visited, the artist was not in the list of important guests. On the face of it, there was nothing to tip him off that the Hyderabad commission would end up as a disaster but it was definitely one of the lowest points in his career.

* * *

The months in Hyderabad are generally not given much importance because, understandably, neither Ravi nor Raja spoke much about it. It tends to get forgotten amidst the flurry of activity that followed in the next few years. Ravi finalized the sale of the press immediately after returning to Bombay from Hyderabad. This didn't mean that he cut off all connections with it. Until his last days, he would make paintings for the press that were the same size as oleographs. When the press was finally handed over to Schleicher in 1903, Ravi Varma had the setup that he had perhaps originally envisaged. The press carried his name and produced his paintings, which he provided, but the daily rigour of running the press was Schleicher's, who was much more passionate than the artist about the business.

Through 1902 and 1903, Ravi and Raja lived between Madras, Thiruvananthapuram, Bombay, and Kilimanoor. They were an idyllic couple of years during which Ravi had few cares to bring his or his brother's spirits down. They worked in their studio at Khotachiwadi and in the evenings, watched plays and attended concerts. It was at a concert at an acquaintance's house in Lalwadi that Ravi met the dancer and courtesan Anjanibai Malpekar. She was rumoured to be Ravi's muse and mistress in Bombay but Anjanibai denied any such relationship. Most men did make advances towards her, she said when asked by an early biographer, but Ravi Varma stood out from the crowd of men particularly because he did no such thing. He told her that she had beautiful eyes and that he would be most grateful if she would model for him. Anjanibai was touched by his politeness. It wasn't often that people treated a courtesan with respect.

There are many photographs of Anjanibai among Ravi Varma's papers. She seems to have been his model for the painting titled 'Mohini', which also became a popular oleograph. Aside from her, there were two other regular models that the Varma brothers had in Bombay. One was Rajibai, who also modelled for their friend, the British painter Frank Brooks. The other was the unnamed Parsi woman who is seen in a number of Raja Varma's paintings. There is no way to determine whether the rumours of affairs are true. The fact that Raja painted the same woman so many times suggests that he did have a fondness for her, and it seems unlikely that a courtesan would have had a completely platonic relationship with Ravi Varma, despite Anjanibai's claim. But even if the rumours were true and the brothers did have romantic relationships with these models, they were fleeting fancies, particularly in case of Ravi who was in his early fifties when he met Anjanibai. Both brothers had only two priorities in their life: their art and each other.

In Madras, Ravi and Raja painted a series of portraits, many of

which seem to be commitments they had made during the time that Ravi needed well-paid assignments. It seems unlikely that the artist would have looked forward to painting as many portraits from photographs as he did at the time. Possibly because of his ill health, Ravi Varma was quite obviously getting ready to pass the baton to Raja. When it was time to submit paintings for the Madras Fine Arts Society in 1903, Ravi submitted paintings but did not enter them for the competition. Raja's 'Husain Sagar' won him the gold medal. The next year, both brothers participated but again, Ravi did not compete for prizes. Raja won both gold and bronze medals this year. The brothers also painted a number of British officials in Madras in 1903, most of which were signed by both of them. After the disappointment of Hyderabad, Madras must have been a great comfort to the Varmas. No one snubbed them here. Senior officials, even the visiting Viceroy, met them. The spate of portraits he painted at this time seems to have reminded the British about Ravi Varma, and the government invited him to be one of the judges at the art exhibition that was going to be held in Delhi as part of the durbar for King Edward VII. If the Nizam of Hyderabad had made Ravi Varma feel like a common, commercial artist, then Madras reassured him that he was indeed the prince among painters. Ironically, this kind of support from the British would be one of the major reasons that Ravi Varma came to be discredited in later years. His art was too closely associated with the colonial rulers and he came to be seen as their accomplice, especially after he was awarded the Kaiser-i-Hind in 1904 by Edward VII. There is no doubting that both Ravi and Raja had a fondness for the British. Raja's diary entry for January 23, 1901, is a lament for Queen Victoria's death and in it he wrote that he found it difficult to imagine India without her.

Once the independence movement was in full swing, awards like the Kaiser-i-Hind, which was instituted by Queen Victoria in 1900, would be seen as symbols of the British government's

benevolence to people they held up as their model Indians. M.K. Gandhi, for instance, was awarded the Kaiser-i-Hind in 1915 for supporting the British in South Africa. Notably, he returned the medal in 1920 as part of his protest against the Jallianwala Bagh massacre. However, the Kaiser-i-Hind unleashed a different set of problems for Ravi Varma because the citation referred to the artist as 'Raja Ravi Varma'. The Maharaja of Travancore was livid and accused the artist of trying to portray himself as something he was not. Even Ravi's old friend Kerala objected to the use of Raja before his name. Ravi wasn't bothered and he determinedly signed the works he painted after 1904 as 'RRV'. He also presented himself as Raja Ravi Varma when he was introduced to King George V in Madras during the royal visit of 1906. Had he been in Thiruvananthapuram at the time of the award's announcement, it's possible that another ego battle would have ensued between the artist and yet another Maharaja of Travancore. However, the artist was on his way to Mysore with Raja because the new Maharaja of Mysore, Krishnaraja Wadiyar, whom the artist had painted as a boy many years ago, had invited them to the southern kingdom.

Mysore ended up being one of the brothers' most enjoyable commissions. There were concerts, trips to palaces, and a wealth of comfort offered to them. The paintings that they made here pleased the Maharaja immensely and he asked Ravi for a set of paintings based on Hindu legends, like the ones he had painted for Baroda so many years ago, for the Jagan Mohan Palace in Mysore, which was being restored. Ravi agreed, promising to return next year with Raja to do the paintings. Krishnaraja Wadiyar had been as gracious and caring a host as his father had been. It was during the last days of the first Mysore commission that Raja fell unexpectedly ill. They were on their way to Bombay but Raja's condition became very serious and they stopped at Bangalore. It turned out that Raja had a tumour in his stomach

and doctors feared that he needed surgery. Ravi rushed him to Madras, hoping that the superior doctors of the Madras Presidency would be able to cure him. The surgeon, however, gave him no such hope. Raja Varma was diagnosed with inflammation of the intestines and had to be operated upon on January 3, 1905. He died the next day. He was only forty four years old.

* * *

Ravi Varma never recovered from the shock of Raja's death. Perhaps it hit him even harder because it came soon after the death of their second brother, Gode, in 1904. But Gode's death had been one that saddened the brothers but did not alter them or their lives in any way. Condolences were sent, hearts were heavy for some time, but Ravi and Raja continued with their lives and their work. Circumstances had led to the loosening of their ties with the rest of the family. Their lives had been spent away from their siblings and cousins so the relationships were politely cordial. They didn't compare with the intensity of the relationship that they shared with each other.

Those who knew Ravi said that he changed as a man when he returned to Kilimanoor without Raja beside him. Sadness sank into his face and aged his body. The once gregarious painter became quiet and cocooned himself in misery. In April, when the family held a feast for his fifty seventh birthday, Ravi Varma announced that he was planning to retire soon and once he did, there would be no more of this painting or public life. Ever the professional, he worked on the nine paintings he had promised Krishnaraja Wadiyar with help from his son Rama. They were grand paintings, celebrating youth, vigour, and masculinity. But it was obvious to his family that Raja's death was pushing him closer and closer to some dreaded edge. He began wandering in the fields that surrounded Kilimanoor Palace and people saw him talking to himself. He muttered, he shook his head, he

listened, he laughed as he walked alone through the green fields of Kilimanoor.

Raja had been a younger brother, a confidant, and a colleague. They had shared everything in the forty four years they had spent together, and they completed each other, matching one's flaws with the other's strengths. Marriage couldn't separate them, their differing opinions about rituals didn't create any rift, and not even personal ambition tainted their relationship. Had Raja actively pursued his own artistic career with the same drive that the two brothers showed for Ravi's career, chances are the younger brother would have been just as well known. He had written the first Indian travelogue and he had painted some exquisite landscapes using fluid lines and a delicate palette of light colours. But Raja Varma wasn't looking for fame. Erudite, quiet, and an unwavering supporter of Ravi Varma, Raja was his elder brother's anchor and without his presence, there was nothing that could give Ravi comfort. To paint was torture; he couldn't remember a time when he didn't have Raja by his side while painting, and now he was gone forever. But with his son as his assistant, he painted the canvases he had promised the Maharaja of Mysore, remembering Raja with every brushstroke.

In September 1905, father and son headed out to Mysore to deliver the paintings they had completed. They had originally intended to leave after hanging the paintings, but the Maharaja requested them to stay for King George V's visit to the state. It must have been very exciting for Rama , who was now a young man in his mid-twenties. What seemed to have dragged Ravi Varma back to the world outside of his imaginings was Rama contracting smallpox during their Mysore stay. For a few days, doctors worried that he wouldn't make it. Ravi nursed his son and prayed desperately for his recovery. His prayers were answered and Rama survived. They completed a few portraits, including one of the Governor of Madras, and a few other paintings during

their stay in Mysore. Some of them were scenes of the elaborate khedda, a trap laid to capture wild elephants, that had been organized for George V's entertainment. The paintings of the Mysore khedda show Ravi Varma wasn't able to hold his brush securely any more. His hands shook but he cleverly used the unsteadiness to create an impressionistic set of works that today seem more powerful than many of the paintings he made with a steady hand.

On September 20, 1906, a little more than a year after Raja's passing, Ravi Varma died in Killimanoor. His last few months had been spent surrounded by the best of allopathic and Ayurvedic doctors but they were unable to stop the diabetes that was ravaging his body. Bedridden, he lost his appetite. Soon he couldn't swallow water. When a carbuncle appeared on his shoulder, it was operated upon to give him some relief but the doctors warned the family that there was little hope of him surviving. In his fifty eight years, Ravi Varma had seen an old world turn to sepia and then crumble into dust. His first journey from Kilimanoor had been on a bullock cart and when he accompanied King George V to Mysore, he rode an automobile. He had been born in a sliver of a kingdom and when he died, he belonged to a country that was the size of a subcontinent. Oil paints had been novelties when he was growing up and now photography and prints made what he used to consider modern seem almost obsolete. Ravi Varma died knowing he had helped to fashion this new world and that even if he was forgotten, what he had painted would not be. His son, his sister, and Schleicher with all his oleographs would ensure it.

The painting 'At the Bath' is one of the few Ravi Varma paintings that the royal family of Travancore retained as its personal possession after Indian independence. The painting was not exhibited to the public during Ravi's lifetime, but there were copies and versions of it that surfaced soon after his death.

Gerhardt had painted a copy of it and titled it 'After the Bath', which Schleicher printed. It seems, from Gerhardt's painting, that he had seen an early drawing of the original or had taken Ravi's 'Moon Daughter' as his inspiration. 'Moon Daughter' was painted in the late 1890s and showed a woman in white, wet from the bath, standing by a moonlit pond. It was one of the paintings that Ravi painted in his buildup to the final canvas that hangs in Cowdiar Palace today. There is a distinct similarity in the posture of the girl Gerhardt painted and the one in 'At the Bath'. Instead of the ghat, the German artist placed his bathed heroine in a forest, possibly because he was very good at drawing leafy backgrounds. This, however, is not the print that is today sold in shops as Ravi Varma's 'At the Bath'. The image has been stolen and reprinted so many times over the past hundred odd years that it is impossible to find out who first came out with it. Everyone who sells it says with absolute certainty that it was painted by Raja Ravi Varma so perhaps the print had first come out of one of Schleicher's competitor presses, like the one called Ravi Varma Press. This print became known as the original and so others copied it too. Some called it 'At the Bath', others titled it 'A Malayali Lady at the Bath'.

The person who painted this version of it was not talentless and had some degree of art education. It doesn't seem as though they had seen the actual painting because everything about the print version is different, beginning with the angle at which the girl is presented to the viewer. But either they had heard a description of it or perhaps they somehow chanced upon one of the sketches or photographs that were taken for the painting. From the mischief in the woman's eyes and lips, one is almost tempted to think the artist knew perfectly well that he was stripping down the dreamy romanticism of the original to what it really was: a painting of a prostitute posing for a client. Despite its boldness, the girl in the original retains the sweet prettiness

that Ravi Varma gave to his painted women and that makes her charming. When critic and art historian A.K. Coomaraswamy wrote about the original 'At the Bath', he commented that the girl was not an 'unsipp'd blossom'. We can only wonder what floral analogy—Venus Flytrap?—would have followed if he had seen the woman in the print version.

When the Ravi Varma Fine Art Lithographic Press was bought by Fritz Schleicher in 1903 for the sum of Rs. 25,000, he inherited about Rs. 6,000 of debt. It would be a lasting source of amusement to Schleicher and Gerhardt that the press that essentially printed mythological scenes was a loss-making venture when owned by two devout and pedigreed Hindu men. But under the management of a German man who had a beer cellar and many mistresses, the press became profitable. The fact was that Schleicher was a good businessman who balanced his expenditures with his demand and had a nose for what people wanted. The press gave India the icons it needed as the country came into being. Heroes, gods, goddesses—they were all coming out of the steam-driven lithographic press in glorious colour. Schleicher's competitors stole from him and occasionally he returned the favour, but thanks to Ravi Varma's paintings, he had a stock of images that everyone wanted and he was liberal about who used his plates. The print of 'Mohini' sold everything from hair oil to health tonics. Ravi Varma's mythological paintings were used for posters, calendars, and postcards.

Under Schleicher's management, the press garnered a reputation for producing high quality prints and experimenting with innovations like adding metallic foil to create an effect that was reminiscent of the Tanjore style of painting. In Malavli, which is a few hours away from Bombay and close to Lonavla, Schleicher built up his small kingdom made up of his home and his press. He employed some people from the nearby villages of Bhaji as labourers and also got them to act as his guides and beaters when

plagiarism became a criminal activity. At the time, however, he was the only artist to print his own work. The prints of his paintings from the Ravi Varma Press were not works by anonymous artists as was the case with those of other presses. Some prints carried his signature, leaving no doubt about these being original works even though somebody else had done the actual drawing on the plate. Ravi Varma had recognized this rampant plagiarism as a problem. It robbed his press of exclusivity and it sullied his own name when amateurish paintings were considered his work. But what he didn't realize was that the plagiarists had unwittingly helped him create a legacy. The fake Ravi Varmas were often odes to the originals. Perhaps if there hadn't been as many copies, Ravi Varma's visions of village belles and traditional beauties would not have been imprinted upon our minds as ideals. Their profusion served to create a stereotype of what is a Ravi Varma painting. That remains instantly recognizable even today, whether it is in a vintage print or a fashion shoot celebrating traditional looks.

The man who owns the cornershop with the 'Lakshmi' print in its plastic altar doesn't know he has a watered-down version of a Ravi Varma painting. But to a large part of middle class India, the artist's name is synonymous with beauty: insipid, perhaps, but still a vision of perfection. Even if the cornershop owner doesn't know Ravi Varma's name, he shares that notion of beauty.

The India that Ravi Varma left behind and Schleicher thrived in was surrounded by the images the painter had made. Rama Varma, who went on to become an artist but didn't enjoy the fame of his father, would have always had an example of his father's painting reproduced as a print to which he would end up comparing his own work. The mysterious eldest son, who may have run away as a boy, would have seen the smiling faces of children, men, and women that his father had created, and as the years passed, these images would settle so deeply into popular memory, that when anyone said 'Lakshmi', they would see the

271

woman Ravi Varma had painted. She would have urged him to buy hair oil, candles, and an array of useless and useful items. He would have seen shopkeepers performing morning prayers to her before opening their doors. He would have glimpsed her through windows of people's homes, filling up empty walls. There would have been constant reminders of the tradition that he was supposed to have inherited and carried on. If Kerala Varma didn't run away from home but instead lived in a corner of Mavelikkara, steeped in alcohol and rejecting the responsibility of continuing the Ravi Varma school of painting, then perhaps he would have felt some vicarious triumph in the way his father's style of painting dissipated within years of his death.

First, critics like A.K. Coomaraswamy would be aghast by the boldness of the paintings. The near-visible breasts, seductive Menakas, and lusty Arjunas would scandalize them. Then critics like E.B. Havell, who was the principal of the Calcutta School of Art and played a key role in promoting the Bengal School of Art, lambasted Ravi Varma's paintings for being bland and unimaginative. Among the elite of India, the popularity of Ravi Varma paintings would wane. They were pretty things but in a time of revolution, art needed to be more vocal and rooted in reality. But for the everyman, Ravi Varma had created the idea of an Indian beauty and thanks to Schleicher, she could be bought for the price of an oleograph or seen in posters and advertisements. A photographic print of the fake 'At the Bath' costs Rs. 100 today, in the more touristy parts of Thiruvananthapuram.

List of Ravi Varma's Major Works

Ravi Varma's works are scattered in private collections and Indian museums. Given below are some of his more famous works and their locations.

Family portrait of Khizhakke Krishna Menon, 1870 (Private collection)

Nair Lady at the Toilet, 1873 (National Art Gallery, Chennai)

Shakuntala Patralekhan, 1876 (Private collection)

Gaekwad in Investiture Robes, 1881 (Private collection)

Laxmi, 1881 (Maharaja Fatehsingh Museum, Vadodara)

Saraswati, 1881 (Maharaja Fatehsingh Museum, Vadodara)

Nala and Damayanti, 1881 (Maharaja Fatehsingh Museum, Vadodara)

Sairandhri, 1881 (Maharaja Fatehsingh Museum, Vadodara)

Sita Siddhi, 1881 (Maharaja Fatehsingh Musuem, Vadodara)

Portrait of Raja Raja Varma, 1882 (Sri Chitra Art Gallery, Thiruvananthapuram)

Portraits of the royal family of Mysore, 1885 (Sri Jayachamarajendra Art Gallery, Mysore)

Judith, 1886 (Sri Chitra Art Gallery, Thiruvananthapuram)

Arjuna and Subhadra, 1888/1890 (Maharaja Fatehsingh Museum, Vadodara)

Shantanu and Ganga, 1888/1890 (Maharaja Fatehsingh Museum, Vadodara)

Nala and Damayanti, 1888/1890 (Maharaja Fatehsingh Museum, Vadodara)

Radha and Madhava, 1888/1890 (Maharaja Fatehsingh Museum, Vadodara)

Bharata and the Lion Cub, 1888/1890 (Maharaja Fatehsingh Museum, Vadodara)

Vishwamitra and Menaka, 1888/1890 (Maharaja Fatehsingh Museum, Vadodara)

Kamsa Maya, 1888/1890 (Maharaja Fatehsingh Museum, Vadodara)

Disrobing of Draupadi, 1888/1890 (Maharaja Fatehsingh Museum, Vadodara)

Harishchandra and Taramati, 1888/1890 (Maharaja Fatehsingh Museum, Vadodara)

Keechak and Sairandhri, 1888/1890 (Maharaja Fatehsingh Museum, Vadodara)

Sita Swayamvaram, 1888/1890 (Maharaja Fatehsingh Museum, Vadodara)

Birth of Krishna, 1888/1890 (Maharaja Fatehsingh Museum, Vadodara)

Devaki and Krishna, 1888/1890 (Maharaja Fatehsingh Museum, Vadodara)

Shantanu and Satyavati, 1888/1890 (Maharaja Fatehsingh Museum, Vadodara)

Galaxy of Musicians, 1889 (Sri Jayachamarajendra Art Gallery, Mysore)

Lady in Moonlight, 1889 (Sri Jayachamarajendra Art Gallery, Mysore)

Malabar Beauty, 1893 (Sri Chitra Art Gallery, Thiruvananthapuram)

There comes Papa, 1893 (Private collection)

Begum at the Bath, 1893 (Private collection)

Expectation, 1893 (Private collection)

Decking the Bride, 1893 (Private collection)

Sisterly Remembrance, 1893 (Private collection)

Poverty, 1893 (Sri Chitra Art Gallery, Thiruvananthapuram)

Lady with Mirror, 1894 (National Art Gallery, Chennai)

Durbar of Pudukottai, 1894 (National Art Gallery, Chennai)

Ravana Carrying Sita, 1895 (Sri Chitra Art Gallery, Thiruvananthapuram)

Draupadi at the Court of Virata, 1897 (Sri Chitra Art Gallery, Thiruvananthapuram)

Damayanti and the Swan, 1897 (Sri Chitra Art Gallery, Thiruvananthapuram)

Sakuntala Looks Back in Love, 1897 (Sri Chitra Art Gallery, Thiruvananthapuram)

Sakuntala, 1898 (National Art Gallery, Chennai)

Hamsa Damayanti, 1899 (Sri Chitra Art Gallery, Thiruvananthapuram)

Swan Messenger, 1899 (Sri Jayachamarajendra Art Gallery, Mysore)

Lady Giving Alms, 1899 (Sri Jayachamarajendra Art Gallery, Mysore)

Mohini and Rukmangada, 1899 (Sri Chitra Art Gallery, Thiruvananthapuram)

Malabar Beauty, 1899 (Sri Jayachamarajendra Art Gallery, Mysore)

A Student (Portrait of C. Raja Raja Varma), 1904 (Sri Chitra Art Gallery, Thiruvananthapuram)

Milkmaid, 1904 (Sri Chitra Art Gallery, Thiruvananthapuram)

Sethubandam, 1905 (Sri Jayachamarajendra Art Gallery, Mysore)

Damayanti and Swan, 1905 (Sri Jayachamarajendra Art Gallery, Mysore)

Bhishma's Vow, 1905 (Sri Jayachamarajendra Art Gallery, Mysore)

The Servitude of Sairandhri, 1905 (Sri Jayachamarajendra Art Gallery, Mysore)

275

Sri Rama Breaks the Bow, 1905 (Sri Jayachamarajendra Art Gallery, Mysore)

Ravana Fights Jatayu, 1905 (Sri Jayachamarajendra Art Gallery, Mysore)

Victory of Indrajit, 1905 (Sri Jayachamarajendra Art Gallery, Mysore)

Krishna as Envoy, 1905 (Sri Jayachamarajendra Art Gallery, Mysore)

Krishna and Balaram Liberating their Parents, 1905 (Sri Jayachamarajendra Art Gallery, Mysore)

Khedda Operation, 1906 (Sri Chitra Art Gallery, Thiruvananthapuram)

Khedda Camp, 1906 (Private collection)

Kadambari Playing Upon a Veena, 1906 (Sri Jayachamarajendra Art Gallery, Mysore)

Suckling Child, 1906 (Sri Jayachamarajendra Art Gallery, Mysore)

The National Gallery of Modern Art in New Delhi also has a few Ravi Varma originals.

C. Raja Raja Varma

Most of C. Raja Raja Varma's paintings can be found in Sri Chitra Art Gallery in Thiruvananthapuram.

Ladies at a Well, 1899 (Pazhassiraja Art Gallery, Calicut)

Husain Sagar, 1903 (Sri Chitra Art Gallery, Thiruvananthapuram)

Siesta, 1904 (Sri Chitra Art Gallery, Thiruvananthapuram)

The Triplicane Temple, 1904 (Sri Chitra Art Gallery, Thiruvananthapuram)

Lady with Parrot, 1904 (Pazhassiraja Art Gallery, Calicut)

Mosque, 1904 (Pazhassiraja Art Gallery, Calicut)

At the Village Tank, 1905 (Sri Chitra Art Gallery, Thiruvananthapuram)

Bibliography

30,000 Years of Art, Phaidon, 2007.

Albuquerque, T., *Bombay, A History*, Promilla, 1992.

Arnold D. and P. Robb (eds), *Institutions and Ideologies: A SOAS South Asia Reader*, Curzon Press, 1993.

Bakhle, J., *Two Men and Music: Nationalism in the Making of an Indian Classical Tradition*, Oxford University Press, 2005.

Badea-P'Aun, G., *The Society Portrait: Painting, Prestige and the Pursuit of Elegance,* Thames & Hudson, 2007.

Basham, A.L., *A Cultural History of India*, Oxford University Press, 1999.

———*The Origins and Development of Classical Hinduism*, Oxford University Press, 1991.

Banerjee S., *The Parlour and the Streets*, Seagull Books, 1989.

Bayly, S., *Caste, Society and Politics in India from the Eighteenth Century to the Modern Age*, Cambridge University Press, 2001.

Brownell, W.C., *French Art, Classic and Contemporary: Painting and Sculpture*, Kessinger Publishing, 2007.

Chapman, G., *The Geopolitics of Asia*, Ashgate Publishing, 2008.

Codell, J., 'Ironies of Mimicry: The art collection of Sayaji Rao III Gaekwad, Maharaja of Baroda, and the cultural politics of early modern India', *Journal of the History of Collections,* 15 (1), 2003.

Codell, J., (ed.), *Imperial Co-histories: National Identities and the British and Colonial Press*, Associated University Presses, 2003.

Codell, J. and D.S. MacLeod (eds), *Orientalism Transposed: The*

Impact of the Colonies on British Culture, Ashgate Publishing, 1999.

Coomaraswamy, A.K., *Dance of Siva: Fourteen Indian Essays*, Kessinger Publication, 2003.

————*Introduction to Indian Art*, Kessinger Publications, 2008.

R. Lipsey (ed.), *Coomaraswamy: Selected Papers, Volume 1: Traditional Art and Symbolism*, Princeton University Press, 1977.

R. Coomaraswamy (ed.), *The Essential Ananda K. Coomaraswamy*, World Wisdom, 2003.

Davis, M., *Late Victorian Holocausts*, Verso, 2000.

Darmon R. and K. Winata, *Made in India*, Chronicle Books, 2008.

Dehejia, V., *India through the Lens: Photography 1840-1911*, Mandala Publishing, 2006.

Doniger, W., *Hindu Myths*, Penguin Classics, 2004.

Dwivedi, S., *Maharaja: Princely States*, Vendome Press, 2002.

Dwivedi, S. and R. Mehrotra, *Bombay: The Cities Within*, Indian Book House, 1995.

Eck, D.L., *Darsan: Seeing the Divine Image in India*, Columbia University Press, 1998.

Eisenstein, E.L., *The Printing Press as an Agent of Change* (Volumes 1 and 2), Cambridge University Press, 1980.

Falconer, J. and R.F. Johnson, *Reverie and Reality*, Fine Arts Museum of San Francisco, 2006.

Guha-Thakurta, T., 'Westernisation and Tradition in South Indian Paintings in the Nineteenth Century: The Case of Raja Ravi Varma, 1848-1906', *Studies in History*, 2(2), 1986.

————'Women as Calendar Art Icons', *Economic and Political Weekly*, vol. 26, no. 29, 1991.

Goswami, M., *Producing India: From Colonial Economy to National Space*, University of Chicago Press, 2004.

Harrison, C., P.J. Wood and J. Gaiger (eds), *Art in Theory 1815-*

1900: An Anthology of Changing Ideas, Wiley-Blackwell, 1998.

Hemenway, P., *Hindu Gods: The Spirit of the Divine (Spiritual Journeys)*, Chronicle Books, 2003.

Iyer, K.B., *Art and Thought*, Luzac, 1947.

Jaisi, S., (tr. N. Luther), *The Nocturnal Court: The Life of a Prince of Hyderabad*, Oxford University Press, 2004.

Jansen, E.R., *The Book of Hindu Imagery: The Gods and Their Symbols*, Weiser Books, 1993.

Jain, K., *Gods in the Bazaar: The Economies of Indian Calendar Art (Objects/Histories)*, Duke University Press, 2007.

Jayawardene-Pillai, S., *Imperial Conversations: Indo-Britons and the Architecture of South India*, Yoda Press, 2007.

Jeffrey, R., *Decline of Nayar Dominance: Society and Politics in Travancore, 1847-1908*, Holmes & Meier Publishers, 1976.

Kapur, G., 'Ravi Varma: Representational Dilemmas of a 19th Century Indian Painter', *Journal of Arts and Ideas*, no. 17-18, 1989.

Keay, J., *The Honourable Company: A History of the English East India Company*, Harper Collins, 1993.

Keshavan, B.S., *History of Printing and Publishing in India*, Vol. 1, National Book Trust, 1985.

———*History of Printing and Publishing in India*, Vol. 2, National Book Trust, 1985.

Kinsley, D.R., *Hindu Goddesses: Visions of the Divine Feminine in the Hindu Religious Tradition*, University of California Press, 1988.

Kuppuram, G., *India Through the Ages: History, Art, Culture and Religion*, Sandeep Prakashan, 1988.

Lawrence-Lightfoot, S. and J. Hoffman Davis, *The Art and Science of Portraiture*, Jossey-Bass, 2002.

Llewellyn-Jones, R., *Portraits in Princely India 1700-1900*, Marg Publications, 2008.

Luther, N., *Raja Deen Dayal: Prince of Photographers*, Hyderabadi. in, 2006.

Mathur, S., *India By Design: Colonial History and Cultural Display*, University of California Press, 2007.

Mitter, P., *Much Maligned Monsters*, Oxford University Press, 1977.

————*Art and Nationalism in Colonial India*, Cambridge University Press, 1994.

Morrison, J., *New Ideas in India during the Nineteenth Century*, BiblioBazaar, 2007.

Nandakumar, R., 'Raja Ravi Varma in the Realm of the Public', *Journal of Arts and Ideas*, no. 27-8, 1995.

————'The Missing Male', *South Indian Studies*, 1, 1996.

Nayar, N. Balkrishnan, *Raja Ravi Varma: A Biography*, Kamalaya Book Depot, 1953.

Neumayer E. and C. Schelberger (eds), *Raja Ravi Varma, Portrait of an Artist: The Diary of C. Raja Raja Varma*, Oxford University Press, 2005.

————*Popular Indian Art: Raja Ravi Varma and the Printed Gods of India*, Oxford University Press, 2003.

Nochlin, L., *The Politics of Vision: Essays on Nineteenth-Century Art and Society*, Westview Press, 1991.

Pattanaik, D., *Indian Mythology: Tales, Symbols, and Rituals from the Heart of the Subcontinent*, Inner Traditions, 2003.

Pelizzari, M.A., *Traces of India: Photography, Architecture, and the Politics of Representation, 1850-1900*, Yale Center for British Art, 2003.

Pillay, K., *Raja Ravi Varma, The Great Indian Artist*, Sarvodyam Press, 1954.

Pinney, C., 'The Nation (Un)Pictured? Chromolithography and "Popular" Politics in India 1878-1995', *Critical Enquiry*, Volume 23, Issue 4.

————*The Coming of Photography in India*, British Library, 2008.

————*The Social Life of Indian Photographs*, University of Chicago Press, 1998.

Ramaswami, N.S., *Tanjore Paintings: A Chapter in Indian Art History*, publication section of Kora's Indigenous Arts and Crafts Centre, 1976.

Ramusack, B., *The Indian Princes and Their States*, Cambridge University Press, 2004.

Richman, P. (ed.), *Many Ramayanas: The Diversity of a Narrative Tradition in South Asia*, University of California Press, 1991.

Rossi, B., *From the Ocean of Painting: India's Popular Paintings, 1589 to the Present*, Oxford University Press, 2000.

Sarkar, S., *Beyond Nationalist Frames: Postmodernism, Hindu Fundamentalism, History*, Permanent Black, 2002.

Sarkar, T., *Hindu Wife, Hindu Nation: Community, Religion, and Cultural Nationalism*, Hurst & Co. Ltd., 2001.

Schama, S., *The Power of Art*, Ecco, 2006.

Schneider, N., *The Art of the Portrait*, Benedikt Taschen Verlag, 1999.

Sharma, R.C. (ed.), *Raja Ravi Varma: New Perspectives*, National Museum, New Delhi, 1993.

Shungoony Menon, P., *History of Travancore from the Earliest Time*, 1998.

Sinha, G., *Art and Visual Culture in India: 1857-2007*, Marg Publications, 2009.

Sinha, M., *Colonial Masculinity: The 'Manly Englishman' and the 'Effeminate Bengali' in the Late Nineteenth Century*, Manchester University Press, 1995.

Sutton, D., *Other Landscapes: Colonialism and the Predicament of Authority in Nineteenth-century South India (Nias Monographs)*, Nordic Institute of Asian Studies, 2009.

Sutton, J., *Lords of the East: The East India Company and its Ships (1600-1874)*, Conway Maritime Press, 2000.

ten-Doesschate Chu, P., *Nineteenth Century European Art*, Prentice-Hall, 2006.

Toman, R., *The Art of the Italian Renaissance: Architecture, Sculpture, Painting, Drawing*, H.F. Ullmann, 2008.

Tomlinson, J.A., *Readings in Nineteenth-Century Art*, Prentice-Hall, 1995.

Woodall, J.(ed.), *Portraiture: Facing the Subject*, Manchester University Press, 1997.

Venniyoor, E.M.J., *Raja Ravi Varma*, Government of Kerala, 1981.

Visscher, J.C. and H. Drury, *Letters From Malabar: To Which Is Added An Account Of Travancore, And Fra Bartolomeo's Travels In That Country (1862)*, Kessinger Publishing, 2008.

Zimmer, H.R., *Myths and Symbols in Indian Art and Civilization*, Princeton University Press, 1972.

Acknowledgements

Considering how I've hounded virtually every person I know, thanks need to be extended to anyone who has taken a call from me or met me in the past year. Thanks should also be proffered to everyone whose call I didn't take and whom I didn't meet because I was writing. Here's proof that I wasn't lying when I said I was writing a book. However, some are always more equal than others and so my grateful thanks:

To the royal family of Travancore in Thiruvananthapuram and the people of M.S. University and the Maharaja Fateh Singh Museum in Vadodara,

To Bala, for introducing me to royalty,

To Sreemati and Joy, for raiding the libraries at Harvard and the London School of Economics for me,

To Bijal, Amit, Suhani, Neha, Fio, Roshni, and other friends at *Time Out Mumbai*, for making sympathetic noises every time I wailed,

To Naresh Fernandes, for always having ten books on Mumbai's history handy when I'd only asked for 'one or two',

To Baijayanta Mukhopadhyay and Leo Mirani, for making good use of Skype and bearing with me as I grew crotchetier and more neurotic as deadlines came and whooshed past,

To Mort and Tara, for pulling out old brochures and telling me ghost stories,

To Chiki Sarkar, for having given me the chance to write this and not becoming crotchetier and more neurotic as deadlines whooshed past,

To my mother, for always having the answers, and my father, for refusing to read a manuscript and demanding 'a real book',

To my in-laws, who were kind enough to keep the faith that somewhere under that snarling creature was their daughter-in-law,

And to Anuvab, for surviving me and Ravi Varma.

A Note on the Author

Deepanjana Pal studied at St. Stephen's College, Delhi, and the University of Warwick. She currently works with *Time Out* Mumbai and writes on art and literature.

A Note on the Type

This book was set in a modern adaptation of a type designed by the first William Caslon (1692–1766). The Caslon face has enjoyed much popularity in modern times. Its characteristics are remarkable regularity and symmetry, and beauty in the shape and proportion of the letters; its general effect is clear and open but not weak or delicate. For uniformity, clearness, and readability it has perhaps never been surpassed.